ICONS
OF ART
The 20th Century

Edited by

Jürgen Tesch and Eckhard Hollmann

Prestel Munich · Berlin · London · New York

Contributors:

Marion Ackermann M.A. Isabel Alcántara / Sandra Dorina Egnolff A.E. David Anfam D.A.

Matthias Arnold M.Ar. Jacob Baal-Teshuva J.B.-T. Sandro Bocola S.B. Barbara Catoir B.C.

Jean Clair J.C. Patricia Drück P.D. Hajo Düchting H.D. Dietmar Elger D.E. Anne Erfle A.Er.

Manfred Fath M.F. Andreas Franzke A.F. Helmut Friedel H.F. Ernst-Gerhard Güse E.-G.G.

Reinhold Heller R.H. Inge Herold I.H. Thomas Heyden T.H. Annegret Hoberg A.H.

Reinhold Hohl R.Ho. Eckhard Hollmann E.H. Joachim Jäger J.J. Friederike Kitschen F.K.

Stephan Koja S.K. Annette Kruszynski A.K. Lothar Lang L.L. Ruth Langenberg R.L.

Alexander Langkals A.L. Karin von Maur K.v.M. Irene Netta I.N. Harald Olbrich H.O.

Susanna Partsch S.Pa. Stefanie Penck S.P. Ursula Perucchi-Petri U.P.-P. Gerd Presler G.P.

Elisabeth Rochau E.R. Lillian Schacherl L.Sch. Ralf Schiebler R.Sch. Wieland Schmied W.Sch.

J.A. Schmoll gen. Eisenwerth J.A.S. Klaus Albrecht Schröder K.A.S. Peter-Klaus Schuster P.-K.S.

Reinhard Spieler R.S. Werner Spies W.S. Walter Springer W.Spr. Peter Stepan P.S.

Bärbel Wauer B.W. Astrid Wege A.W. Alfred Weidinger A.Wei. Evelyn Weiss E.W.

Ulrich Wilmes U.W. Katharina Wurm K.W.

Artists:

Foreword

"If there were only one single truth,
it would not be possible to paint a hundred
pictures of the same subject."
Pablo Picasso

Since every work of art is based, in the broadest sense, on that which is seen, experienced, and perceived — and because artistic development would be inconceivable without models and mentors — our selection begins with the great harbingers of art in the 20th century such as Rodin, Van Gogh, Gauguin, and Munch, among others. These artists broke with representational art and thus created the conditions for pictorial autonomy. Matisse once aptly and succinctly described this detachment from 19th-century academic notions of art. When asked about the "unnaturalness" of *The Dance*, he replied: "I do not paint women, I paint pictures."

Presented in chronological order, the works in this volume — as well as the artists' biographies — shed light on the ever-changing conceptions of art over the last hundred years. They not only reveal the development of painting, from the early modern period to our time, but also the integration of new methods, the use of light instead of paint and paintbrushes, the development of new techniques and forms of expression, such as installations, Land Art, and performance art, and finally the penetration of new media and technology into fine arts.

"There is good reason to assume that the modern age has come to an end. There are many indications that we are going through a period of transition; it appears as though something is dying out while something else is painfully being born. It is as though something is perishing, falling apart, has become exhausted, while something else, still undefined, rises from the ruins." These thoughts of the Czech Republic's president, Václav Havel, express what many feel, faced, at the end of this century, with a world that seeks to redefine itself and its future prospects in the wake of the tremendous social, political, economic, and cultural changes which have taken place in this century. Such uncertainty is also evident in the disparity and dissipation of the art of today, while current discussions on Post-Modernism, "second modernism," and the "end of art" bear witness to the same phenomenon.

The question that becomes paramount is: what shall remain valid in the art of this century, and what kind of art shall bear the fruit of new developments capable of paving the way to the 21st century? The present volume undertakes to introduce a modest selection of the work of 100 artists who are key representatives of the 20th century. However, such a selection is subjective by nature; the planned size of this book has also made it necessary to restrict its scope and to expound solely upon European and American art.

Since its publication of the German edition of Werner Haftmann's *Painting in the Twentieth Century* in 1954, Prestel has produced over 1,000 publications on related subjects. We naturally drew on these experiences when selecting the works illustrated in this book. Discussions held with authors such as Wieland Schmied and Sandro Bocola also provided us with helpful insights; for their assistance we would like to extend our heartfelt thanks.

In selecting the works illustrated and discussed in this volume, we also allowed ourselves to be influenced by the fact that the public's reception of art plays an important part in its development. As Sandro Bocola once wrote: "The success of an artist indicates that the public was in some way able, or thought it was able, to recognize itself in his work (or in his person), thereby identifying itself. Only the 'successful' work reflects the consciousness of 'its' time; this also applies when this consciousness and thus success — as in the case of some pioneers — lags temporally behind the work of art." A chronicle of the great artistic successes thus also inevitably reflects the development of the artistic consciousness of an era.

In this context it again becomes evident that no other artist has influenced 20th-century notions of art to the extent that Pablo Picasso has. Consequently, he is the only artist who is represented by two works of art in this volume: *Les Demoiselles d'Avignon*, the "Cubist picture of humanity" purely and simply, the "ultimate provocation" (Werner Spies), and the undoubtedly most famous anti-war painting in the history of art, *Guernica*.

The final exponent discussed is Louise Bourgeois, the grande dame of American contemporary art, whose work — which is "autobiographical in all its phases" (Barbara Catoir) — was discovered quite late and was embraced by the art world. In its precursory role, the oeuvre of this extraordinary avant-garde artist reflects many important trends prevalent in the art of our century.

Our century, equally marked by its progressive thought and by its catastrophes, has witnessed a profusion of artistic trends and developments like no other. To manifest these developments, to bring together works of art that have changed the world of art, if not the world, is the object of this volume.

The Editors

Auguste Rodin

The Thinker, 1880–81

1840 Auguste Rodin is born on November 12 in Paris

1854 Attends the state-run school of arts and crafts, the Petite Ecole, in Paris

1864 Creates his first work, *Man with the Broken Nose*

to 1871 Works on decorative sculptures in the studio of Albert Carrier-Belleuse

1875 First visit to Italy; studies the works of Michelangelo, Donatello, and the sculptors of classical antiquity; *The Age of Bronze* (1876) is so realistic that it is suspected of being cast from nature

1879 *Saint John the Baptist* receives a salon prize

1880 Receives his first major state commission, for *The Gates of Hell*

1883 First meeting with the sculptress Camille Claudel, who inspires Rodin to create many works, including *The Kiss* (1886)

1884 Receives commission for *The Burghers of Calais*

1888 Receives commission for a statue of Victor Hugo for the Panthéon in Paris

1891 Receives commission for a statue of Balzac

1895 Moves to the Villa des Brillants in Meudon, Paris

1900 Creates his own pavilion during the Exposition Universelle

1916 Bequeaths his entire estate to the French state

1917 Marries Rose Beuret on January 29; dies on November 18

1919 Musée Rodin opens in Paris

The Thinker is perhaps Rodin's most famous work — and at the same time the one subject to most speculation. There are many unanswered questions concerning this figure (who is he and what is he thinking about?), but the discussion surrounding it and the various attempts at interpretation have merely further underlined its importance as a work of art. It was originally conceived as part of Rodin's *Gates of Hell* (started in 1880), which was intended to portray scenes from Dante's *Inferno* and represented the entrance to hell, over which the poet's inscription seems to hover invisibly: "Abandon all hope ye that enter here." Rodin had originally considered portraying Dante himself, the poet and visionary of hell, but he chose to create this individual instead, who seems to be brooding about fate and pondering the meaning of existence. Even outside the context of the massive *Gates of Hell* — which were set up in front of the Paris Panthéon in 1906 and immediately triggered heated discussion, subsequently being removed after it was the target of vandalism — *The Thinker* still remains an important example of an entirely new departure in the plastic arts. The concentrated mass of this compact figure and the relaxed left hand, contrasting with the controlled tension of the rest of the body, point to a number of different emotional states. **R**odin was the leading sculptor at the turn of the century and as such exerted a lasting influence on his contemporaries and on subsequent generations of sculptors. His works themselves reveal the direct influence of some of the major European styles. Thus, in addition to impressionist elements, one can also find a certain symbolist content as well as expressionist overtones striving to achieve form in his work. **I**n 1952, Constantin Brancusi said of Rodin: "... in the 19th century, sculpture was in a desperate state. Then Rodin came along and managed to change everything. It was thanks to him that Man once again provided the proportions for statues.... It was thanks to him that sculpture, in its dimensions and spiritual content, became human again. Rodin's influence was and still is enormous...." *J. A. S.*

Crone, R. and S. Salzmann (eds.). *Rodin: Eros and Creativity*. Munich, 1992.
Fath, M. (ed.). *Auguste Rodin: Das Höllentor, Zeichnungen und Plastik*. Munich, 1991.
Laurent, M. *Rodin*. Cologne, 1989.
Schmoll gen. Eisenwerth, J. A. *Auguste Rodin and Camille Claudel*. Munich, 1994.

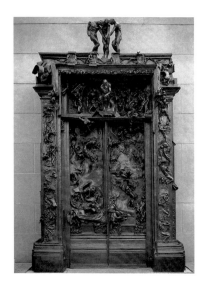

The Gates of Hell, 1880–1917

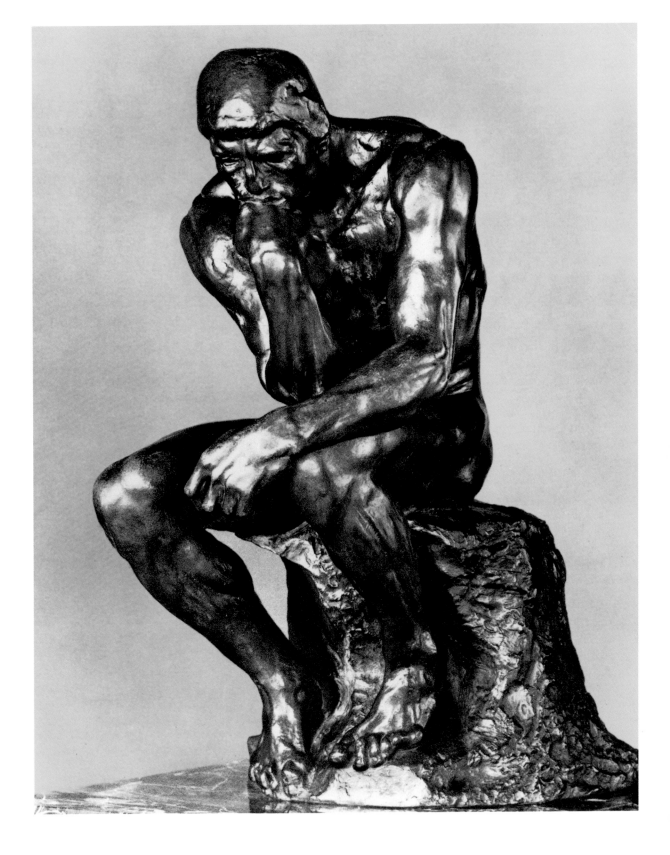

Vincent van Gogh

Cypresses, 1889

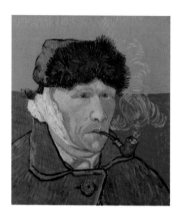

On June 25, 1889, Van Gogh wrote to his brother Theo from the mental hospital in Saint-Rémy about the paintings he was then working on: "Two studies of cypresses in this difficult bottle-green tone; I treated the foreground with thick white lead, which gives the terrain its stability.... The cypresses are constantly on my mind, I would like to make something like the sunflower pictures out of them, and I am surprised that they have never before been painted the way that I see them. They are beautiful, like an Egyptian obelisk in both line and proportion.... I think that of the two cypress pictures, the one that I sketched is the better one. In it the trees are very large and ponderous. The foreground very low, with blackberry brambles and shrubs. A green and pink sky with a crescent moon behind the violet-colored mountains. Above all, the foreground is painted in impasto, blackberry bushes with yellow, violet, and green reflections. I will send you sketches of it...." In addition to the small sketch he made in his letter, Van Gogh did in fact complete another abstract and bold pen drawing in sepia (Brooklyn Art Museum, New York) of this motif, which for him was unusual. This heavily impastoed painting is one of the artist's most remarkable and rare vertical landscape paintings produced in his mature period. It represents the first and, at the same time, the most striking painting of cypress trees done by the Dutch painter. While its counterpart was being reworked — not necessarily favorably — by the painter at the beginning of February 1890, the New York painting underwent only very minor retouching after it had dried, particularly near the edges of the dark silhouettes of the trees, which subtly reduced the contrast between light and dark in the painting. Already by September 1889 the artist was able to send it to Theo in Paris. The Japanese-inspired, asymmetrical composition, the finely gradated color tones, the structured, relief-like impastoed facture produced through numerous parallel and converging brushstrokes, and, finally, the two omnipotent trees with their vigorous outward and inward forms suggest a virtual pantheistic natural drama, an earthshaking convulsion. For the first time in modern European landscape painting, emotions — of the "seismographically" sensitive painter — are symbolically given expression. On February 2, 1890, Van Gogh recounted: "When I produced the sunflowers, I looked for something opposite yet of equal value and I told myself: That is the cypresses." In the subject matter from Saint-Rémy, Van Gogh found what he had found in his sunflower depictions painted in Arles: the cypress, the tree found in Mediterranean cemeteries, this almost black "obelisk" transformed by the artist — a man who was to live only a few more months – into a "tree of life," a symbol of life. Such emotional landscapes, such movingly rhythmic images by Van Gogh would become standard-setting "icons" for Expressionist painting, which was to emerge in the 20th century.

M. A.

Arnold, M. *Vincent van Gogh: Werk und Wirkung*. Munich, 1995.

Vincent van Gogh und die Moderne. Exh. cat. Museum Volkwang Essen. Essen, 1990.

Nemeczek, A. *Van Gogh in Arles*. Munich, 1995.

Walther, I. F. and R. Metzger. *Vincent van Gogh: Sämtliche Gemälde*. Cologne, 1989.

Cypresses, 1889 *Sunflowers, 1888*

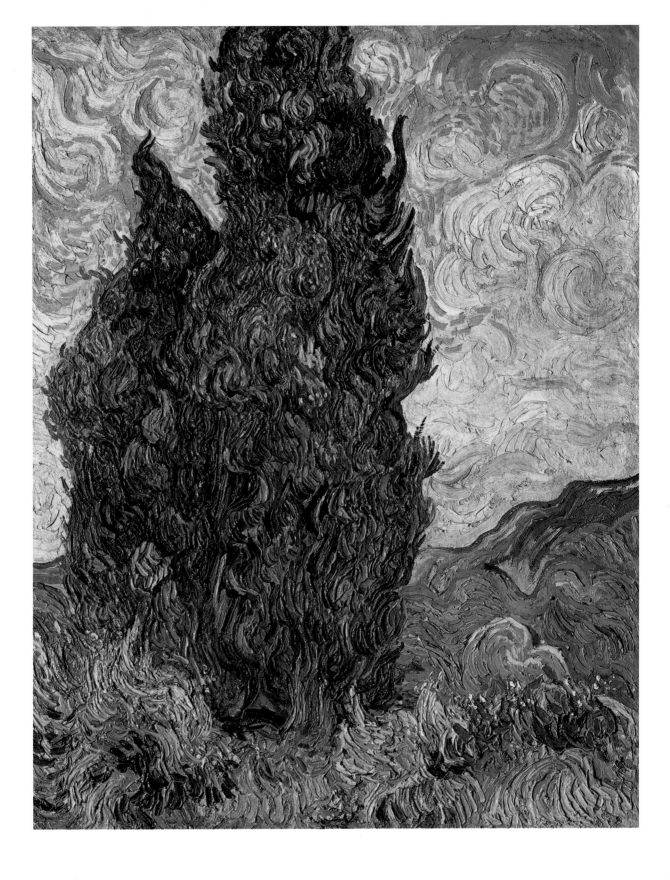

Paul Gauguin

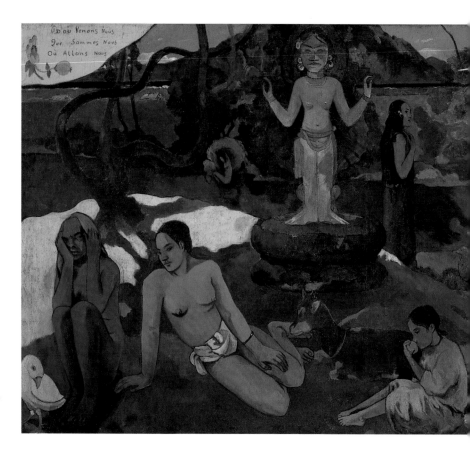

Where Do We Come From? Who Are We? Where Are We Going?, 1897

In 1893, when Paul Gauguin returned to Paris from his first journey to Tahiti with more than 60 paintings in his luggage, he was certain that the exhibition of these works would prove a triumph for him. All the more bitter was his disappointment when critics and the public alike reacted to his art as they had always reacted: with misunderstanding and ridicule. His "brown Eva" in the picture *Beautiful Land* was mocked as a "female ape," although with this work in particular Gauguin had achieved a successful fusion of Western iconography and his new, boldly colored, planar painting technique. Gauguin went back to the South Seas and remained there, despite the adverse circumstances of his life, until he died. Towards the end of 1897, he began to paint a large picture — almost thirteen feet wide — directly on the canvas without any preliminary drawing: *Where Do We Come From? Who Are We? Where Are We Going?* "I have painted a philosophical work on this subject comparable to the Gospels. I believe it is successful," he later wrote in a letter to Daniel de Monfreid, and he went on to report to his friend: "The two upper corners are chrome yellow, with an inscription on the left and my signature on the right, as if it were a fresco painted on gold ground that was damaged at the corners." The compositional framework of the painting is formed by three groups of people. On the right, three women with a child represent birth and childhood. In the middle, a woman is plucking an apple. Here, Gauguin makes reference to the biblical story of the Garden of Eden and the Fall. Eva takes the apple from the tree of knowledge. It reveals to her the nature of

love, but at the same time plunges her into sin. On the extreme left of the picture squats an ancient woman, a symbol of death. The picture radiates a sense of calm and tranquility. The main figures are arranged in three different planes that articulate the depth of the picture. The figures overlap only slightly and are developed strictly out of the planar surface. The coloration is restrained and based on the contrasting tones of blue-orange and red-green. As a result, the picture has a monumentality that is achieved by purely artistic means and that is quite independent of its true dimensions. It might easily be a fresco. The figures seem to bear scarcely any relation to each other, nor to the idol in the left-hand third of the picture, which embodies divinity in the broadest sense of the word. They are tied into the surrounding landscape, are a part of nature, of the Creation to which they belong, from which they came, to which they will return, regardless of their actions, their relations to each other, or whatever religious allegiance they may have. It is a picture of earthly existence, a plea for the *joie de vivre* that man should enjoy as intensely as possible before social pressures, or simply the biological process of aging, rob him of such pleasures. That is the painter's simple message, evoked in a most successful pictorial and formal composition. *E. H.*

Delightful Land (Te nave nave fenua), 1892

Hoog, M. *Gauguin*. London, 1987.
Hollmann, E. *Paul Gauguin: Images from the South Seas*. Munich, 1996.
Paul Gauguin e l'avanguardia russa. Exh. cat. Ferrara, Palasso dei Diamanti. Florence, 1995.

1860 James Sidney Ensor is born on April 13 in Ostend, Belgium

1877–80 Studies at the Academy in Brussels under Robert, Stallaert and van Severdonck

1880 Returns to Ostend

1883 Member of "Les Vingt," a group of Brussels artists

1884 Publication of his essay "Three Weeks at the Academy," which mocks teaching at the Academy

from 1885 Regularly participates in exhibitions of "Les Vingt"

1885 Travels to England, where the light effects in William Turner's paintings make a strong impression on him

1886 Adopts the Impressionist style of painting

1888–89 Produces his principal work *Entry of Christ into Brussels*

1896 First solo exhibition, in Brussels

1900–14 Period in which his creative output diminishes

1901 Co-founds the Belgian Free Academy

1907 Repeats earlier works in lighter colors

1929 Elevated to the peerage

1949 Dies on November 19 in Ostend

"Oh, the masks, the bestiary of the Ostend carnival: giant lama heads; naive birds with paradisiacal trails of plumage; cranes with azure beaks that scream out unintelligible lies; architects with feet of clay; dense know-it-alls with moldy skulls full of recalcitrant earth; heartless vivisectionists; strange insects; hard shells with soft mollusks inside. This testifies to Christ's entry into Brussels, where all the hard and soft folk, who were belched forth by the sea, crawl." **G**rotesque physiognomies, masks, larvae — these "folk" threateningly push themselves into a concentrated mass, wedged in between stage-like architecture, towards the viewer. Out of the center of the procession, in the middle of the picture, the central figure of the painting rises: Christ riding a mule, enveloped by a golden halo. However, Christ is depicted with the facial attributes of James Ensor, the "painter of masks." The artist portrayed himself as Christ in other works as well. Here, however, in his most important painting, the comparison assumes its greatest significance. Misjudged and surrounded by hostility, the artist sees himself as being at once self-conscious and triumphant amongst his fellow citizens. His isolation is underpinned by the composition as well as by the colors employed. The intensely colored row of musicians' hats nearly cuts off the front half of the painting from the Christ figure. Several themes are woven together in this painting: the biblical story of Christ's entry into Jerusalem and the carnival; banners and flags, reminiscent of demonstrations, refer to the political situation in contemporary Belgium, which was marked by social unrest. **E**xtreme and abrupt color contrasts determine the events. The excited and resounding atmosphere in the foreground is created by the contrasting and expressive colors. The, in part, garish and harsh colors stand diametrically opposed to one another; there is not a trace of the Impressionistic highlight painting that features in Ensor's earlier work. Just as abrupt are the figures that have been cut off at the edge of the painting, so that the format seems to be bursting at its seams. Conversely, the small size and the bleached-out quality of the scene in the background serve to enhance further the suction effect of the composition. This graphic vividness used as an artistic device is a novelty in Ensor's work. **B**ecause masks were sold in the family-owned souvenir shop during the carnival, Ensor was familiar with them from an early age. They provided him with the most diverse range of possibilities regarding human physiognomy in his paintings — they served to help him expose his fellow human beings. For many years Ensor felt neglected by his bourgeois surroundings because his work invariably received incisive criticism. The *Entry of Christ into Brussels* was publicly exhibited for the first time as late as 1929 because, when it was completed, the painting was rejected by the contemporary avant-garde. At this time, however, Ensor's artistic strength seems to have been exhausted, and much of his effort was given to copying his own works. At the same time, admiring contemporaries, such as Emil Nolde and Erich Heckel, sought out the artist. **"T**he manifoldness of his work, in regard to both form and content, substantiated the difficulty his contemporaries had in evaluating it, but also insured that it remained up-to-date. This allowed individual facets of his oeuvre to draw on a variety of styles, such as Expressionism, Tachisme, Surrealism, and Fantastic Realism."

K. W.

James Ensor: Belgien um 1900. Munich, 1989.
James Ensor: Das druckgraphische Werk. Strasbourg, 1995.

Still Life in the Studio, 1889

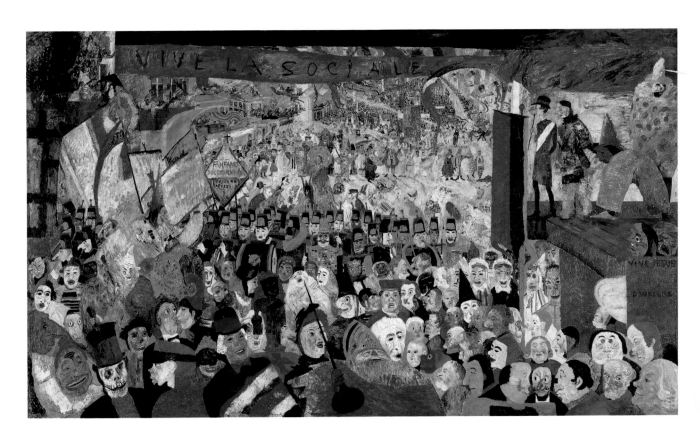

Edvard Munch

The Scream, 1893

1863 Edvard Munch is born on December 12 in Løten, Norway

1881–84 Studies in Oslo under Frits Thaulow, Christian Krøhg, and Heyerdahl

1885 Travels to Paris

1889–90 Takes a several-month-long course on nude painting with Léon Bonnat in Paris; meets Henri Toulouse-Lautrec, Paul Gauguin, and Vincent van Gogh

1891 Travels to France and Italy

1892 Exhibition in the Vereinigung Berliner Künstler (Association of Berlin Artists)

1894 *Puberty*; *The Sick Child*; first lithographs and etchings

1895 Collaborates on *Pan*

1897 Exhibits *Frieze of Life* at the Salon des Indépendants

1898–1901 Travels to Germany, France, and Italy

1902 Exhibition at the Berlin Secession

1900–07 Resides mainly in Germany; lives in Åsgårdstrand during the summer months

1906 Sketches for Max Reinhardt's production of Ibsen's *Ghosts*; partly redesigns the *Frieze of Life* for the foyer of Berlin's Kammerspiele

1909 Returns to Norway

1910–16 Mural paintings for the University of Oslo's auditorium

1912 Takes part in the Sonderbund exhibition in Cologne

1922 Mural paintings for the cafeteria of the Freia Factory in Oslo

1944 Dies on January 23 near Oslo

Few images of modern art enjoy greater recognition today than Edvard Munch's work entitled *The Scream*, which he painted in 1893 and produced as a lithograph in 1895. Other painters may be better known, but Munch's scene of Oslofjord, with a view of Oslo's skyline at sunset before which stands a humanoid figure twisting and writhing as it raises its hands to its head and shapes its mouth into a scream, has been more widely reproduced than any other artwork. It is as if, as we take leave of the 20th century, its unequaled history of horror, terror, violence, and brutality has been consolidated and crystallized into this one intense image of existential anxiety, fear, and dread. Munch's painting is rooted in a personal experience of 1890, when he was walking with two friends while the sun set over the fjord: "The sky became a bloody red. And I felt a touch of melancholy. I stood still, dead tired. Over the blue-black fjord and city hung blood and tongues of fire. My friends walked on. I stayed behind, trembling with fright. I felt the great scream in nature." He describes a synaesthetic experience in which nature's forms absorb the gesture of the figure and vibrate with the sensation of the scream, denying the figure all solidity, individuality, and identity. Munch entitled a study for the painting *Despair*, reflecting in it Søren Kierkegaard's analysis of despair as the "sickness unto death," a process of psychological self-destruction derived from the total loss of hope and faith in life. When he exhibited the painting in 1893, Munch used it as the closing statement in a series of works collectively entitled "Love." The series tracked the beginnings and development of love between woman and man, from the initial attraction to kisses and consummation as the woman, identified as the Madonna, is impregnated with new life, rejects the man and gives rise to jealousy, from which despair is then born. Later, he expanded the series with themes of illness and death, transforming it into a frieze — without beginning or end — that encircles a room and makes a multi-imaged statement on human love, the continuities of life and death, and on a non-Christian eternal life postulated on the indestructibility of matter within a monistic universe. For the remainder of his life, Munch repeatedly reproduced the compositions of the *Frieze of Life*, often inserting new images, and never permitted the series to attain true closure. Nietzsche, Schopenhauer, Kierkegaard, Ibsen, and Strindberg were the major figures that inspired Munch's metaphysics of sexual attraction and reproduction, and like them he too pushed the concepts of Romanticism and Symbolism beyond their limits. Although based, in its extreme subjectivity, on the ideals of Symbolism and, in its curving landscape, adapting the characteristic lines of Art Nouveau, *The Scream* functions as a prototype of 20th-century Expressionism with its accentuated brushstrokes and streaks of flat color, its emphatic ugliness and disharmony, and the extreme psychological state approaching madness that it depicts. Precociously, Munch spoke and painted in the vocabulary of our century. *R. H.*

Bock, H. and G. Busch. *Edvard Munch: Probleme, Forschungen, Thesen*. Munich, 1973.
Heller, R. *Edvard Munch: Leben und Werk*. Munich, 1993.
Schneede, U. M. *Edvard Munch: Die frühen Meisterwerke*. Munich, 1988.

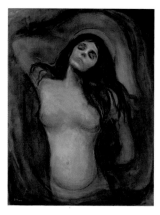

Madonna, ca. 1894

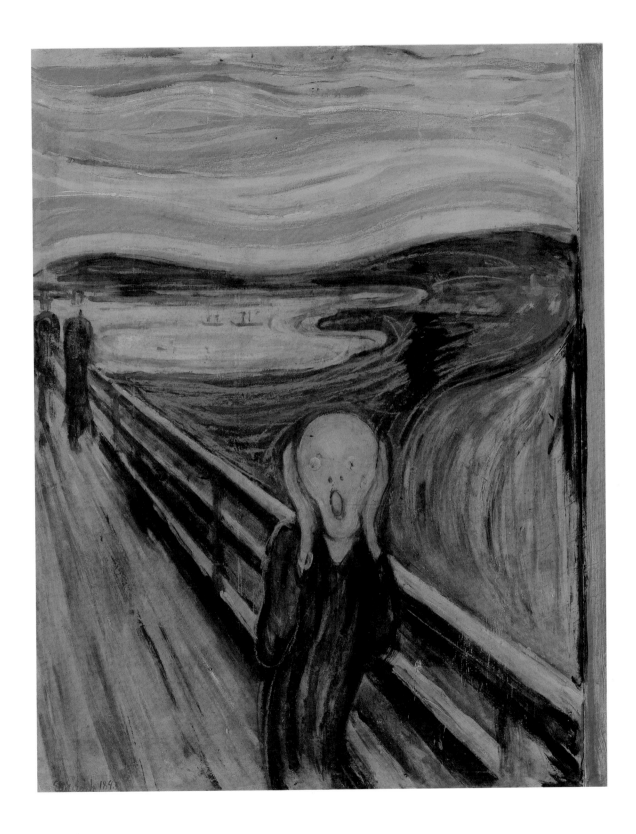

Edgar Degas

Behind the Scenes, ca. 1898

Although the new century seemed to have begun everywhere in the art world long before the calendar said it did, the ballet of the Paris Opéra still had no intention of jumping right in: no, it tiptoed by as if caught in a mesh of spiderwebs. At that time the only progressive painter of ballerinas was Edgar Degas. What did he care about glamorous displays, staid symmetry, dull classical frontality? Degas sought out diagonals in his compositions, cut brutally through tender limbs and gauze tutus with picture edges, chose eccentric, oblique perspectives from up high or down low, and brought his dancers near to the viewer in close-ups. In the artificial light of the stage, and still more in the flickering light of the ballet studio or in the deep shadows in the theater wings, the painter, obsessed with movement, studied every inch of gesture. Early ballet pictures full of snow-flake charm, late pastels giddy with color, and, in between, sparkling, extravagant, bold images in oil and crayon, a swirling series of monotypes, and the group of wax figures, which he kept secret: in about six hundred "balancing acts," Degas captured the fleeting gesture, the dashing movement in works of pulsating permanence. In the pastel *Behind the Scenes*, the permanence has become a flowing wonder of color. The almost delirious blue, laid on layer by layer and smudged capriciously, or furrowed or covered with streaks, seems gossamer-light and transparent despite the thick surface texture. A drizzle of green, orange, and violet tones veils the scenery backstage; in interplay with shadows it vibrates nervously on backs, shoulders, décolletés, faces. Concentrated color and concentrated gestures become one. In Degas' later work, the stage, ballet studio, bar, mirror — even facial features — become unimportant. Paying attention only to the upper half of the body, Degas abbreviates and monumentalizes the movements of three dancers in a close-up view; a fourth dancer bends down; maybe the ribbon of her shoe has worked itself loose. The gestures flow in a melodious rhythm — rounded for a pirouette, opposing head and body positions, snake-like arm movements. But the notorious analyst of movement is fooling us: these are not three dancers but just a single girl in three different phases of movement. The "camera" of the artist's eye really begins to operate here as Degas depicts a pirouette in slow motion through multiple views of the figure. Photo negatives from his estate have confirmed such "cinematographic" experiments, which Degas was one of the first to use for painting purposes. The great artist varied this constellation of three dancers many times, each version displaying more virtuosity in the use of pastels, more freedom in the fiery breath of its colors than the next.

L. Sch.

Adriani, G. *Edgar Degas: Pastels, Oil Sketches and Drawings*. London, 1985.

Baumann, F. and M. Karabelnik (eds.). *Degas: Die Portraits*. Exh. cat. Kunsthaus Zürich. London, 1995.

Kendall, R. *Degas beyond Impressionism*. London, 1993.

Schacherl, L. *Edgar Degas: Dancers and Nudes*. Munich, 1996.

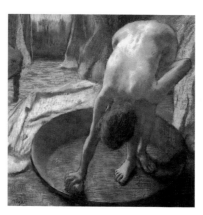

Woman Bathing in a Shallow Tub, 1885–86

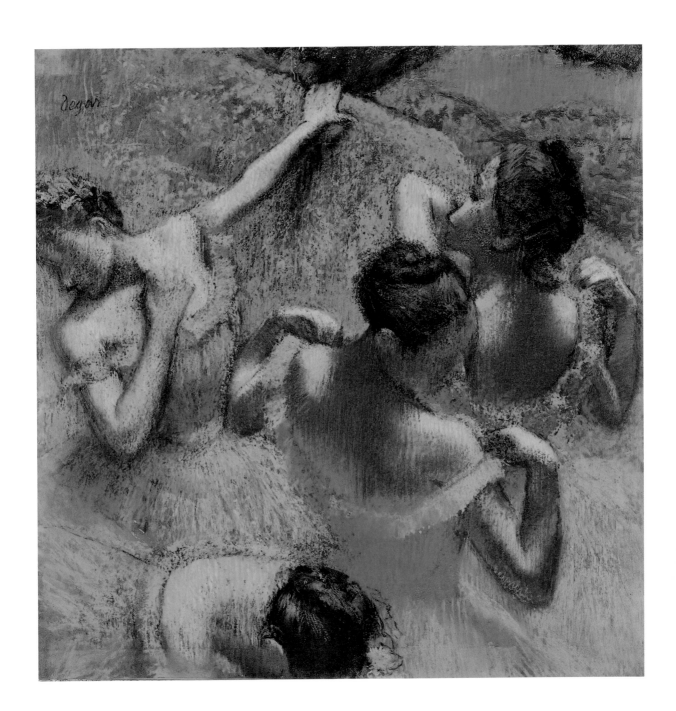

Käthe Kollwitz

Weavers' Uprising, 1893–97

1867 Käthe Kollwitz is born Käthe Schmidt on July 8 in Königsberg, Germany

from 1881 Takes drawing lessons in Königsberg

1885–86 Studies at the Berlin School for Female Artists

1888–89 Studies in Munich and Königsberg

1890–91 Deeply involved with Max Klinger's essay "Painting and Drawing"

1891 Moves to Berlin; marries the medic Karl Kollwitz

1893 The jury of the Great Berlin Art Exhibition rejects her work

1898, 1903 Studies at the Berlin School for Female Artists

1899 Enters the Berlin Secession

1903–08 *Peasants' War* cycle

1904 Stays in Paris, studying for a short time at the Académie Julian; becomes acquainted with Auguste Rodin

1907–09 Illustrations for the *Simplicissimus*

1907 Villa Romana Prize; study trip to Paris

1910 First of her sculptural works

1914 Her son dies in Flanders

1919 Appointed to the Prussian Art Academy

1921 Woodcut *Memorial to Karl Liebknecht*

1924–25 Participates in the first exhibition of German art to take place in the Soviet Union

1928 Heads a master studio in graphic art at the Berlin Art Academy

1929 Awarded the order of merit

1933 Leaves the Prussian Art Academy

1934–35 Lithograph cycle *Death*

1936 Forbidden to exhibit

1942 Lithograph *The Seeds of Fruit Should Not be Ground*

1943 Evacuated to Nordhausen

1944 Moves to Moritzburg near Dresden

1945 Dies on April 22 in Moritzburg

Begun in 1893 and completed in 1897, the sequence of pictures that comprise the *Weavers' Uprising* was first shown at the Great Berlin Art Exhibition in 1898, where it was highly praised by Adolf Menzel and established Käthe Kollwitz's reputation as an artist. Her cycle was produced in reaction to Gerhard Hauptmann's drama *The Weavers*, the premiere of which Kollwitz attended on February 26, 1893, at the Freie Bühne in Berlin. In its epic content and perceptive depth, however, *Weavers' Uprising* goes far beyond its literary model. The three lithographs and three engravings of this series are not just illustrations of the events that take place on the stage: dramatic fate assumes form in them. **T**he first two lithographs, *Hardship* and *Death*, express a deep sense of depression, from which the third, *Counsel*, desperately seeks a way out. The events are steeped in darkness, and a spiritual state of gloomy dejection is articulated in a concentrated graphic *chiaroscuro* language. The influence of Max Klinger is evident here. The dramatic group dynamics of the following two engravings, *Procession of Weavers* and *Storm*, are achieved through the bold rhythm of these expressive, realistic scenes. The cycle concludes with the engraving *End* — death and mourning, an oppressive life, devoid of hope, from which there is no escape: hard reality in an impressive stillness. **A**lthough she had still not reached the full height of her technical powers, Kollwitz achieved an emotional intensity in this series of works that is unequaled in the graphic art of her time. This is communicated by the exciting harmony that exists between realism and symbolism. It was to become a trademark of her art and was to reach its peak in the seven engravings of the *Peasants' War* series created between 1903 and 1908. In these works, the narrative aspect is restrained in favor of a compact unity of composition and an alienating monumentality of the body language. As a result, the statement these works make seems divorced from time and place and acquires a universal social validity. **T**he progressive minds of that time were fascinated by "social literature," although the movement known as Junge Kunst (Young Art) was more concerned with "overcoming naturalism," as Hermann Bahr described it. The humanity and social commitment implicit in the *Weavers' Uprising* cycle proved pathbreaking in terms of the graphic dialectic with social reality.

L. L.

Fecht, T. (ed.). *Käthe Kollwitz — Das farbige Werk*. Berlin, 1987.
Hinz, R. (ed.). *Käthe Kollwitz 1867–1945: Druckgraphik, Plakate, Zeichnungen*. Berlin, 1980.
Kollwitz, H. (ed.). *Käthe Kollwitz — Das plastische Werk*. Hamburg, 1967.
Schneede, U. M. *Käthe Kollwitz — Das zeichnerische Werk*. Munich, 1981.

Pietà, 1903

Gustav Klimt

The Kiss, 1907–08

Gustav Klimt is probably the best-known representative of the Viennese Art Nouveau movement. He first gained a reputation as a decorator of the interiors of houses on Vienna's Ringstrasse, together with his brother Ernst and Franz Matsch. They were also responsible for embellishing the staircase in the Museum of Art History in the style of Hans Makart. But in the 1890s he gave up this promising career and, within ten years, had become one of the leading exponents of Viennese "Jugendstil." His so-called "Golden Period" started in 1902 with the *Beethoven Frieze* and culminated in works such as the *Stoclet Frieze* of 1905–11 and the painting entitled *The Kiss*, which is probably his most famous piece. Klimt painted this work on a 72 by 72 inch canvas in 1907–08. Against a golden background, which has been darkened by doubling the canvas, it portrays a flowery meadow at the edge of which a pair of lovers is kneeling. Both are encased in golden robes and are depicted against a golden halo, so that they form a single unit. The only clear delineations are found in the ornamentation of the robes and the halo. The man's clothes are covered in geometrical patterns, such as were familiar from the work of the Viennese workshops with which Klimt was closely associated. The woman's dress, on the other hand, echoes the flowers of the meadow with its colorful circular forms. She is kneeling directly at the edge of the meadow, her bare feet supporting her and preventing her from sliding into the abyss. Her face is turned to the side, eyes closed, and her head is leaning on her shoulder, enclosed by the hands of the man, who is bending over her and kissing her. All you see of him is the nape of his neck, the back of his head decorated with leaves, and the profile of his facial features. With *The Kiss*, Klimt was returning to a motif that he had already portrayed in 1895 in his painting *Love* and subsequently, in a larger context, in his *Beethoven Frieze*. The latter was created on the occasion of the unveiling of a statue of Beethoven by Max Klinger in Vienna. The Viennese Secession movement, begun in 1897, exhibited the statue together with works specially created for the occasion by its members. The high point of the exhibition — and an object of violent criticism — was the *Beethoven Frieze*, which covered three walls of the first room and translated into pictorial form the composer's ninth symphony as interpreted by Richard Wagner. The salvation of humanity by art reaches its climax in the final depiction, in which a naked couple embraces against the background of a golden paradise. Here, the man's body almost completely blocks out that of the woman, and their faces are covered. In the *Stoclet Frieze*, the sketches for which Klimt completed in 1910, the couple is dressed in a similar way to the couple in *The Kiss*, and the woman's eyes are also closed. She is not being "kissed awake" but rather remains in her allotted role as a passive object. Thus, *The Kiss* should not be read as portraying the sexual union of man and woman, but rather as a symbol of a paradisiacal love in which ornamentation assumes the role of eroticism. *S. P.*

Frodl, G. *Klimt*. Cologne, 1992.
Partsch, S. *Gustav Klimt: Painter of Women*. Munich, 1994.
Ströbl, A. *Gustav Klimt: Die Zeichnungen*. 3 vols. Salzburg, 1980/82/84.

Emilie Flöge aged 17, 1891

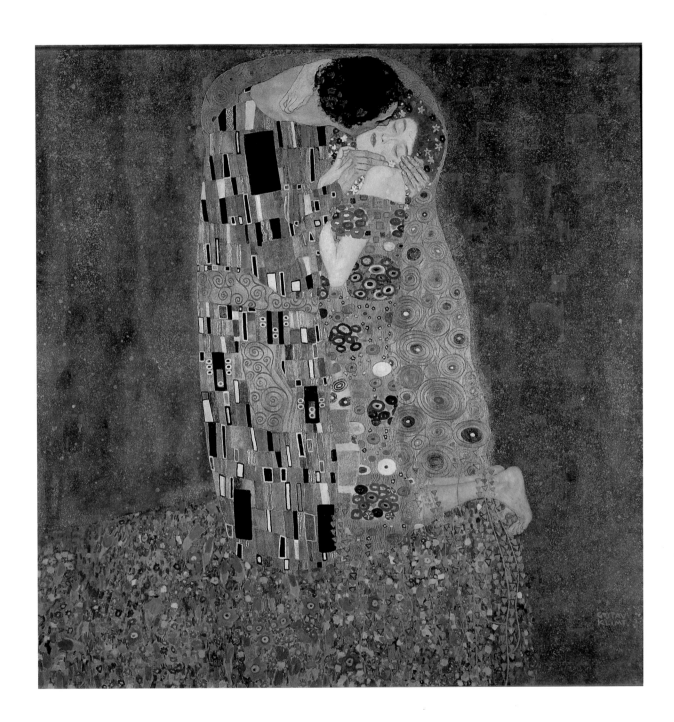

Paul Cézanne

Mont Sainte-Victoire, ca. 1901

Mont Sainte-Victoire, the mountain that rises to the east of Cézanne's home town of Aix-en-Provence, is one of the painter's most famous motifs. Around 1885, Cézanne started to withdraw increasingly from Parisian artistic circles and had only occasional contact with fellow Impressionists Camille Pissarro, Auguste Renoir, and Claude Monet. At the same time, he began to set up his easel in the hills near Aix in order to paint the distinctive conical shape of Mont Sainte-Victoire from the west. In more than thirty-five different oil paintings and countless watercolors he made the hill into a symbol of his love of the natural surroundings of his birthplace and of his determination to free himself from the Impressionists' improvisatory approach and insistence on recording fleeting impressions. He used the solid permanence of the hill to record his perceptions and feelings in a concentrated and deliberate process based on careful reflection on the conditions under which he was seeing and painting. **W**ith its bright colors, transparent application of paint, and its delicate, dark-blue outlines linking the bare branches in the foreground to the lines structuring the landscape on the surface of the picture, the painting in the National Gallery of Scotland is reminiscent of the watercolors Cézanne produced during the same period. It forms a link between the compact depictions of the 1880s and 1890s, which stress the dignity and solidity of the hill, and the later pictures, whose dark slabs of color bear witness to the profundity of the painter's emotions when faced with the beauty and dramatic qualities of his subject. **P**aul Cézanne was determined to continue painting in direct contact with nature. He deliberately did not continue along the path towards abstract art on which, like some of his contemporaries, he had embarked. But his concentrated, simplified forms, his subtle use of color and line, and above all his definition of the picture as an autonomous world of color and shapes — or, as he put it himself, "harmony *parallel* to nature" — made him one of the most important models for several generations of 20th-century artists. Henri Matisse praised him as "a kind of god of painting," while Pablo Picasso put it rather more prosaically: "Cézanne is the father of us all."

F. K.

Adriani, G. *Cézanne Watercolors*. New York, 1983.

Cézanne. Exh. cat. Philadelphia Museum of Art. New York, 1996.

Rewald, J. *Paul Cézanne: The Watercolors, A Catalogue Raisonné*. Boston and London, 1983.

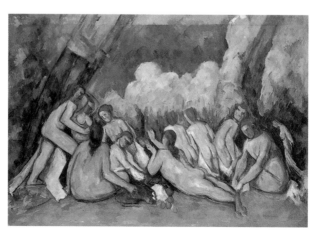

The Large Bathers, 1895–1904

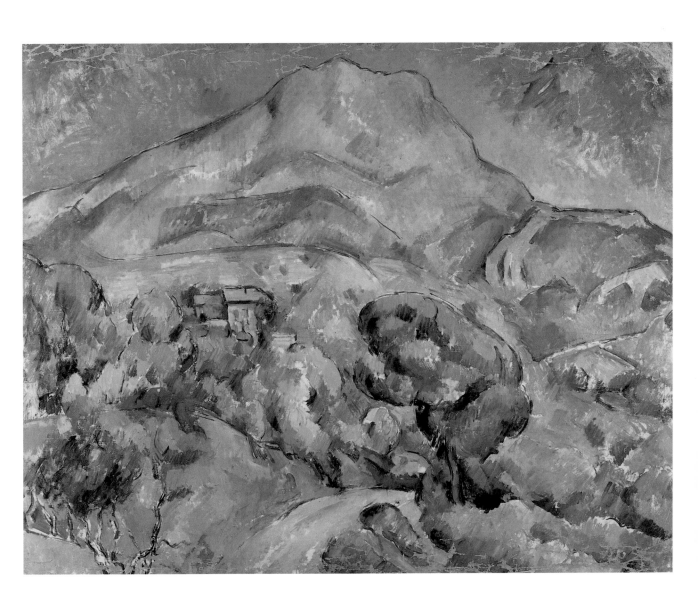

Claude Monet

Waterlilies, 1916–20

The many different landscapes entitled *Waterlilies* that Claude Monet painted were created in Giverny between the 1890s and the artist's death in 1926. Over the years, the paintings in this series — with their constantly varying formats — gradually lost their plastic, spatial qualities, and it became increasingly difficult to distinguish the "original" from its mirrored image in the artist's landscapes. Monet was attempting to create the illusion of an endless expanse of water in which spatial orientation is no longer possible, and in so doing he was breaking with the traditional approach to painting represented by the Barbizon School. The simultaneity of the original and its reflection create an expanded spatial environment in which the shapes of the waterlilies seem to hover over an undefined space. Monet worked for years on this series of paintings and was constantly postponing the exhibition that was supposed to be devoted to it, because he was dissatisfied with the results. It was not until 1909 that the paintings were presented to the public in the Galerie Durand-Ruel in Paris under the title of *Waterlilies, A Series of Waterscapes* (*Les Nymphéas, Paysage d'Eau*). In 1910, a severe flood wreaked so much damage on Monet's garden that the artist was unable to paint there for many years, and it was not until 1914 that he returned to this subject matter after having a studio specially built to accommodate his large-format paintings. This late phase in his artistic development increasingly reveals his affinity with the symbolist approach, whereby art is no longer thought to be a reflection of reality but rather must free itself of predetermined knowledge and concrete expression. For the Symbolists, the basis of expression was provided by feelings, and in this respect they were strongly influenced by the contemporary writings of Stéphane Mallarmé and Marcel Proust. These late waterlily paintings, taken as a whole, bear witness to the juxtaposition of various levels of internal and external reality in which painting becomes a projection of subjective emotions. In his waterlily landscapes, Monet finally broke with traditional ideas on painting. Their overt and deliberate ambiguity, created by an abstract and expressive manner of painting, exerted a strong influence on modern art in the 20th century.

S. K.

Koja, S. *Monet*. Munich, 1996.

Sagner-Düchting, K. *Monet in Giverny*. Munich, 1994.

Tucker, P. H. *Monet in the 90s: Series Paintings*. Boston, 1989.

Wildenstein, D. *Biographie et catalogue raisonné*. Lausanne, 1974.

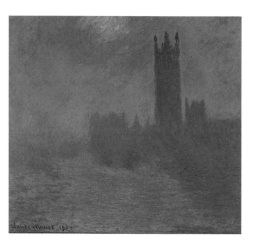

The Houses of Parliament, London, Sun through Fog, 1904

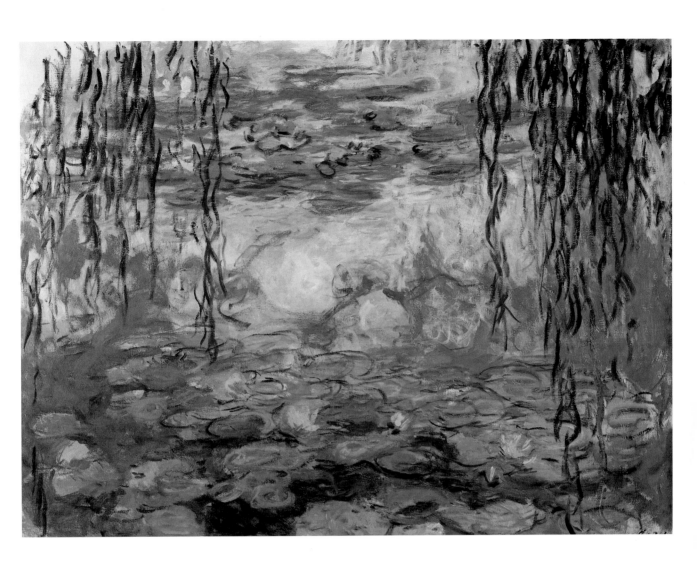

Pablo Picasso

Les Demoiselles d'Avignon, 1907

Even if to us today this picture seems *the* key picture in the art of the 20th century, its suspiciously hesitant effect shows that it remained a closed door to many for a long time. **L**es Demoiselles d'Avignon only went on public view for a brief period in 1916. We do not know why Pablo Picasso wanted to emphasize its aggressive initial shock at that particular time, just as he was turning away from Cubism and seeking a model in Ingres and his classicism. The painting then returned to the studio, entering the collection of the fashion designer Jacques Doucet in 1924. From this collection the picture, which its owner would have liked to see in the Louvre, went to the Museum of Modern Art in New York in 1939. It was the museum's pride in owning it and the enthusiastic statements made by the director, Alfred Barr, which led to the painting being accorded that status within the history of art that it possesses today. Nothing can get past this painting — it is a barricade that Picasso laid down for the future. For some, this was an outrageous, constricting farce, with which Picasso rejected decisively all that had earlier gone to make up his fame. The art dealer and writer Daniel-Henri Kahnweiler, who was one of the few to study the painting early on, was also shocked, but he recognized the action of somebody who wished, with his work, to rebel against his environment. **I**n *Les Demoiselles d'Avignon*, Picasso frees himself from literary content and thereby paves the way for his experimentation with form that would generally characterize Cubism. It is worth looking at the original. Overall, this is a densely painted work: there are no empty zones. Almost all sections of *Les Demoiselles d'Avignon* have been overpainted, even on the left and in the center. In color consistency and materiality the draped fabric on the left side is equal, in every respect, to that on the right. The graphically hectic color application that covers the right-hand figures also crops up in other places: sufficient testimony that Picasso balanced out the picture as regards its color and graphic elements during a final reworking. The pink tone of the bodies holds the painting together. **T**his work amounts to a rejection of the type of painting that was based on classical norms and believed in the cumulative effect of beautiful things, in the improvement of the beautiful. In his definitive version Picasso depicts five women. Why such a tautological figural image at a time when his concern was to introduce maximum provocation into a picture — provocation aimed at all normative art, but also at the art of his most progressive contemporaries? None of the five *demoiselles* whom Picasso portrayed in 1907 at the beginning of this new, non-representational type of painting could stand alone as testimony to this reversal of normative beauty into dissonance. In the picture Picasso adopts the depiction of modalities — the already-mentioned repetition that leads, of necessity, to change. The visit to a brothel, to which the painting's title refers, is reinterpreted to become a reflection on the frailness or coincidental nature of representational conventions. A new ethic of seeing emerges from the moral theme.

W. S.

Daix, P. *Picasso*. Cologne, 1991.

Rubin, W. (ed.). *Pablo Picasso: Retrospektive*. Exh. cat. The Museum of Modern Art, New York. Munich, 1980.

Rubin, W. *Picasso und Braque*. Munich, 1990.

Spies, W. *Pablo Picasso: Das plastische Werk*. Stuttgart, 1971.

Warncke, C.-P. *Pablo Picasso*. Cologne, 1993.

Weiss, E. (ed.). *Picasso: The Ludwig Collection*. Munich, 1992.

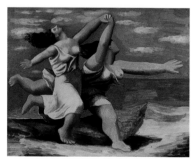

Women Running on the Beach (The Race), 1922

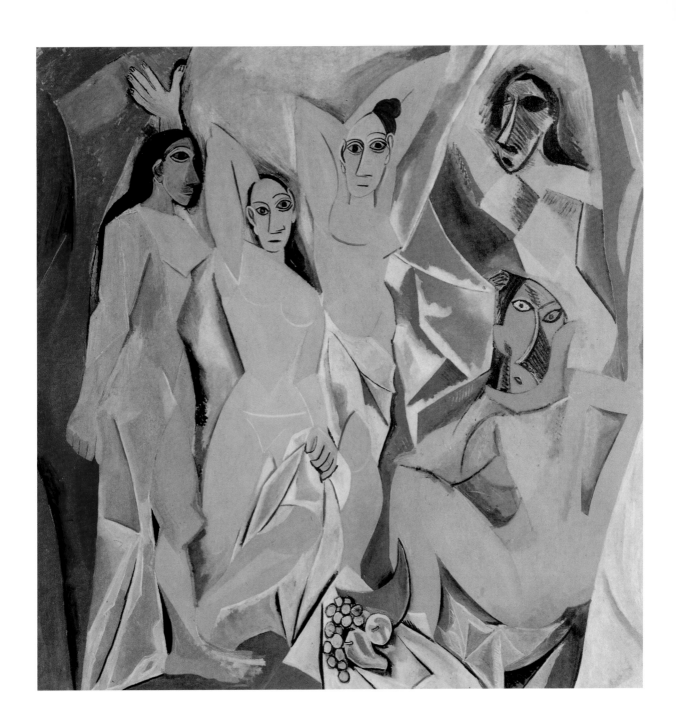

Georges Braque

Man with a Guitar, 1914

Georges Braque's *Man with a Guitar*, painted shortly before he was called up for military service in 1914, stands at the end of one of the most momentous artistic collaborations in modern art, that of the kindred spirits Braque and Picasso, with their development of Cubism. Inspired by Cézanne's pictures, the two painters had subjected the objects they depicted to formal analysis in order to integrate them into aperspective geometric spaces as graphic facets of form. Finally, in 1912, the two artists reversed the process, composing their pictures synthetically, according to the principles of collage, from forms and symbols that had now become discrete entities. The things themselves become freely exploitable visual material. The forms, now independent of the objects, become materials one has not seen before in pictures; even letters of the alphabet enter the field of painting. Braque composed his guitar player — or rather, he created a collage — from various rectangular areas that are interwoven with the figurative images of a guitar, a man wearing a bow tie, and a wineglass. In well-tried illusionistic manner, the various areas of the painting seem to overlap with the use of shading; they imitate the grain of wood; and the tight pictorial structure is relaxed at other points by means of pointillist decoration. In two clearly recognizable areas, however, Braque does not imitate the texture of wood; he inserts a concrete substance, namely sawdust, into his painting. In this way, reality re-enters the picture in the form of a banal material that was formerly regarded as alien to art. *Trompe l'œil* and *trompe l'esprit*: Braque's rhythmic visual puzzle, which plays with flat planes and three-dimensional space, with illusion and reality, excites the eye and the mind of the observer. The explicitness of the subject seems to have fallen victim to the fascinatingly clear pictorial order of verticals and planar diagonals. As a result, the picture itself has become the subject of painting; and the guitar player is a mere pretext, of secondary importance. Protracted debates have been held to determine whether it was Picasso or Braque who took the decisive step that led to the discovery of collage. As William Rubin has proved in his meticulous reconstruction of the events preceding the appearance of collage, the decisive impulse would seem to have come from Braque, while his fellow artist and genius, Picasso, immediately varied this innovation with his accustomed virtuosity. The Cubist fragmentation of objects and the "discovery" of collage mark the beginning of one of the most significant chapters in modern art. A few years later, the Italian Futurists, the Dadaists and the Parisian Surrealists were to adopt this revolutionary extension of the concept of art, which provided a firm foundation for their own ideas and goals. *W. Spr.*

Georges Braque: Ausstellung zum 100. Geburtstag. Zeichnungen, Collagen, Druckgraphik, illustrierte Bücher aus der Staatsgalerie Stuttgart und Sammlungen in Baden und Württemberg. Exh. cat. Stuttgart, 1981.
Hofmann, W. *Georges Braque. Das graphische Werk.* Stuttgart, 1961.
Raphael. M. *Raumgestaltungen.* Frankfurt am Main/New York, 1986.
Rubin, W. *Picasso and Braque: Pioneering Cubism.* Exh. cat. The Museum of Modern Art. New York, 1989.

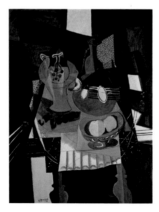

Still Life with Fruit Dish, Bottle and Mandolin, 1930

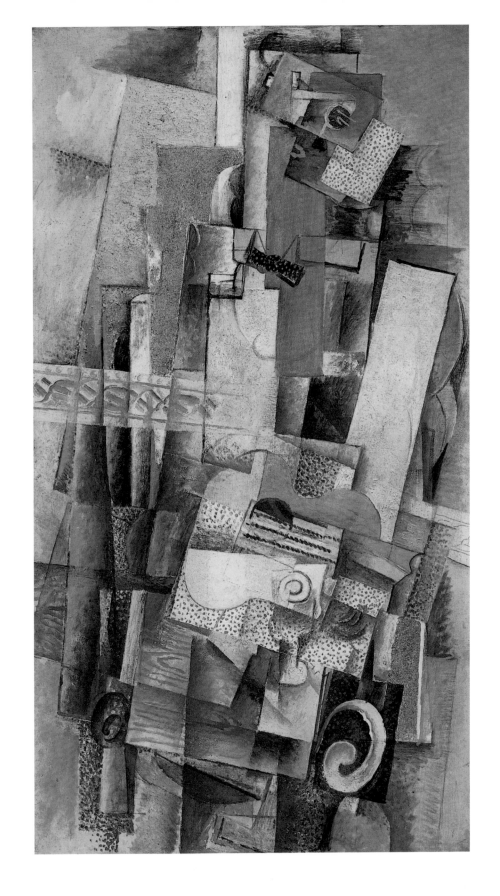

Robert Delaunay

The Red Eiffel Tower, 1911

1885 Robert Delaunay is born on April 12 in Paris

1902–04 Apprentice in the workshop for stage set design at Ronsin in Belleville

1904 Travels to Brittany; contacts the School of Pont-Aven; first exhibition of his Impressionist paintings in the Salon des Indépendants

1907 Involvement with Cubism; *Portrait of Wilhelm Uhde*

1909 His so-called Destructive Period; his work takes the direction of Analytic Cubism as the precursor to Orphism; paints the *Saint-Séverin* and *Eiffel Tower* series

1910 Marries Sonia Terk

1911 Accepts an invitation from Vassily Kandinsky to participate in the first exhibition of the *Blaue Reiter* in Munich

from 1912 His so-called Constructive Period; *Windows, Circles, Circular Forms*

1913 Essay "On Light"

1914 Moves to Madrid

1915–17 Resides in Portugal

1921 Returns to Paris

1922 Paints portraits

1923 First advertising posters

1924–26 Continues the *Eiffel Tower* series

1925 Together with Fernand Léger, produces murals in the Palais de l'Ambassade de France for the Decorative Arts Exhibition

1930–35 Mainly concerned with plaster reliefs and the *Rhythms* series

1935 Produces neon advertising

1937 Produces murals for the Paris Exposition Universelle

1939 Co-founds the first Salon des Réalistes Nouvelles

1940 Retreats to Auvergne, later to Mougins near Cannes

1941 Dies on October 25 in Montpellier

The "Eiffel Tower" pictures are among Robert Delaunay's best-known works. Unlike the Cubists, also working in Paris at that time and creating still lifes and portraits, Delaunay was interested in large objects seen from a distance: airplanes, Zeppelins, the huge Ferris wheel that stood on the Champ de Mars, and, time and again, the true symbol of Paris, the Eiffel Tower. For Delaunay, the Eiffel Tower was not merely a formal motif. It was a symbol of the modern age, a technical wonder which, like a concave mirror, concentrated the contemporary visions of technology and progress at one focal point. Delaunay saw in it a symbol of communication with the entire world, a metaphor for the new language of simultaneity. The artist forces the gigantic subject, which is never quite depicted in its entirety, into the picture space by tightly juxtaposing varying perspectives. The proud red tower seems to be compressed as if by a giant's fist, shot through with white lightning bolts that give the picture a feeling of doom. These pictures were in fact interpreted as metaphors for a shake-up of the old world view by, above all, the German Expressionist avant-garde. For Delaunay, the pictures mainly represented an exploration of Cubism and the demise of old-fashioned, descriptive painting. The end of an epoch coincided with the end of the traditional concept of art, as Delaunay wrote: "The art of catastrophes … a prophetic vision, also with a social echo: the war, the foundations are shaken…. These are cosmic tremors, but also the wish for purification, the wish to bury the old, the past…. But in the midst of the storm vision, something new is born…." What had already been announced in *The Red Eiffel Tower* — the dominance of pure color and the autonomous picture structure — would be developed further by Delaunay with great consistency in a subsequent series, the "Window" pictures. *H. D.*

Düchting, H. (ed.). *Zur Malerei der reinen Farbe: Schriften von 1912–1940.* Munich, 1983.
Robert et Sonia Delaunay. Exh. cat. Musée d'Art moderne de la Ville de Paris. Paris, 1985.
Schuster, P.-K. *Delaunay und Deutschland.* Cologne, 1985.

Saint-Séverin, No. 3, 1909

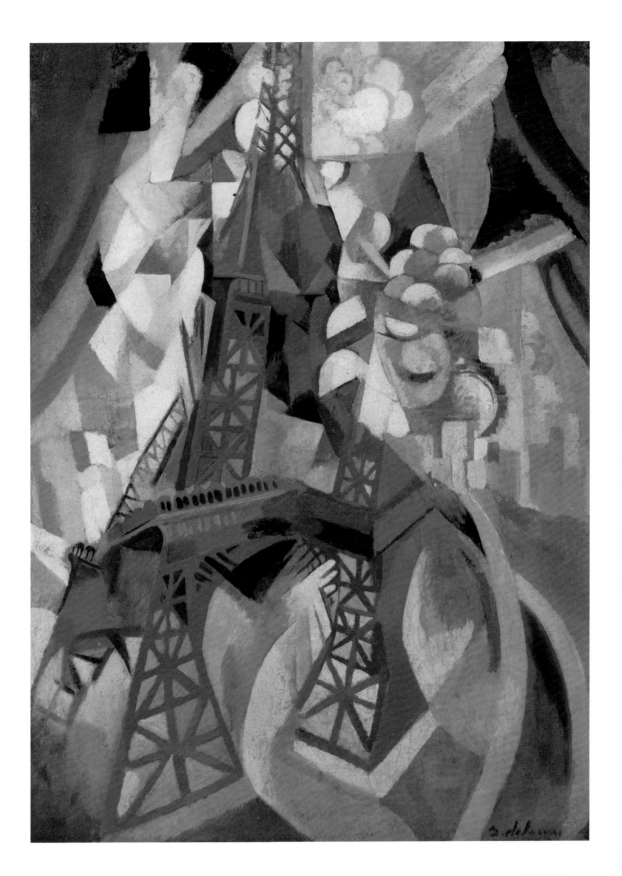

Henri Matisse

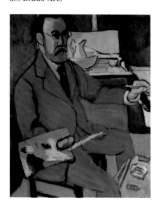

The Dance, 1910

Henri Matisse abandoned Fauvism around 1907, having previously been its undisputed leading exponent. The years between 1908 and 1913 were marked instead by simple, monumental figures in riotous colors: color was now the primary substance of Matisse's paintings to the extent that it even dictated form. In March 1909 Matisse painted the first version of *The Dance*, today in the Museum of Modern Art in New York, and in 1910, a second version (shown here) now in the Hermitage in St. Petersburg. He showed this painting to the collector Sergei Shchukin during his visit in Paris. At the end of the month, Shchukin commissioned three paintings depicting a dance, music, and a state of rest for the stairwell of his Moscow residence. *The Dance* and *Music* were to become key works from this period. *The Dance* shows five dancers forming a circle on a hill. The color red dominates and the dancers are only fleetingly sketched in and utterly non-three-dimensional. It is as though the dancers were caught up in their own movements, unaware that they are being observed. When Matisse exhibited *The Dance* and *Music* in the Salon d'Automne the critics were scathing. The autonomous, non-representational use of green, blue, and red paint was new and unfamiliar to the general public. Even Shchukin was initially so disconcerted by the critics' unfavorable reaction that he wanted to have nothing to do with the paintings, but soon he recognized the innovative power and dynamics of Matisse's simplified colors and forms. Matisse returned to *The Dance* in 1932–33 as the basis for the structure and contents of a mural for the main hall of the Barnes Foundation, where, for the first time since 1910, he once again portrayed figures in motion. Now Matisse began to cut figures out of pre-painted paper using them to arrange new compositions on the wall. This technique forced him to reduce his range of colors yet further and to abandon pictorial depth. Matisse's entire oeuvre is characterized by powerful simplicity, richness and clarity, with portraits, the female nude, and still lifes as his preferred genres.

S. P.

Barr, A. H. *Matisse: His Art and His Public*. New York, 1951.
Cowart, J. *Matisse in Morocco: The Paintings and Drawings, 1912–13*. London, 1990.
Elderfield, J. *Henri Matisse: A Retrospective*. The Museum of Modern Art. New York, 1992.
Güse, E. G. (ed.). *Matisse: Drawings and Sculpture*. Munich, 1991.
Schneider, P. *Matisse*. Munich, 1984.

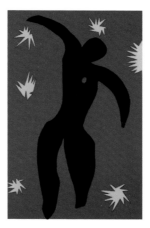

Icarus, 1947

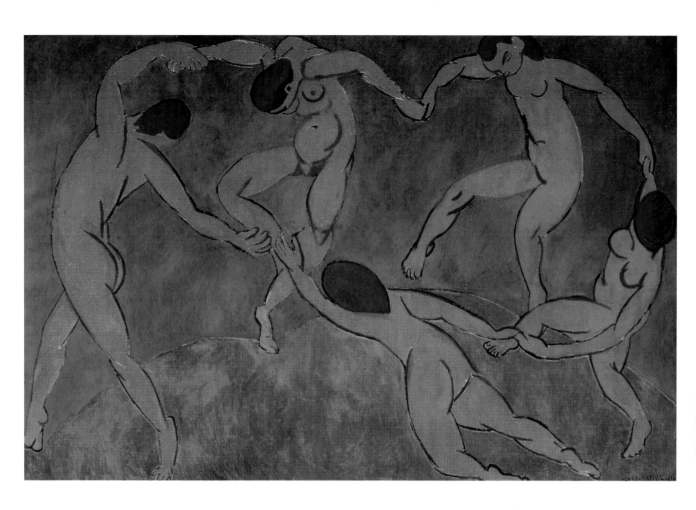

Pierre Bonnard

Nude against the Light, 1908

In the 1890s, Pierre Bonnard was a member of the Parisian group of artists called "Les Nabis," who regarded themselves as "prophets" of a new approach to painting. Reacting against wearisome academic traditions and the imitation of nature by means of illusionist-naturalistic methods taught at the art academies, Bonnard created a new method of depiction based on the two-dimensional qualities of the picture, which aimed to replace the illusionist approach to bodily forms, the traditional view of perspective, and the laws of proportion and movement which had been handed down since the times of the Renaissance. **T**he approach to space found in all his works was particularly revolutionary and — building on the work of artists such as Cézanne, Degas, Gauguin, and Van Gogh — he paved the way for 20th-century ideas, which were then further developed by Surrealism, Tachisme, Art Informel, and Abstract Expressionism. Bonnard developed a spatial environment with a "moveable perspective" in which — in contrast to the fixed, "one-eyed" viewing position imposed by a central perspective — several angles of vision can be combined, so that the eye moves from one object to the next. This can clearly be seen in *Nude against the Light*, a work dating from the period following 1900, when Bonnard underwent an important change of style, moving from the flat compositional approach of the Nabis to a new focus on the representation of space. His colors have become brighter and more luminous, and the light flooding through the window accentuates the spatial environment, pointing up shapes and objects. Bonnard brings out the eroticism of the nude figure by exaggerating the curve of the hips and by selecting a viewpoint that looks up at the woman's body, which stands out against the light. **A**fter the turn of the century, Bonnard increasingly returned to classical traditions and mythological motifs, which is reflected in his use of the *contrapposto* in this picture. In the mirror above the dressing table he even quotes the classical statue of the *Medici Venus* — as Sasha Newman discovered. The figure of Marthe, the model whom the painter courted for so many years, is suffused with light as she applies perfume to her body, and this is echoed by the gray, timeless image in the mirror. The female body is thus transfigured, and the simple bathroom with its shimmering light takes on an existence somehow removed from everyday life. **I**n his later works, Bonnard incorporated classical references into his works to create highly complex pictures, in which subjective motifs assume a more general validity and contemporary subjects take on a timelessness within a modern view of reality which has been liberated from aesthetic convention. *U. P.-P.*

Bonnard. Exh. cat. Kunsthalle der Hypo-Kulturstiftung München. Munich, 1994.
Clair, J. *Bonnard*. Paris, 1975.
Terrasse, A. *Pierre Bonnard, Illustrator: A Catalogue Raisonné*. New York, 1989.

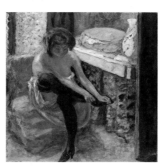

Woman with Black Stockings or The Shoe, ca. 1900

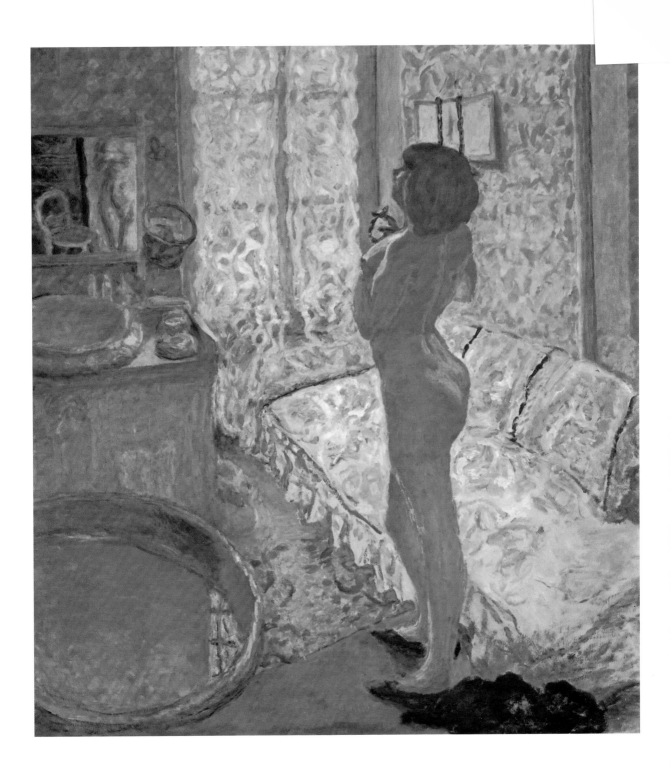

Marc Chagall The Fiddler, 1911

In August 1910, as Marc Chagall got off the train at the Gare du Nord in Paris after a three-day journey from St. Petersburg, the revolution in modern art had just reached a climax: with the invention of Cubism, Picasso and Braque had shattered the traditionally illusionistic picture space; the Fauves around Henri Matisse had freed color from any obligation to naturalistic representation; and Robert Delaunay had developed a musical style of painting, "Orphism." All of this must have been a revelation for the twenty-three-year-old Chagall. This newly won freedom of pictorial methods presented him with an ideal medium into which to translate his ebullient feelings and fantasy world, his poetic sensuality, his melancholy memories. Like the memory of the fiddler in the small town of Vitebsk who inspired in Chagall, the slightly-built son of a bitterly poor fishmonger's assistant, the wish to be an artist: "In our yard there also lived a fiddler. Nobody knew where he came from. During the day he worked for an ironmonger, in the evening he gave violin lessons. I managed to screech out a tune. It was all the same whatever or however I played, he tapped out the rhythm with his boot and cried, "Wonderful, wonderful!" And I was convinced: I'm going to be a violinist. I'll go to the conservatory." It was a decisive experience, since the fiddler and the child are ever-present in Chagall's iconography, which is fed by Talmudic scholarship, Hasidic mysticism, and the folkloric color of the small town. The fiddler and the child meant for him what his fellow artists in Paris saw personified in Pierrots and Harlequins from Watteau to Picasso: the artist who lives from the alms and applause of a society which, nevertheless, treats him as an outsider. The themes of Chagall's pictures are inseparable from his own experiences and sensations. From his canvases emerge — like the facets of color and form in a kaleidoscope — memories, longings, and images from dreams, only to merge again gently into the background of the picture: a fiddler dressed in red and with eyes strangely skewed; a beggar boy who presents the scene to the observer; a village lane, winding boldly around a crooked wooden house, along which a pair of women — one with bared breasts — follow the musicians. Darkest shadow areas alternate with blinding sunlight or moonlight, the color leads a cheerful life of its own, and forms defy normal expectations: the roof of the house lifts off, the figures' fingers and feet are free of any necessity for strict anatomical accuracy. Chagall painted *The Fiddler* less as an intellectual, avant-garde experiment, rather more as a poetical proclamation of his homesickness for Vitebsk and for his bride Bella, who was waiting for him there. Until his return to Russia in 1914 Chagall varied this theme in ever bolder forms and colors. *W. Spr.*

Marc Chagall: Himmel und Erde, Druckgraphik und andere Werke. Exh. cat. Sprengel Museum Hannover. Hanover, 1996.
Marc Chagall. Daphnis and Chloë. Munich, 1994.
Compton, S. *Marc Chagall: My Life — My Dream.* Munich, 1990.
Schmalenbach, W. and C. Sorlier. *Marc Chagall.* Frankfurt am Main, 1979.

Time has No Shore, 1930–39

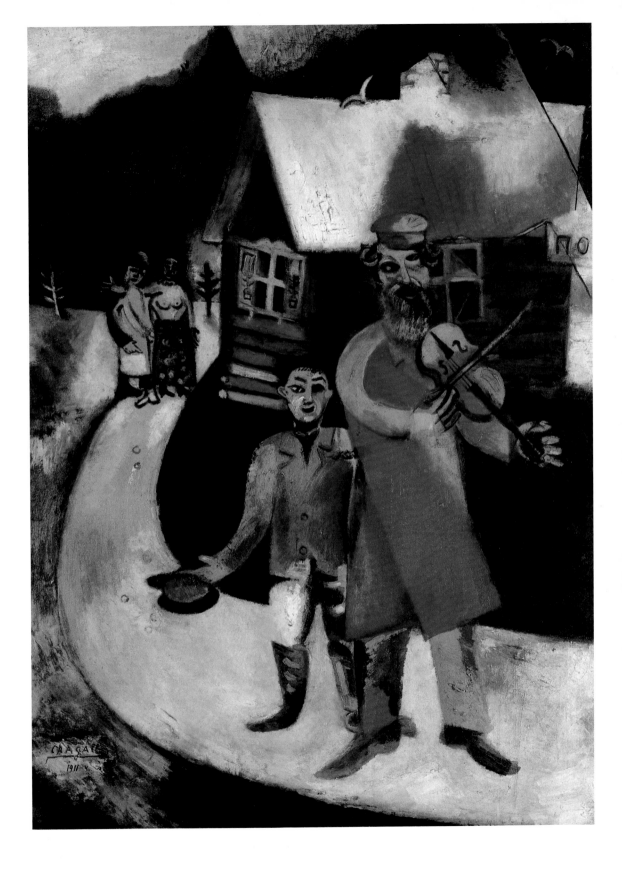

Ernst Ludwig Kirchner

Street Scene in Berlin, 1913

Ernst Ludwig Kirchner — whose street scenes had a considerable influence on the development of German Expressionism — was the leading figure of the association of artists known as "Die Brücke," which, between 1905 and 1913 — initially in Dresden, then from 1911 in Berlin — contributed significantly to 20th-century German art. Erich Heckel described him with the words: "Without exaggeration, one can say that Kirchner was a genius at everything he did." The group consisted of Kirchner, Heckel, Karl Schmidt-Rottluff and Fritz Bleyl, although Bleyl soon resigned. Max Pechstein was an active member from 1906 to 1912; Otto Mueller joined the group in 1910; and Emil Nolde was a member for a brief period in 1906. In 1906, Kirchner made a woodcut for the "Programm der Brücke," a striking foundation charter that contained the words: "With a belief in development, in a new generation of creative minds and connoisseurs of art, we summon the whole of youth…. Everyone who gives direct and unadulterated expression to the things that compel him to creative activity is one of us." Between 1906 and 1912, the active members of the group issued seven annual portfolios of printed graphic works to a growing number of passive members. In 1913, it was decided to intensify the relationship between artists and subscribers with a special document, the *Chronicle of the Artistic Association Die Brücke*. Kirchner wrote the text and compiled the material. When everything was ready, a disagreement broke out that culminated in the accusation: "Kirchner gives himself too much credit." In May 1913, the group wrote to its members, who by that time numbered seventy-six: "The undersigned have determined to dissolve Die Brücke as an organization of artists." Kirchner's signature was not on the document. He later completed the *Chronicle* (in a 67 Σ 51 cm format) without his friends' knowledge and sent out a few copies. The woodcut on the title page, which was probably executed after 1917, formed the introduction to the text that had been written in 1913. The picture shows Kirchner (top left) as a restless firebrand, his head surrounded by tongues of flame. Against him nestles a woman's head. Heckel (top right), Schmidt-Rottluff (bottom left) and Mueller (bottom right) are also portrayed. In 1926–27, Kirchner would again assemble the four in an oil painting entitled *The Painters of the Brücke Group* (Museum Ludwig, Cologne). Pechstein was excluded; he is portrayed neither on the woodcut title page of the *Chronicle* nor in the oil painting. Kirchner accused him of "breaking his word" and made him responsible for the demise of the Brücke. It is still not clear what actually led to the break-up of the group. In the years they worked together, a number of conflicts had evidently developed: personal rivalries, financial problems, the increasing independence of the individual members, and "womanizing." The woodcut shown here may be regarded as the final act of what was an unprecedented achievement in the history of German art — the Expressionism of the Brücke group. At the same time, it is a sad document of farewell. *G. P.*

Dube, A. and W.-D. *E. L. Kirchner: Das graphische Werk*, 2 vols Munich, 1980.
Ernst Ludwig Kirchner 1880–1938. Exh. cat. Nationalgalerie Berlin. Munich, 1980.
Grisebach, L. *Ernst Ludwig Kirchner 1880–1938.* Cologne, 1995.

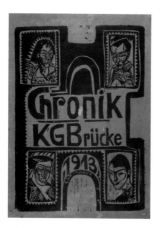

Woodcut for the title page of the *Chronik KG Brücke*, 1913

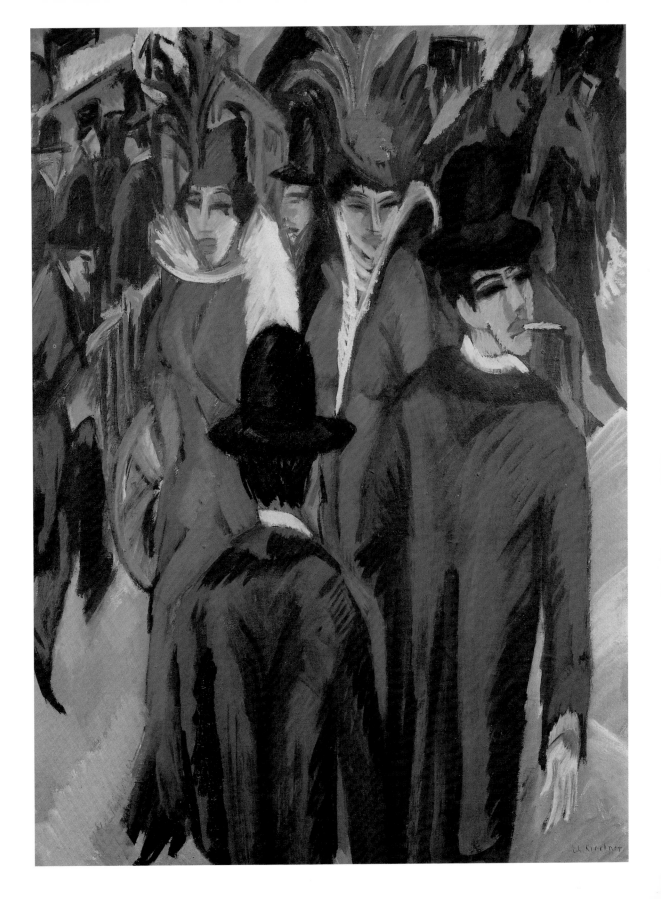

Franz Marc ## The Tiger, 1912

The Tiger is one of Franz Marc's greatest works from the period up to the end of 1912. This was before the artist developed a still greater simplification of form in abstract, rhythmic sweeps and blocks of color, influenced by the simultaneously perceived, pulsating colors of the Frenchman Robert Delaunay. The almost square picture format is dominated by the powerful, crouching form of the tiger, with its head turned back with a bold swing. Its contours are angular, as if chiseled from stone. The facets of its yellow, glowing body merge with the transparent, cubic formations of its surroundings to become an indissoluble unity in which no differentiation between organic and inorganic substance is possible. Despite the tendency to abstraction, here the essence of the beast of prey is depicted with the utmost precision and condensed to its essential form: it is precisely in the strict framework of forms in relation to one another that the majestic nature of the animal is expressed, its energy, tamed yet liable to explode at any moment, its muscles tensed and ready to spring, its suppleness. **A**ll the details of this mature work are foreshadowed in a small bronze, *The Panther*, of 1908 (Städtische Galerie im Lenbachhaus) which Marc, although inexperienced as a sculptor, modeled with astounding confidence. In the painting, the form repertoire of Cubism — which Marc had encountered in works by Pablo Picasso and Georges Braque at the second exhibition of the Neue Künstlervereinigung (The New Artists' Association) in Munich, and which he was able to study again at the large Sonderbund exhibition in Cologne in 1912 — is only an additional means of expression for an already conceived original form. His reaction to Cubism is an expressive transformation of its techniques. **I**t is significant that Marc begins his famous remarks at the conclusion of his essay "Die Wilden Deutschlands" (The Wild Ones of Germany) in the almanac *Der Blaue Reiter* of 1912 with the comment that the question as to the progressive formal development in painting — from Impressionism to the newest trends in Cubism — pales beside the more exalted aims and spiritual values of the "new art": "The most beautiful prismatic colors and the famous Cubism have become meaningless as the goal of these 'wild ones.' Their thoughts have another target: through their work to create symbols for their times which belong on the altars of the coming intellectual religions, behind which the technical producer vanishes." *A. H.*

Franz Marc 1880–1916. Exh. cat. Städtische Galerie im Lenbachhaus. Munich, 1980.
Gollek, R. (ed.). *Franz Marc 1880–1916.* Munich, 1986.
Lankheit, K. *Franz Marc: Katalog der Werke.* Cologne, 1970.
Rosenthal, M. *Franz Marc.* Munich, 1992.

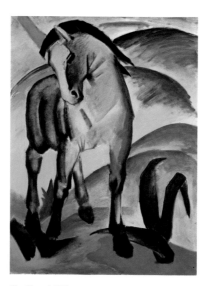

Blue Horse I, 1911

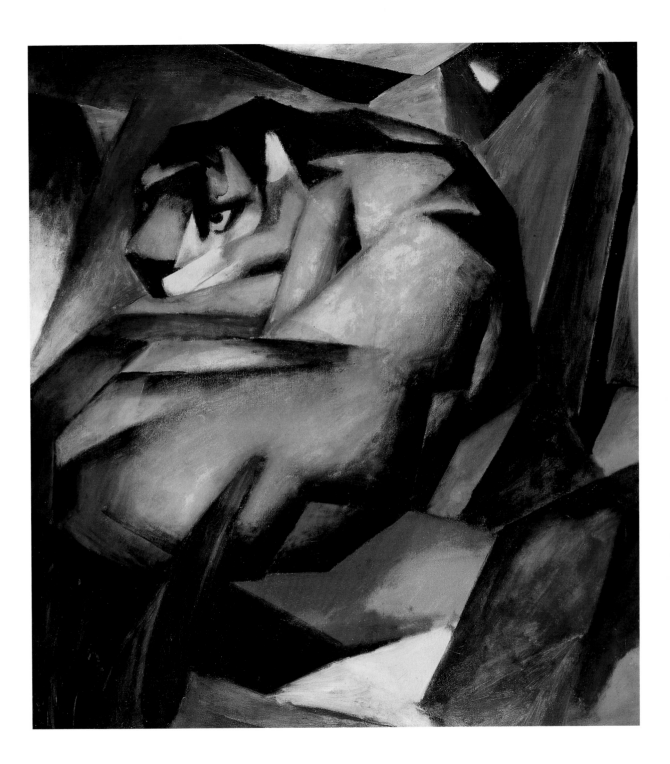

Vassily Kandinsky

Improvisation 26 (Rowing), 1912

1866 Vassily Kandinsky is born on December 4 in Moscow

1886-92 Studies law and economics at the University of Moscow

1895 Appointed to the Faculty of Law at Moscow

1896 Moves to Munich; final decision to pursue a career in art

1897–99 Attends the Anton Ažbé School of Painting; studies at the Munich Academy of Art under Franz von Stuck, meets Alexej Jawlensky and Marianne Werefkin

1901 Co-founds the artists' society, the Phalanx

1903–07 Travels widely including to Holland, Russia, France, Italy, and Switzerland

1905 Participates in exhibitions in the Salon d'Automne and in the Salon des Indépendants in Paris

1908 Stays with Gabriele Münter in Murnau, joined there by their friends Jawlensky, Werefkin, Marc, and later Franz Macke

1909 Founding of the Neue Künstlervereinigung (New Artists' Association) in Munich

1911 Together with Marc founds the *Blaue Reiter*

1912 Publication *On the Spiritual in Art*

1913 Participates in first German Autumn Salon in the Berlin Gallery Der Sturm

1914 Returns to Munich on the outbreak of the First World War

1918 Member of the Art Collegium of the People's Commissariat in Moscow and Professor at the state art-industrial workshops

1920 Honorary Professor of Art Theory at the University of Moscow

1921 Founder of the Russian Academy of Artistic Sciences; moves to Berlin

1922–23 On the staff of the Bauhaus in Weimar and Dessau; occupied with his own free painting class from 1927

1924 Together with Paul Klee, Jawlensky, and Lyonel Feininger founds the group "Blue Four"

1926 Publishes *Point, Line, and Surface*, volume 9 in the Bauhaus series

1928 Stage performance of Mussorgsky's *Pictures at an Exhibition* in the Dessau Theater

1929 First solo exhibition in Paris

1933 Moves to Neuilly near Paris; contact with Marc Chagall, Fernand Léger, Piet Mondrian, Joan Miró, and Hans Arp; participates in the events put on by the group Abstraction-Création

1944 Dies on December 13 in Neuilly-sur-Seine near Paris

In the years from 1909 to 1911, the most important phase of his creative activity before the First World War, Vassily Kandinsky painted more than a dozen *Improvisations*. Like his great *Compositions*, these are among the highlights of a new type of painting: Expressive Abstraction. He described the *Improvisations* as "mainly involuntary, for the most part suddenly created expressions of processes of an inner character, as impressions of 'inner nature'." This contrasted with his *Impressions*, which he defined as "direct impressions of 'outer nature'." These theoretical statements already show that, with *Improvisations*, as in general with his development of non-object-related painting, Kandinsky was concerned to seek out anti-material forms of expression that would be capable of translating inner visions, associations, emotional or intellectual matters into pictorial form, beyond reality as perceived through the senses. The subtitle of *Improvisation 26* — that is, *Rowing* — describes the subject of the painting, the rudiments of which are just barely discernible. An open, madder lake curve indicates the body of a boat which glides along, weightlessly, in and above an area of shimmering color. Jet-black lines mark the parallel oars, as well as the bowed backs of the two rowers who sit facing each other. Despite Kandinsky's renunciation of corporeal representation, this figuration — achieved solely by forceful graphic ciphers, together with a line of waves or hills, again in the red known as madder lake — emits a strong sense of physical presence. The intrinsic value of line, which is simultaneously the vehicle of expression, is opposed by color, now become autonomous, and its space-shaping powers. This conflict between line and color, on the one hand, helps bring about emancipation from the traditional representation of an object, disguises the subject of the picture, and aids spatial relationships. On the other hand, however, its new synthesis produces not only a previously unknown pictorial content but also a novel conception of space. *Improvisation 26* is a superb example of how Kandinsky achieves a floating spatial state that exceeds the limits of traditional perspective, merely through his selection, weighting, and overlapping of colors. In his essay, *Über das Geistige in der Kunst* (On the Spiritual in Art), Kandinsky also considers the Cubists' experiments and their dismantling of ordinary space. He compares these with other possibilities, for example "color which, used correctly, can step forwards or backwards and make the picture into an essence hovering in the air, which is equivalent to the painterly expansion of space." In his dream-like *Improvisation 26 (Rowers)* Kandinsky is completely successful in expressing this type of "fourth dimension" in painting.

A.H.

Barnett, V. E. and A. Zweite. *Kandinsky: Watercolors and Drawings*. Munich, 1992.
Illetschko, G. *Kandinsky und Paris*. Munich, 1997.
Ringbom, S. *The Sounding Cosmos: A Study in the Spiritualism of Kandinsky and the Genesis of Abstract Painting*. Abo, 1970.
Roethel, H. K. and J. K. Benjamin. *Wassily Kandinsky: Werkverzeichnis der Ölgemälde*. Vol. I: 1900–15: Munich, 1982, vol. II: 1916–44: Munich, 1985.
Zweite, A. (ed.). *The Blue Rider in the Lenbachhaus, Munich*. Munich, 1991.

Railway at Murnau, 1909

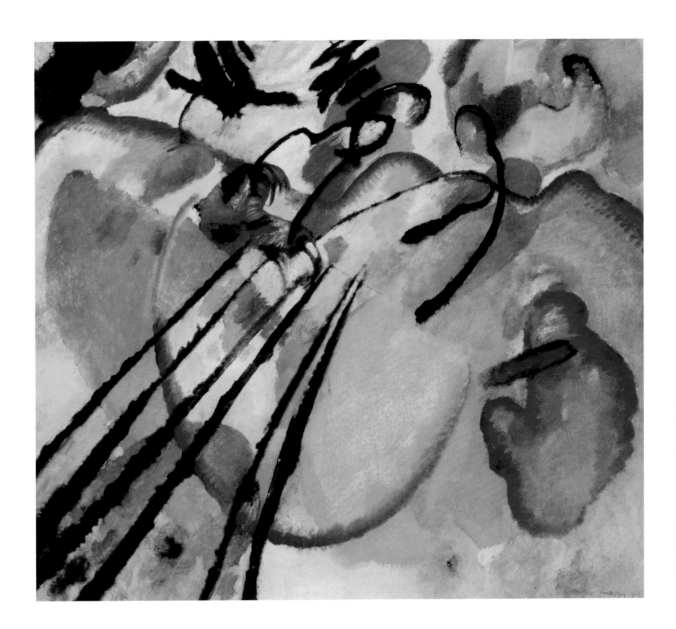

Egon Schiele

1890 Egon Schiele is born on June 12 in Tulln, Austria

1906–09 Studies under Christian Griepenkerl at the Academy of Visual Art in Vienna; influenced by Gustav Klimt and Ferdinand Hodler

1907 Becomes friends with Klimt

1909 Founds the New-Art Group with Anton Faistaner, Franz Wiegele, and Albert Paris Gütersloh

1909–10 Takes part in the "Art Show 1909" and in the New-Art Group exhibition at the Salon Pisko

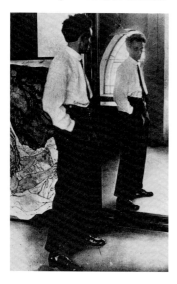

1911 Moves first to Krumau (Český Krumlov) in southern Bohemia, then to Neulengbach near Vienna; *Self-Portrait*

1912 Travels to Munich, Zurich, and Gyor; takes part in the Sonderbund exhibition in Cologne; *Cardinal and Nun*; charged with corrupting a minor, he is arrested; the charge is dropped, but he is sentenced to three days' detention for negligent custody of "indecent" drawings

1914–18 Military service

1918 Successful exhibition at the Vienna Secession; dies on October 31 in Vienna

Standing Female Nude with Blue Scarf, 1914

Even in 1895, Tolstoy was already complaining that art merely served to please and had lost any real sense of the aesthetic. The call for inner truth and a return to morality, both in everyday life and in art, was growing ever louder at the beginning of the new century. With the advent of the First World War and the consequent atmosphere of insecurity and menace, attention was increasingly turning towards inner truth; this also provided a ripe breeding ground for psychoanalysis in Vienna. Descriptions of dark powers that lay beyond our comprehension, of subconscious drives in man, had a direct impact on both literature (see Robert Musil's *Die Verwirrungen des Zöglings Törless*) and on painting. The unsettling of man's belief in a God-determined world order led to a profound isolation of the individual as well as a loss of man's sense of belonging. Egon Schiele's *Nude with Blue Scarf* is overshadowed by this feeling of melancholy and vague longing. The figure is absorbed in itself and exhibits no link with the outside world. Rejecting the observer, she is looking downward, avoiding any opportunity for contact. Her strict contours hold the body mass and room partitioning in check. The angular figure, brittle, almost masculine, is located in undefined space; its only accessory is a blue scarf which, being a powerful pictorial component, provides a counterweight to the strict linearity of the body. Entirely different is the *Seated Woman with Bent Knees*, painted three years later. Here, the figure's movements are relaxed, she is at ease with herself, and her gaze seeks contact beyond the picture. The sharp angles and aggrievedness give way to swinging, more rhythmic brushstrokes. Color and depiction are now mutually dependent and form one single unit. In his final creative period from 1915 to 1918, Schiele's painting loses its over-sensitive, near-morbid agitation, giving way to a quieter, more balanced temperament. He proceeds from his model's spiritual state of mind, but then takes a step back; the resulting portrayals contain a greater element of realism. These artistic developments occur within the short timespan of just one decade. In following the call of Expressionism, Schiele succeeded in turning the traditional way of seeing things upside down; it was now inner truth that became worthy of representation. *B. W.*

Kallir, J. *Egon Schiele: The Complete Works*. New York, 1990.
Koschatzky, W. (ed.). *Egon Schiele: Aquarelle und Zeichnungen*. Salzburg, 1968.
Leopold, R. *Egon Schiele: Die Sammlung Leopold Wien*. Cologne, 1995.
Nebehay, C. M. *Egon Schiele: Leben und Werk*. Salzburg, 1980.
Schröder, K. A. *Egon Schiele: Eros and Passion*. Munich, 1995.

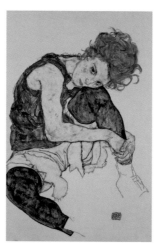

Seated Woman with Raised Knee, 1917

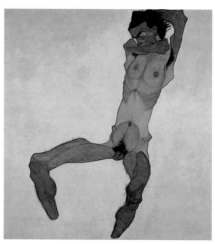

Large Seated Nude, 1910

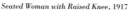

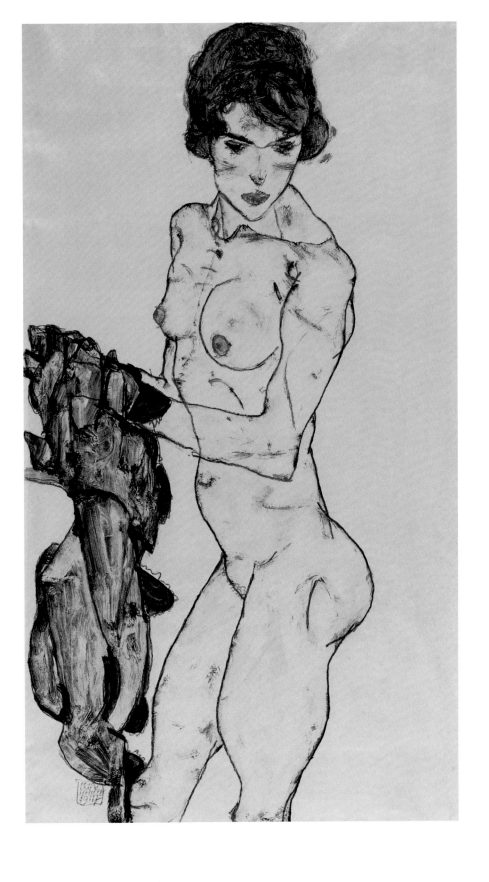

Umberto Boccioni

Continuous Forms in Space, 1913

1882 Umberto Boccioni is born on October 19 in Reggio di Calabria, Italy

to 1898 Works as a journalist and writer

1898 Moves to Rome

1898–1902 Studies painting in Rome; befriends Gino Severini and Giacomo Balla

1902–04 Stays in Paris and Berlin

1905 Joint exhibition with Severini at the "Mostra dei Rifintari"

1906 Short stay in Paris, followed by a trip to St. Petersburg

from 1908 Lives in Milan; befriends Carlo Carrà and Emilio Marinetti

1909 Becomes an adherent of Futurism

1910 Together with Luigi Russolo, Carrà, Balla, and Severini, signs the "Technical Manifesto of Futurist Painters" on February 11

1911 Travels to Paris with Severini; first encounters Cubism; *Street Noises Invade the House*

from 1912 Searches for new associations between the object and space through Futurist sculpture

1912 Publication of the "Technical Manifesto of Futurist Painters"; takes part in the first international exhibition of Futurist art in the Bernheim-Jeune Gallery in Paris

1913 *Continuity of Time*

1914 Produces works which are based on the painting system developed by Cézanne; publication of his book *Pittura, scultura futurista, dinamismo plastico*; registers for military service of his own free will

1916 Dies on August 16 near Verona, Italy

The 20th century began with enormous élan. The feeling of *fin de siècle* and the doubts at the turn of the century seemed to have been swept away. An inspired vitality strove for expression in many forms. Perhaps it was expressed most intensely in the striding figures which the Futurist Umberto Boccioni created in 1913. He called these *Continuous Forms in Space*, a title with an allusion above and beyond all the conditions and constrictions of human existence. This figure, striding forward against strong resistance as though in a hurricane, but which obviously no force in the world can stop, in which all the hopes, all the utopias, of the new century seem to be concentrated — is this not the most convincing, the most striking, artistic incarnation ever accorded to Nietzsche's vision of the *Übermensch*, the "superman"? We know that Boccioni was very familiar with Nietzsche's works — he had discovered common ground with Gino Severini through reading Nietzsche, and he frequently discussed the works of the German philosopher with Filippo Marinetti. Nietzsche's influence on the Futurists at times seemed so great that Marinetti was forced to publish a polemic with the title "Che cosa ci separa da Nietzsche" (What separates us from Nietzsche). **W**hat separated Boccioni from Nietsche and the latter's *Zarathustra* was a fascination with technology. Boccioni's *Continuous Forms in Space* show a human figure which has become merged organically with technological forms. These are not his tools or his armor, they are nothing extraneous to him; rather, he has transformed himself into them — they have become his innermost being. Human and technology form a symbiosis that seems to make them invincible. They can no longer be separated, except through some dreadful sacrifice. **I**n the hurricane, it seems as though steel pinions are growing out of the figure. Is this some modern Daedalus, intent on reaching to the stars, flying into space? Or is it the human being who will discover how to split the atom: the inventor who strides forward without sparing a single thought for the consequences of his invention? Will nothing stop him — this believer in technology, this being obsessed with progress, who does not fear the steely touch of war? *W. Sch.*

Ballo, G. *Boccioni*. Milan, 1964; 2nd edn., 1982.
Calvesi, M. and E. Coen. *Boccioni: L'Opera Completa*. Milan, 1983.
Coen, E. (ed.). *Boccioni*. Exh. cat. The Metropolitan Museum of Art. New York, 1988.

Street Noises Invade the House, 1911

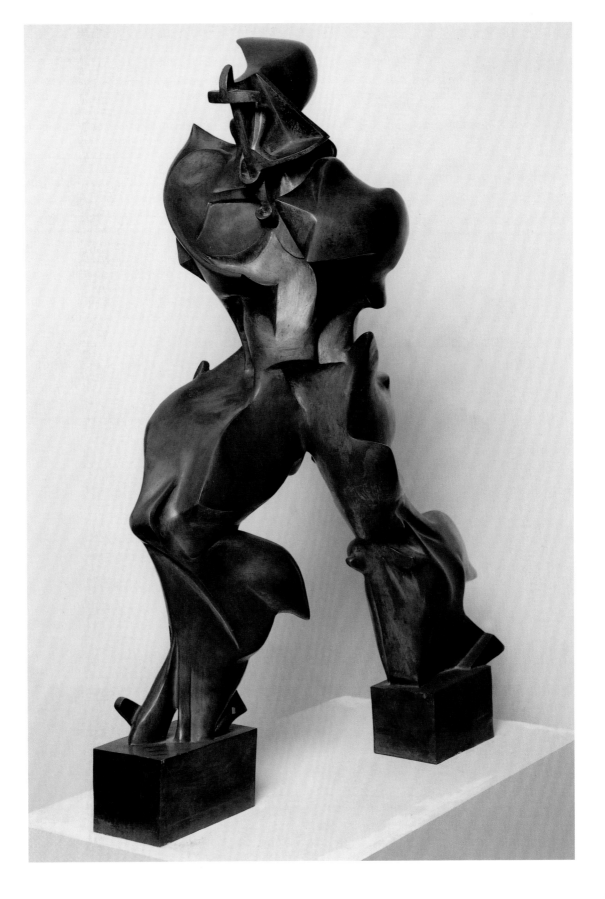

Giacomo Balla

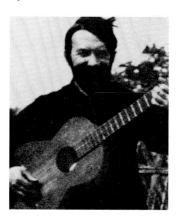

Mercury Passing before the Sun, 1914

In 1910, the "Technical Manifesto of Futurist Painters" was issued, and signed by Balla, Boccioni, Carrà, Russolo, and Severini. It contained the words: "The events we depict on canvas will no longer be fixed moments in the general state of dynamism; they will be dynamic sensation itself." This sensation was to be captured through the simultaneous depiction of different phases of movement. The aim of these artists was to record not a single fixed moment in time, but the changing nature of a certain event. Giacomo Balla therefore documents *Mercury Passing before the Sun* in its various phases in time. The planet pushes its way slowly across the face of the sun, and the temporal sequence of movements is represented by a spatial sequence in which one phase is depicted next to another. The use of arcs and segments of circles, of acute angles and diagonal lines to create a directional counterpart suggests movement along a certain trajectory. The concept of universal dynamism is here transposed to a cosmic plane. The cosmos is depicted as an animated rotation of astral systems, caused by oscillations, radiation, and force fields. With this almost complete dissolution of the subject of the picture into fields and lines of movement and through the depiction of crystalline structures, Balla leaves the stylistic features of Futurism almost completely behind and moves towards the abstractions of Kandinsky. In 1900, Balla, the oldest of the Futurists, lived for a time in Paris, where he was influenced by the Divisionist concept of coloration and by the analytical dissection of objects that characterized French Cubism. He developed these stylistic experiences further beneath the outward tokens of Futurism. Through the representation of illumination and atmosphere, speed, simultaneity, and the interpenetration of objects, he achieved an analysis of movement that was to document the speed and dynamics of a new, fully technological age. In Germany, too, a number of artists belonging to the "Storm" group and its successor, the "November Group," adopted aspects of Futurism, while Russian artists were to develop their own individual form of Cubist Futurism. *B. W.*

Fagioli dell'Arco, M. *Balla the Futurist*. New York, 1988.
Giacomo Balla: Studi, richerche, oggetti. Exh. cat. Verona, 1976.
Robinson, S. B. *Divisionism and Futurism, 1871–1912*. Ann Arbor, 1981.

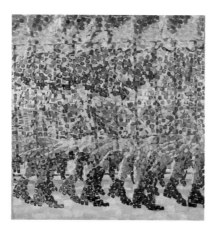

Walking Girl on a Balcony, 1912

Giorgio de Chirico

Mystery and Melancholy of a Street, 1914

1888 Giorgio de Chirico is born on 10 July in Volos, Greece; following a classical-humanist education, attends painting classes at the Polytechnic in Athens

1906–09 Studies at the Art Academy, Munich

1909 Moves to Italy (Milan, Turin, Florence)

1911–15 Stays in Paris; befriends Guillaume Apollinaire and Pablo Picasso

1912 Exhibition in the Salon d'Automne; *Piazza d'Italia*

1913 *The Mystery and Melancholy of a Street*

1913–14 Exhibitions in the Salon des Indépendants

1916 *The Disquieting Muses*

1916–17 Meets Carlo Carrà; beginnings of metaphysical painting

1918–19 Moves to Rome

from 1924 Stays in Paris for several years; works on the journal *Révolution surréaliste*

1945 Returns to Rome; publication of his autobiography *Memorie della mia vita*

1978 Dies on November 20 in Rome

This painting was created in Paris in 1914, Giorgio de Chirico's great year, a year in which his most exciting pictures were successful. **M**ystery and Melancholy of a Street relates an encounter between two figures: a small girl with a hoop, and the statue of a politician. Only the shadow of the statue can be seen, and even the girl appears only as a dark silhouette against the light. She is running with her hoop towards a concealed light source, and the long shadow thrown by the statue shows her the way to go. As both figures, the living being and the man of stone, head towards each other, they become more and more similar: the two shadows are about to meet. **A**t the same time, this is a picture of the meeting between light and dark. The two zones remain strictly separate: on the left the reflection of light, on the right the region of darkness, and somewhere in between, concealed, a secret source of light. The white wall on the left is as though lit up by floodlights, with the dark arcade openings and the yellow sandy ground across which the girl is moving. On the right lies the world of shadows, the building with its arcades completely sunk into the darkness. Into this dark zone is pushed an empty freight car or removal truck with its side walls and doors mysteriously lit up by a light coming from nowhere. Is it the light from times past that this truck has retained, or the reflection of a reflection that bounces off its walls? The girl has just crossed the tracks and is about to run past this truck — or will it swallow her up? **T**here is still an evening breeze. It is making the small red flag flutter at the exit of the arcades, and it tugs at the girl's hair. The horizon is dark green, and the darkness is deepening in the sky above. At any moment now it will be night. **T**his is a picture full of mystery. The greatest mystery, however, is the perspective. Here we have two contradictory vanishing points: that of the light and that of the dark. All the lines of the building that lies fully illuminated meet at the right above the horizon behind the dark building; however, the alignments of the shadowy zone meet at a point where the black truck roof touches the dark yellow of the side wall and the lighter yellow of the sandy ground. These two vanishing points will never converge, any more than the girl will ever reach the shadow of the statue. This is part of the secret of the street, this is what makes it melancholy. *W. Sch.*

Giorgio de Chirico. Exh. cat. Verona, 1988.

Giedion-Welcker, C. *Die magische Dingwelt der Pittura metafisica (Schriften 1926–71).* Cologne, 1973.

Schmied, W. et al. *Giorgio de Chirico: Leben und Werk.* Munich, 1980.

Schmied, W. *De Chiroco und sein Schatten.* Munich, 1989.

Schneede, U. M. *Die Malerei des Surrealismus.* Cologne, 1973.

Soby, J.I. (ed.). *Giorgio de Chiricio.* Exh. cat. The Museum of Modern Art. New York, 1966.

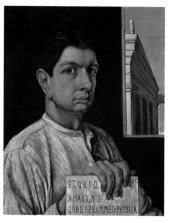

Self-Portrait, 1920

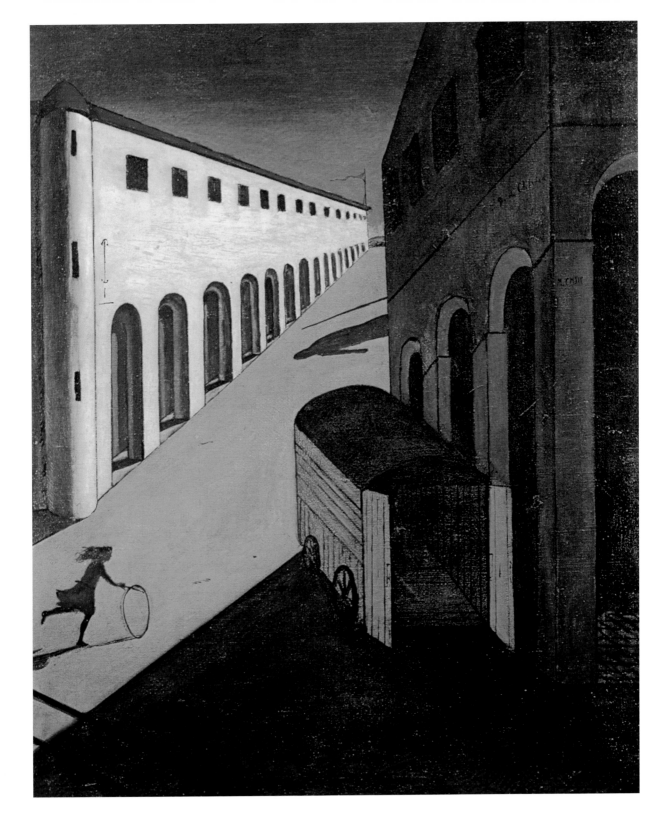

Marcel Duchamp

Bottle Rack, 1914

1887 Marcel Duchamp is born on July 28 in Blainville, France

1903 Moves to Paris, studies at the Académie Julian

1909 First exhibition in the Salon des Indépendants in Paris

1910 Works as a librarian; continues his artistic development through self-education

1911 Takes part in meetings of the Cubists centered around his half-brother Jacques Villon; befriends Guillaume Apollinaire and Francis Picabia

1912 Formation of the "Section d'Or"; *Nude Descending a Staircase*

1913 Participates in the "Armory Show" in New York; produces his first ready-mades; *Bicycle Wheel*

1914 *Bottle Rack*

1915–18 Stays in New York; contacts Man Ray

1917 *Fountain*; publication of the journals *The Blind Man* and *Rong-Wrong*

1918–19 Returns to Paris via Buenos Aires

from 1920 Is back in New York, together with the collector Katherine Dreier; foundation of the "Société Anonyme"

1921 The journal *New York Dada* is started

1923 Completes the construction *The Bride Stripped Bare by Her Bachelors, Even (The Large Glass)*

1923–42 Stays in Paris; apart from taking part in the experimental films of his friends, he ceases his artistic activities; becomes a professional chess player

1926 First exhibition of *The Large Glass* at the International Exhibition in Brooklyn, NY

1942 Returns to New York; publishes the journal *VVV* together with André Breton and Max Ernst

1947 Organizes the Surrealist Exhibition in Paris with Breton

1968 Dies on October 2 in Neuilly

In 1914, Marcel Duchamp, a twenty-seven-year-old painter who had already aroused attention with a spectacular series of cubistic pictures, bought a bottle rack of galvanized cast iron in a Paris store and signed it. This gesture marked a turning point in the development of modern art. By repeating it consistently, Duchamp created a new type of artwork, which he termed "the ready-made." The ready-made contradicted all existing concepts of art at that time as well as the expectation that art should give form and expression to some meaningful, universal truth. Duchamp negated the usual question about the meaning of a work and replaced its answer with a thing, a practical object. As absurd as this gesture may seem, it does create relationships, since Duchamp's object exists, not in a vacuum, but in the context of all Western art history. This history is so inseparably interwoven with that of the development of intellectual values that even an intended negation of this dimension is understood as a statement and as a value judgment. Through the absence of an explanatory or explainable comment, the question as to the meaning is formed in the viewer, that is, is present as a question. Since it seems to represent nothing except itself, Duchamp's provocative object points to this new, so unexpected characteristic for a work of art, namely this absence of a definitive, given meaning, and thus to a fundamental experience of our times. At the same time as Mondrian and Kandinsky were announcing the primacy of color and form with their first steps towards non-representational art, Duchamp succeeded in charging the object with meaning in a completely new, surprising, and disquieting way, thus bringing the "shadow" of modern art — its loss of meaning — into the artistic consciousness. Furthermore, he accomplished a radical turn-around of creative principles up to that time; personal choice replaces a binding canon. The choice of an already existing object replaces creation by the artist. The emphasis of the creative process shifts from the execution of the work to its intellectual conception. The artistic intention remains concealed; the work becomes an enigma. The outstanding significance of the *Bottle Rack* for the artistic development of the post-classical Modern period is due to this intellectual and creative revolution. "Art is not what we see; it is in the spaces between," declared Duchamp in an interview. It is the observer who must fill in these gaps. Without his or her creative participation the work remains a fragment — and he/she alone can complete it. *S. B.*

Daniels, D. *Duchamp und die Anderen: Der Modellfall einer künstlerischen Wirkungsgeschichte in der Moderne.* Cologne, 1992.

D'Harnoncourt, A. and K. McShine (eds.). *Marcel Duchamp.* Munich, 1989.

Schwarz, A. *66 Creative Years: From the First Painting to the Last Drawing.* Milan, 1972.

L'Œuvre de Marcel Duchamp. Exh. cat. Musée National d'Art Moderne Centre Georges Pompidou. Paris, 1977.

Fountain, 1917/1964

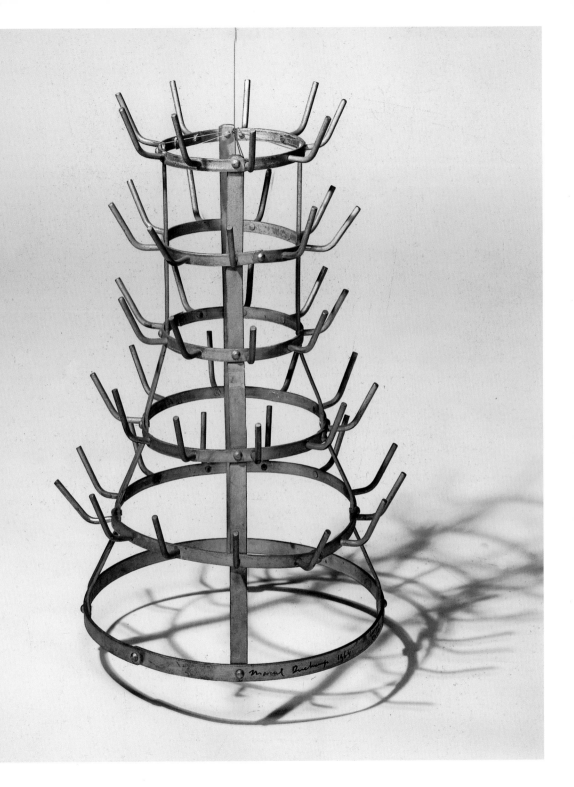

Amedeo Modigliani

Nude with Necklace, 1917

A beautiful naked woman is put on show. The artist presents her as if she were a precious object. She is the embodiment of feminine enticement, and not even a hint of a scarf or sheet conceals her. Only a necklace of fine pearls adorns her neck. She has sunk into sleep and does not care who looks at or paints her. No servant girl disturbs our observation of her. The artist relishes the flawlessness of her body, the warm flesh tones, and the perfect contours of her figure. In order better to accentuate her womanliness, he brings his subject as close to the observer as possible, choosing to forgo showing her all the way down to her feet. **O**ur meditative contemplation of the painting contrasts sharply with the tremendous scandal which nudes like this originally provoked. In 1917, when Amedeo Modigliani created such uncompromising images, the police felt provoked by the nudes to such an extent that they forbade the artist from showing them in public, resulting in the abrupt closure of the only solo show that the artist was to hold in his life. **M**odigliani was notorious not only as a synonym for scandal, but above all for his excessive use of drugs and alcohol and his passionate involvements with women. As an artist, Modigliani, a native Italian who emigrated to France, stood between the poles of the traditional and the modern reflected by those two countries. He hoped to measure his knowledge of the Old Masters against modern styles, yet he failed to find his proper place in Paris, the center of the avant-garde, and came to ruin in the clash between the world of conservative Salon painting of the *fin de siècle* and that of avant-garde movements such as Cubism and Fauvism. **M**odigliani's goal was to portray human beings. With only a few exceptions, his entire oeuvre consists of images of people. The artist perfected his art of the portrait in the period around 1916 when he created works like the *Portrait of Max Jacob*, in which he assimilated elements such as a cubistic fragmenting of forms as well as principles of "primitive" sculpture. But Modigliani's style was soon to change. The hard forms which often seemed to conflict with each other developed into soft, flowing figurations. Under the influence of the sun of southern France Modigliani created lighter-toned portraits with elongated faces and almond-shaped eyes. **H**is nudes are among his most famous works, and yet they account for no more than a tenth of his entire output — hardly more than thirty works. Only a few nudes provoke through tense, offensive aggressivity. For the most part the artist, in works such as this one, celebrates the beauty of the female body and bases his compositions on the work of famous precursors such as Titian, Goya, and Ingres. *Nude with Necklace* also recalls the work of the Old Masters; the outstretched body exudes the same relaxed sense of inner peace which Giorgione had given his *Sleeping Venus* of 1508. **M**odigliani was no champion of political programs or manifestos. His thought was firmly grounded in late 19th-century notions, and the novels of Gabriele d'Annunzio as well as the verses of Dante Alighieri and Lautréamont were his constant companions. And just that is the fascination of Modigliani's work: the conflict between retrospective sentiment and a modern sense of style which resulted in the last great contributions to the art of the organically rendered human form. *A. K.*

Kruszynski, A. *Amedeo Modigliani: Portraits and Nudes*. Munich, 1996.

Lipchitz, J. *Amedeo Modigliani*. London, 1968.

Schmalenbach, W. *Amedeo Modigliani: Paintings, Sculptures, Drawings*. Munich, 1990.

Portrait of Max Jacob, 1916

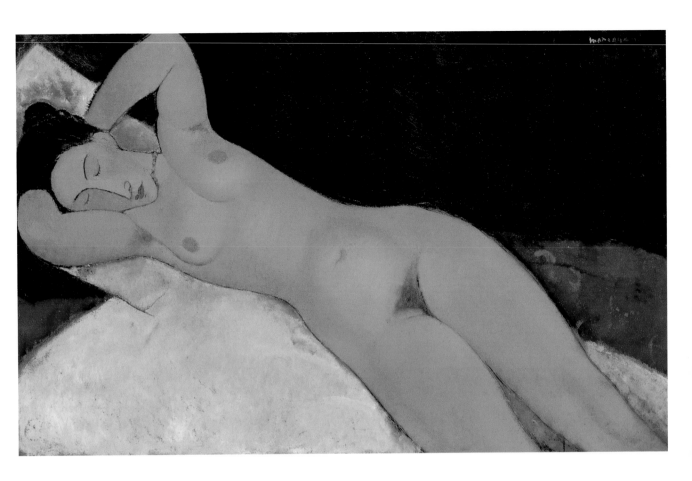

Kurt Schwitters

Merzbild 31, 1920

An outstanding early work by Kurt Schwitters, *Merzbild 31* of 1920 was one of the few large-format pictures he created. The artist had given up traditional painting only two years before and had begun to replace it with works made in a collage technique. Schwitters' ostensible reasons for this change were his experience of losing the First World War and the subsequent revolutionary uprisings in Germany. "Everything was destroyed anyway," as he summed up the situation, "and it was our task to build a new life out of the wreckage." His first collages were born of this resolve. Schwitters collected rubbish from the streets and carried it home in order later to incorporate it into his works. Thus the picture surface of *Merzbild 31*, too, is a composition of numerous found objects: the top of an old tin can, fabric scraps, broken bits of wood, pieces torn out from newspapers, and calendar pages. At the same time, Schwitters based his work on a rigid compositional framework borrowed from the form criteria of Cubism and Italian Futurism. He ordered the glued-on materials in rotating circular paths and crystal-like beams whose dynamic movements seem to positively burst the picture frame. The composition is held together by added passages of paint which Schwitters applied to meld the small collage pieces into larger units. In the central upper third of the composition, a glued-on diagonal "31" gives the work its name. To distinguish this type of work from his small-format paper collages (*Merz* drawings), Schwitters dubbed these assemblages of object fragments and painted passages his *Merz* pictures. **D**espite his use of unconventionally combined materials, Schwitters was nonetheless always interested in composing harmonious works of art. This dissociated him in a decisive respect from the anti-aesthetic approach of the Berlin Dadaists, who for that reason refused him membership in their "Club Dada." Schwitters subsequently founded his own solo art movement, *Merz*, in 1919. He had cut out and used the German word fragment "merz" from the bank name "Commerz- und Privatbank" for one of his collages, the so-called *Merzbild*. From then on this work lent its name to the entire range of Schwitters' artistic activities, from his *Merz* drawings to his *Merz* poems, *Merz* architecture, and his "total sculpture," the *Merzbau*. *D. E.*

Kurt Schwitters. Exh. cat. Musée National d'Art Moderne Centre Georges Pompidou. Paris, 1994.

Elger, D. *Kurt Schwitters — Der Merzbau*. Cologne, 1984.

Schmalenbach, W. *Kurt Schwitters*. Munich, 1984.

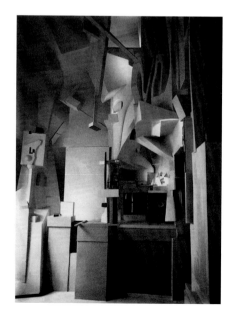

Merzbau, 1933

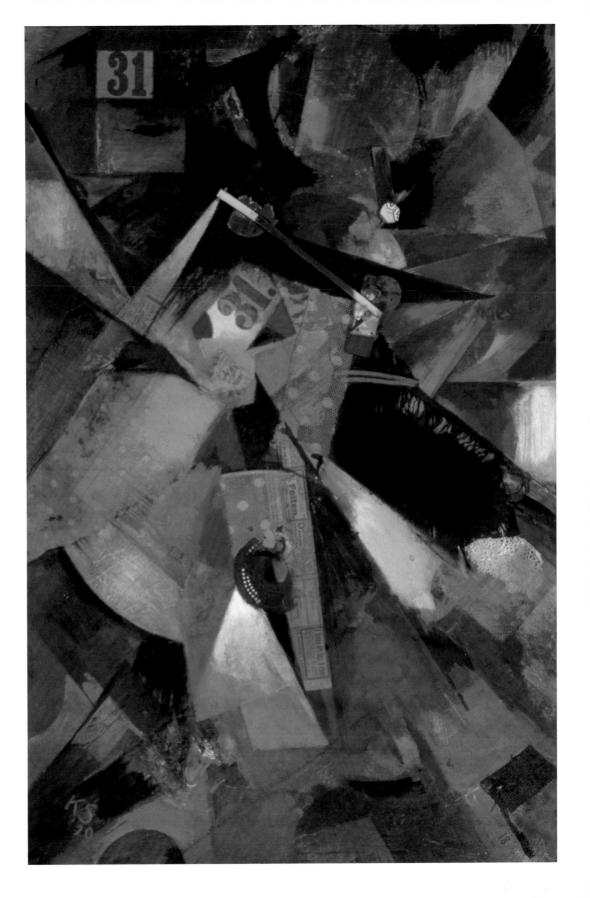

Vladimir Tatlin

Model of the Monument for the Third International, 1920

Vladimir Tatlin's best-known work is his model of the *Monument for the Third International*. It was created in 1920 both as a consequence of a change in his artistic direction and as a polemic response to traditional and didactic ideas of monumental art in Soviet Russia. Tatlin's "tower" unites a rising twin spiral with four stereometric bodies suspended within it. These are designed to rotate at different speeds on axes at a slight variance, corresponding to the lean of the tower. They were built to incorporate the various organs of the Internationale. Intended as "an artistic construction combining the materials of iron and glass" (Tatlin), the "tower" combines purely artistic, autonomous form with an underlying purpose. In 1914 Tatlin had turned away from traditional painting. He was aware of Cubist experiments using *papiers collés* and material collages, as well as the aesthetics of beeing true to the material as propounded by the Reform Movement since William Morris. Accordingly, in 1914, he moved from depictional art towards an abstract working of the material for its own sake and the sensitive combining of different types of materials. His interests subsequently lay in the investigation of material, space, and construction. In a declaration concerning the 1920 exhibition "tower", Tatlin linked his experience and goals. He stated emphatically: "Our sense of touch predominates over our visual perception." He saw the architecture of the tower as a model. It was designed "to stimulate exploration" in the development of a new world and "to awaken our creative powers for the renewal of representational forms." Tatlin had been politically motivated since 1917, but he never imagined he would abandon his role as an independent artist. The exhibition of his model polarized the Russian artistic avant-garde. This spatial construction comprising elementary forms and materials turned Tatlin into the "father" of Constructivism. And yet he never saw himself as a Constructivist, even distancing himself from constructivist techniques and geometric form. He rejected any mechanization of art. Intuition always remained more important to him than any search for rules. Even the spiral as a utopian symbol of progress stands alone in his work. On the other hand, he felt that material formed a special organism, with "hidden energies" that it was his task to set free. Hence only curved and rhythmically sweeping lines held any attraction for him. The founder of an experimental culture based on materials for fashioning a humane environment, Tatlin had a lifelong interest in organic form.

H. O.

Harten, J. (ed.). *Vladimir Tatlin. Leben: Werk, Wirkung. Ein internationales Symposium.* Cologne, 1993.
Strigalev, A. and J. Harten (ed.). *Vladimir Tatlin: Retrospektive.* Cologne, 1993.

Letatlin, 1929–32

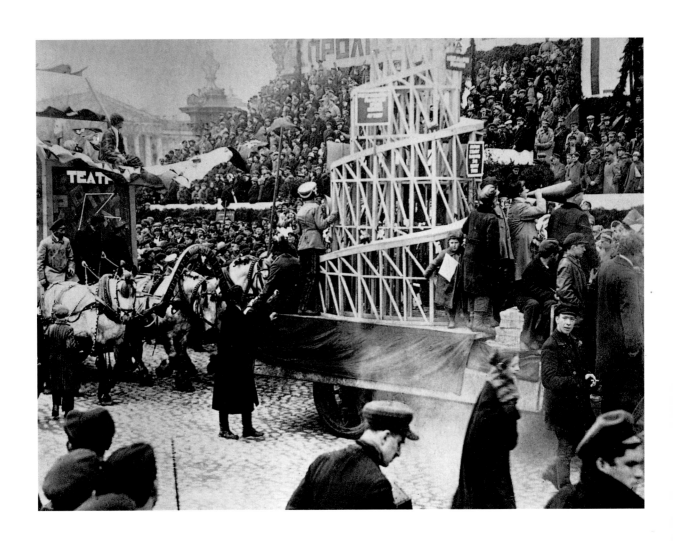

El Lissitzky

1890 El Lissitzky is born Lazar Mardukhovich Lisitsky on November 23 in Pochinok, near Smolensk, Russia

1909–14 Studies architecture at the Technical University in Darmstadt, Germany

from 1916 Works for a Jewish publishing company and other cultural organizations; after the Revolution, is a member of the Council of the Arts in the People's Commission for Enlightenment

1919 Director of the department of architecture and the workshop for graphics and printing at the Vitebsk Academy; under the influence of Kasimir Malevich, creates his first non-figurative, constructivist paintings

1920 Joins the INChUK, the Institute of Artistic Culture, in Moscow

1921 Returns to Moscow; teaches architecture and monumental painting at the VchUTEMAS (Higher State Workshops); the first Russian Art Exhibition is organized in Berlin

1923 First solo exhibition, at the Kestner Gesellschaft in Hanover, Germany

1924 Designs the architectural model *Skyhook Towers*; with Hans Arp publishes *Die Kunstismen*

1925 Teaches wood- and metalwork at the VchUTEMAS; moves away from painting

1926 Participates in the International Art Exhibition in Dresden

1928 Designs the Soviet Pavilion at the "Pressa" in Cologne

from 1931 Leading artist/architect for the continual building exhibition in Gorky Park

from 1932 Collaborates as a book artist on the magazine *SSSR na stroike*

1941 Dies on December 30 in Moscow

El Lissitzky would certainly have been an enthusiastic user of the programs with which architects today develop three-dimensional designs on the screens of their computers. As head of the workshops for graphic art, printing, and architecture at the school of art in Vitebsk, he developed an exercise for his studies that was later to be given the name "Proun." The term is an acronym either of the words "proekt Unovisa" (UNOVIS project) or of "proekt utverschdeniia novogo" (project for the confirmation of innovation). The purpose of this exercise was to achieve a multi-dimensional form of representation, using various geometric elements, in an attempt to capture not just a single image seen from one viewpoint, as in a central perspective, but a number of views simultaneously. To this end, an axonometric construction was used in which the lines are drawn parallel to each other. The technique was designed not only for his students; El Lissitzky also experimented with it himself. The *Study for "Proun G7"* is a collage of colored paper and cardboard. An elongated white rectangle set at an angle is given volumetric form by the addition of shading. All the other elements are made up of pieces of paper combined to create larger shapes. Since the eye perceives the white bar as a volumetric form, the observer begins to analyze the various spatial layers. The black of the cruciform structure and the surrounding areas of dark gray suggest a sense of depth. The position of the oval between the background plane and the white bar is also clearly recognizable. One can read it as a plane surface or as a volume — or is it perhaps recessed into the black cross? The smaller elements, such as the red dot or the small white strip that resembles an exclamation mark, are further means of creating a sense of advancing or receding volumes and planes. Color plays a vital role in this context. It can make an object seem light at one moment and heavy at the next. The effect of a "Proun" was not meant to be restricted to the surface of a sheet of paper. It was Lissitzky's declared aim to integrate the many insights gained in the course of design into the process of reshaping all aspects of life. This reflected ideas circulating at that time in the UNOVIS union of artists, for which Kasimir Malevich, the leading figure of the movement, had gained El Lissitzky's support after his arrival in Vitebsk. Before being appointed professor at the Academy of Art, El Lissitzky had occupied himself, among other things, with Jewish themes, and had illustrated children's books. The "Prouns" were a step towards the non-figurative form of representation that he was to pursue in the future. *W. Spr.*

El Lissitzky 1890–1941: Catalogue for an Exhibition of Selected Works from North American Collections. Exh. cat. The Sprengel Museum Hannover and the Staatliche Galerie Moritzburg Halle. Cambridge, 1987.
El Lissitzky: Architect, Painter, Photographer, Typographer. Exh. cat. Stedelijk Van Abbemuseum Eindhoven. Eindhoven, 1990.
Richter, H. *El Lissitzky: Sieg über die Sonne. Zur Kunst des Konstruktivismus.* Cologne, 1958.

Design for a flagpole at the "Pressa," 1927

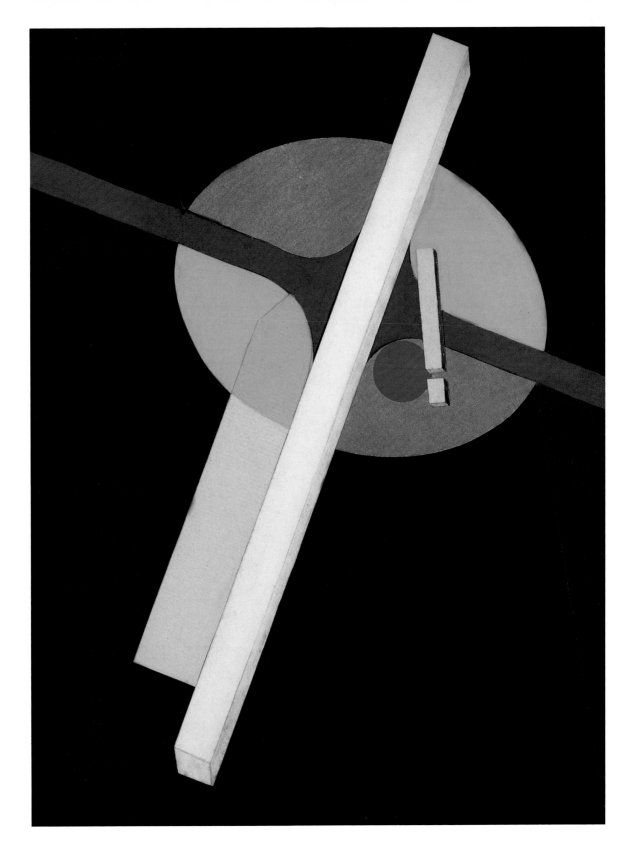

Piet Mondrian

Tableau I, 1921

In his treatise *Le Néo-plasticisme*, published in 1920, Piet Mondrian describes the goals of his art: "The new spirit cannot hide behind that which is characterized by the particular, behind natural form and color. Much rather, it must be expressed in the abstraction of form and color, in the straight line, and in color in its purest sense." These words characterize Mondrian as a painter whose pictures — after being purified of all representational elements — create a new order which is carefully thought through and precisely planned. Apart from the straight line, horizontals, and the right angle, his formal methods include the dividing up of the picture surface into non-colored (black, white, gray) and primary-colored (red, blue, yellow) fields. Mondrian aims for a sense of balance through the contrast of horizontals and verticals and of pure colors and non-colors, which he was first to fully achieve in his *Tableau I* of 1921. The picture is a clear study in pro-portion composed of elements which have been reduced to a minimum. Mondrian makes universal harmony visible through the equal value he gives to all the elements of his picture. What is astounding and at the same time completely innovative about this conception of painting is the creation of an equilibrium out of asymmetry, which brought to an end the traditional dominance of the inflexible principle of symmetry. In 1917, together with Bert van der Leck, Theo van Doesburg, and several other artists who pursued similar goals, Mondrian founded the artists' group "De Stijl." At the same time there appeared the first issue of a magazine of the same name which, until 1925, served as a theoretical forum for the artists. The wish to postulate this new art form as a lifestyle too found a corresponding resonance in Dutch architecture and influenced the *nieuwe beelding* (new plastic) of the 1920s. Numerous "De Stijl" impulses were also adopted and further developed by the Bauhaus, which published Mondrian's book *Die neue Gestaltung* (The New Form) in 1925.

B. Wa.

Holtzman, H. and M. S. James (eds.). *The New Art — The New Life: The Collected Writings of Piet Mondrian.* London, 1986.

Jaffé, H. L. C. *Piet Mondrian.* Cologne, 1990.

Seuphor, M. *Piet Mondrian.* New York, 1956.

Welsh, R. P. and J. M. Joosten. *Two Mondrian Sketchbooks, 1912–14.* Amsterdam, 1969.

Landscape with Trees, 1911–12

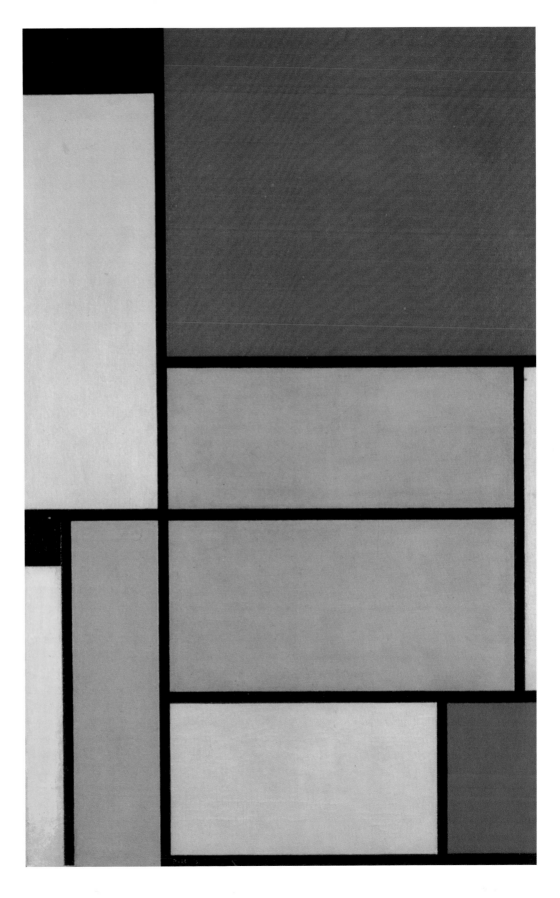

Paul Klee

The Twittering Machine, 1922

In 1921, the year in which Paul Klee began teaching at the Bauhaus in Weimar, he completed a pen-and-ink drawing entitled *Concert on the Twig*, which was a preliminary study for the watercolor *The Twittering Machine*, painted the following year. Four fantastic bird-like creatures, the heads of which bear a greater resemblance to fish than birds, are huddled close together on the branch of a tree. From their open beaks stream sounds — visualized in the form of graphic symbols — that make up a most singular concert. Reduced to just a few lines in the pen-and-ink drawing, these fantastic beasts, half fish, half fowl, appear to be the product of some mechanical or constructive spirit rather than organic, living creatures. **T**he Twittering Machine adopts the fantastic group of birds, but adds to the branch of the tree a construction with a rod and cranking handle, as if to suggest that the song of the birds could be reproduced and listened to at will, as if played on an old Gramophone. **F**antastic mechanical worlds devoid of any real function were often depicted by Dadaist artists. Ideas of this kind were the product of an age in which the machine came to exert an ever greater influence and threatened to overwhelm man and nature. In this watercolor, nature is presented in a mechanically transformed state in one of Klee's characteristically ironic and blithe formulations. Reference is made here to the tragic situation of a world alienated from its roots. Klee's watercolor makes a grotesquely pointed allusion to mechanical birdsong and to a natural world that is in the overpowering grip of a civilization far removed from its origins. More than this, however, fish and fowl, swimming and flying, to which Klee's depiction makes simultaneous reference, signify the free movement described by the artist in his essay "Wege des Naturstudiums" (Ways of studying nature), a movement that was seen as being capable of transcending all boundaries. **T**he Twittering Machine is also a depiction of song, concert, and music and draws attention to the potential these possess for dissolving all earthly bonds.

E.-G. G.

Fath, M. (ed.). *Paul Klee: Die Zeit der Reife*. Munich, 1996.

Grohmann, W. *Paul Klee*. New York, 1954.

Güse, E.-G. *Paul Klee: Dialogue with Nature*. Munich, 1991.

Kornfeld, E. W. *Verzeichnis des graphischen Werkes von Paul Klee*. Berne, 1963.

Schmalenbach, W. *Paul Klee: Aquarelle, Zeichnungen*. Exh. cat. Düsseldorf, 1977.

Zweite, A. (ed.). *Paul Klee: Das Frühwerk 1883–1922*. Munich, 1979.

Paul Klee: Œuvreverzeichnis, Vol. 1: Die Werke des Jahres 1940. Stuttgart, 1990.

Main Path and Secondary Ways, 1929

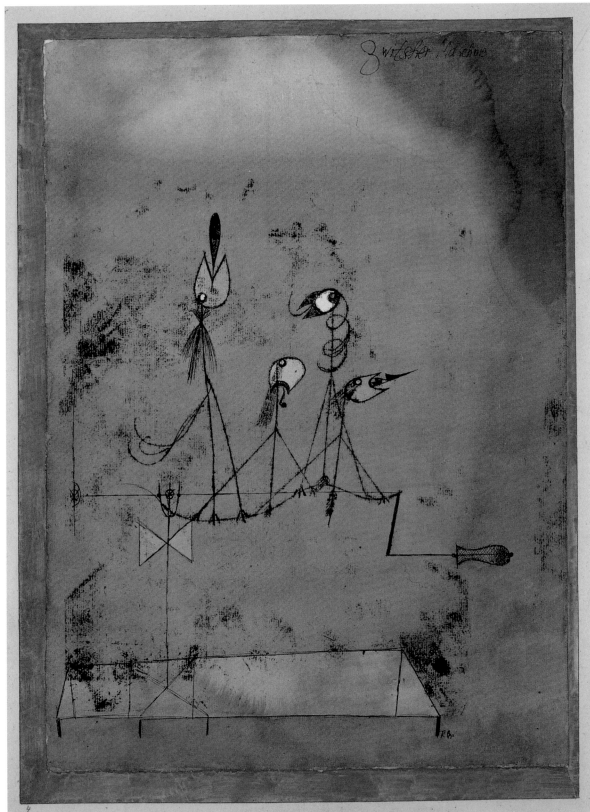

Zwitscher Maschine

4 1922/151 Die Zwitscher-Maschine

Man Ray

Le violon d'Ingres, 1924

"I paint what I cannot photograph, and I photograph what I cannot paint," Man Ray once remarked. An artist of universal talent, wit, and imagination, he experimented with all kinds of techniques. He was not only a photographer and painter; he also worked as a graphic artist and sculptor, created *objets trouvés*, and made films. In New York, the city in which he grew up, he belonged to the circle of Dadaists; and in 1921, when he went to Paris, he quickly made contact with the Dadaist-Surrealist artists around Marcel Duchamp and André Breton. This formed the background of his photographic oeuvre, which made him one of the pioneers of photography in the 20th century. He was one of the first to explore photography without a camera to create a series of photo-graphics, which were called "Rayographs" after him. Man Ray used a technique that had been discovered in the 19th century, whereby objects were laid on light-sensitive paper to create fantastically distorted, abstract compositions. In his camera photography, too, there seemed to be no limits to his inventiveness. He worked directly on negatives as well as on positive prints; he used double exposure; he employed enlargements and distortions to accentuate surrealistic effects; and he discovered, together with Lee Miller, the technique of solarization, by which the gray values of a picture could be manipulated through a second exposure of an already developed photo. **M**an Ray's favorite model in the 1920s was Kiki, his female companion at that time. A femme fatale, singer, dancer, and model, she was one of the most glittering figures of the Montparnasse artists' quarter. She also posed for the artist's *Violon d'Ingres*, published in 1924 in André Breton's surrealist journal *Littérature*. Resembling one of the beauties in Ingres' *Turkish Bath*, she is shown wearing a turban and with two violin f-holes drawn on her naked back, which is turned towards the observer. This ambiguous photo-collage, in which the body of Man Ray's lover is presented as a decorative object, plays not only on the well-known comparison between a woman's body and a musical instrument. It is also a pun on the words "*violon d'Ingres*," meaning a hobby or passion. Ingres entertained visitors to his studio by playing the violin before he allowed them to see his paintings. Various possible interpretations of this picture, therefore, suggest themselves. Is Man Ray's pastime photography or the classical form of the female body, here stylized into an object? What is more important: the homage to the French painter — who, like Man Ray, loved portraying nudes — or the tribute to the beauty of women? *I. H.*

Man Ray: Inventionen und Interpretationen. Exh. cat. Frankfurter Kunstverein. Frankfurt am Main, 1979.
Penrose, R. *Man Ray.* London, 1975.

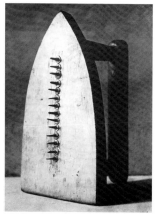

Gift, 1921

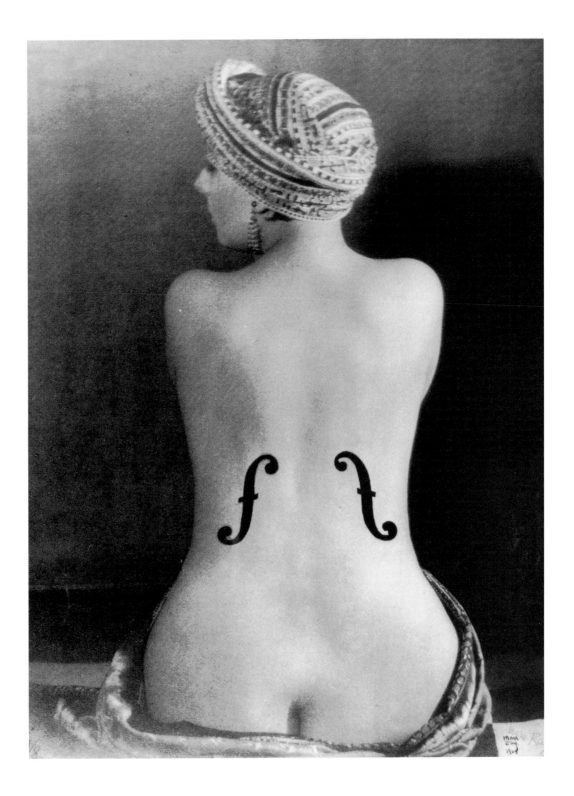

Lovis Corinth

Ecce Homo, 1925

During a time when Europe was experiencing major upheavals and radical changes Lovis Corinth became an artist in Berlin, taking up painting with a veritable passion. In a land of painter-poets, painter-philosophers, and painter-missionaries intent on whipping up the public conscience, this made him a loner — an altogether untimely contemporary. Corinth's images of himself reflect his retreat into painting. Comparable only to Max Beckmann, Corinth practiced role-playing to an excessive extent. It apparently served as a means of exorcizing his obsessions. In his diary-like *Selbstbiographie*, Corinth portrayed himself in the manner of Kasper Hauser, thus as a prototype of the German artist so rebuked by August Macke for being "a confused person, who does not have a command of language." Death is ever present in the profusion of life depicted in Corinth's paintings. The energy and dynamism of his work as *natura naturans* have their raison d'être in the knowledge of death. From 1911, when he suffered an apoplectic stroke, Corinth's art imparts this very elementary knowledge. Military defeat shook the very foundations of his world and his faith in it. Everything appeared to be unstable and frail — a reality to be escaped only through the maelstrom of painting, in which everything brought forth onto the white canvas is done so by the artist. What the painter reveals as being ephemeral must first be created with the brush, then transformed into absolute painting. The constant undermining of ephemerality by means of the spiritual occurs alongside the ever-present reference to the vital force in nature as well as its decay. Corinth's passion for painting had two sides. It was a passion, an obsession, for the sensual world and the sensuousness of painting, which was also informed of the decay of life, its guilt, death, and death's imminent presence. His passion for painting assumes two forms in his nudes: the joy of painting as a celebration of all worldly things, and as transcendence of his precious, fixed ephemerality. This ambivalence in Corinth's painting, its two sides, passion and suffering, illuminate Corinth's penchant in his final year for juxtaposing the erotic with the religious. In his painting of the corpulent whore entitled *The Fair Imperia* (1925), Corinth reveals once again his fascination with erotic passion, which ultimately leads to the purification of the lovers. Ecce Homo is a depiction of the most humiliating moment in Christ's Passion, the procession of the Son of God before the mocking crowds, which precedes the consummation of his suffering and his redemption. The artist as Christ, Corinth's chosen role, is a recurring theme which extends to the Munich *Self-Portrait with Skeleton* (1896); to *Red Christ* (1922), revealing certain similarities to the blood-drenched Man of Sorrows, who shows traces of Corinth's own features; and, finally, to the *Self-Portrait as Man of Sorrows* (1925), used to illustrate the last page of his *Selbstbiographie*. In his favorite role as Christ, the painter continually played with the double meaning of his passion for painting — that is the pious and dithyrambic veneration of the richness of life, and at the same time the knowledge of its finitude and the constant attempt to overcome it through the delightful torment of painting. Corinth's passion for painting is the redemption of the mortal world — interpreted as "Imitatio Christi" — through the continually renewed power of painting. *P.-K. S.*

Lovis Corinth, 1858–1925: Gemälde und Druckgraphik. Exh. cat. Städtische Galerie im Lenbachhaus. Munich, 1975.
Berend-Corinth, C. *Die Gemälde von Lovis Corinth.* Munich, 1958.
Felix, Z. (ed.). *Lovis Corinth — Gemälde, Zeichnungen und Graphik.* Cologne, 1985.

The Jochberg and the Walchensee, 1924

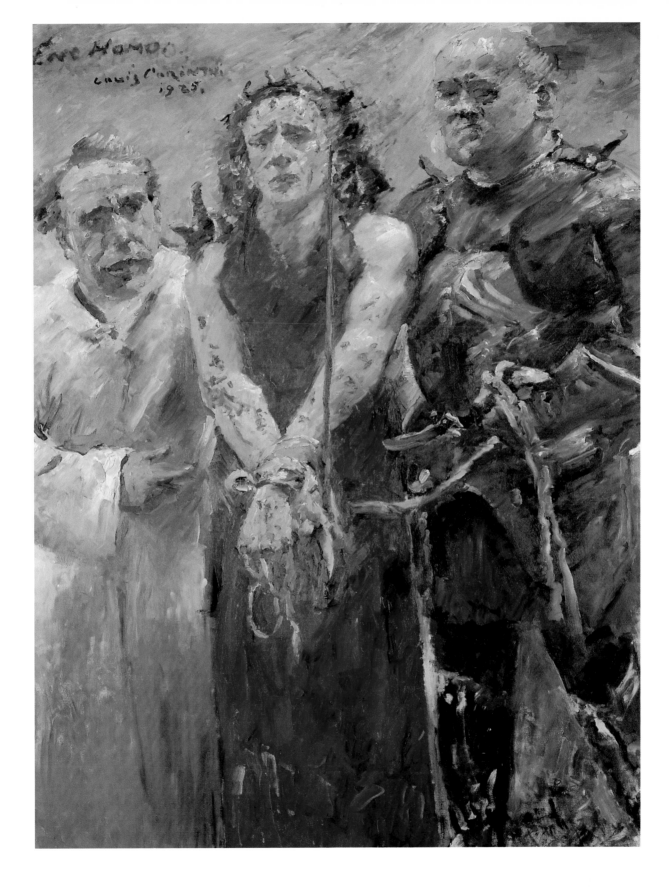

Oskar Kokoschka

Tower Bridge, London, 1925

1886 Oskar Kokoschka is born on March 1 in
Pöchlarn, Austria

1905–09 Studies at the Kunstgewerbeschule, Vienna

1907 Works in the "Vienna Workshops" founded
by Josef Hoffmann

1908 In contact with Karl Krauss and Viennese
literary figures

1910 Temporary stay in Berlin, works on
Herwarth Walden's journal *Der Sturm*; first
solo exhibition

1911 Returns to Vienna; beginning of his
relationship with Alma Mahler

1913 Travels to Italy; paints landscapes

1914 *The Tempest*

1914–16 Military service

1919–23 Professor at the Dresden Academy

1925–31 Extended travels in Europe

1931 Returns to Vienna

1934 Moves to Prague

1937 *Self-Portrait as a Degenerate Artist*

1938 Emigrates to London

1947 Adopts British citizenship

1948 Stays in Italy

1949 Travels to the U.S.A.

1953 Moves to Villeneuve on Lake Geneva;
produces the stage sets for Mozart's *Magic
Flute* and Weber's *Oberon*; foundation of the
International Summer Academy in Salzburg

1975 Adopts Austrian citizenship

1980 Dies on February 22 in Montreux,
Switzerland

Oskar Kokoschka left the Dresden Academy at the end of the summer of 1923 and embarked on a long journey that would take him from Paris through Europe, North Africa, and the Near East. After a stay of about two months in Paris from May to June of 1925, during which he sold all the pictures he had painted in the course of his travels to the art dealers Paul Cassirer and Jakob Goldschmidt, he continued on to Holland in early July and finally reached London on July 9. Between July 9 and 15 of that same year Kokoschka painted his first cityscape of London from an upper story of the recently completed Adelaide House, near London Bridge. This painting shows the view downriver, over the northern banks of the Thames towards Tower Bridge. In the foreground are the London Pool and Billingsgate Market, with behind them the Custom House and St. Dunstand-in-the-East. Kokoschka regularly kept his family and friends informed about the countries and cities he visited, and never neglected to report on the progress he was making in his painting. Thus, on July 15 he wrote to his mother: "In the first hour I arrived in London I immediately found the place to paint. On the 10th floor beside the Thames. The whole river and a city ten times the size of Vienna. First painting finished." That year Kokoschka would paint twenty-five cityscapes in all, each of which generally took him two days to complete. In his early portraits it was Kokoschka's un-

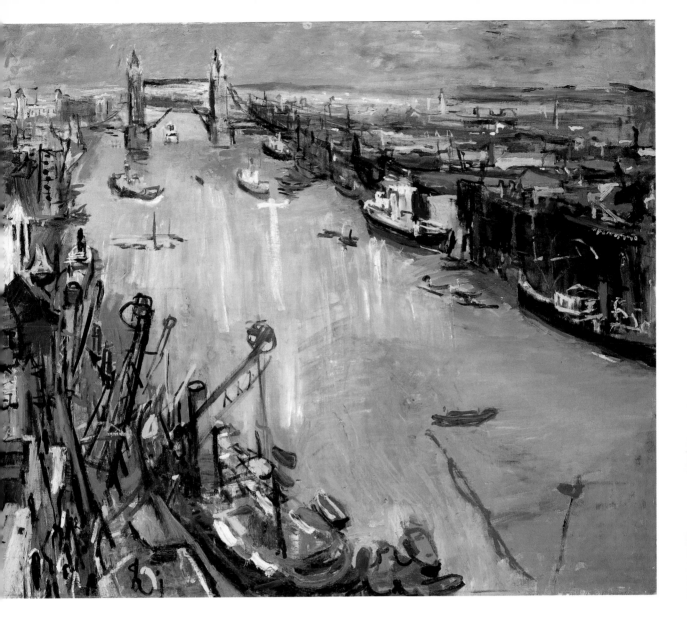

compromising radicality that impressed, the incredible self-confidence with which he faced his models and robbed them of their features, only to perfect them analytically through his own psychological experiences rendered into pictorial images. In the late 1920s he increasingly employed a similar process to depict landscapes and city "portraits." The topography of a city is usually easily recognizable. Nevertheless, these paintings were handled differently from the early portraits: because he usually painted them from a raised viewpoint, and consequently had a wider viewing angle, he would condense the panorama and, as in nature, set several vanishing points side by side. Characteristic, too, are the expressive brushstrokes with which he captured his fleeting perceptions. The importance of this artist for the development of 20th-century art lies primarily in his parallel talents. While Kokoschka was producing his first paintings, he was also writing poetry and beginning his analysis of past and contemporary literature, exploring the interrelationship between

art and poetry. He broke taboos by depicting the problems of puberty, the struggle between the sexes, and the transfer of religious concepts into the secular world. In so doing, he carried mythological and mystical matters over into the sphere of contemporary problems. Through his intensive literary and artistic studies and their transformation into the experimental, and not least through his extensive travels, Kokoschka acquired an inherent, universal knowledge that would ensure him a place in the annals of art history, not just as an artist, but also as a humanist *par excellence.* A. Wei.

Feuchtmüller, R. (ed.). *Oskar Kokoschka: Ölbilder, Aquarelle und Zeichnungen.* Vienna, 1986.
Kokoschka. *My Life.* London, 1974.
Schröder, K.A. and J. Winkler. *Oskar Kokoschka.* Munich, 1991.
Wingler, H. M. *Oskar Kokoschka: The Work of the Painter.* Salzburg 1958.
Wingler, H. M. (ed.). *Oskar Kokoschka: Schriften.* Frankfurt am Main, 1964.

George Grosz

Pillars of Society, 1926

Marked by war and revolution, a generation of artists was born who used cutting realism to decry the social ills of post-war Germany. In this context George Grosz painted *Pillars of Society*, whose title ironically refers to Henrik Ibsen's play of the same name. In the 1930s this theme was taken up again and updated in critical works by John Heartfield and Oskar Nerlinger. **G**rosz's censure of contemporary society took on a particularly drastic form in a beer-drinking German Nationalist with a monocle, scar, and swastika, as well as an open skull out of which climbs a war horse. Behind him stands a Social Democrat, probably Eberl, President of the Republic, holding a German flag and brandishing the demagogic slogan "Socialism is work" (just don't strike). He also has an open skull. Beside him is the journalist, Alfred Hugenberg, with a palm branch in his hand and a chamber-pot on his head, a symbol of his limited intelligence. A further pillar of society is an unctuous clergyman who tolerates the bloodshed perpetrated behind his back by members of the Reichswehr and the right-wing veterans' associations "Stahlhelm" and "Wehrwolf." Apparently it is the military, the clergy, and the press who provide the seemingly brainless politicians with instructions to govern this chaos. **G**rosz sometimes called himself a Dadaist. For him, however, Dada did not exclusively mean rejection of every tradition and convention but also possessed a political dimension. The collage or montage became his expressive medium, later complemented by such Futurist-inspired techniques as the simultaneous portrayal of multiple phases of motion. These various stylistic elements lost importance during the 1920s, however, in favor of social criticism and satirical verism. Grosz developed a typology which was effective through the use of exaggeration and deformation. Extreme close-up perspective and detail distort the object's natural appearance and place it in a new, surprising context. With cutting perspicacity, exemplary situations from the real world are depicted in order to accuse the guilty and touch the viewer. **T**hus there arose a type of militant realism which was born of a given historical situation and which logically also ended with it.

B. Wa.

Baur, J. I. R. *George Grosz.* Exh. cat. The Whitney Museum of American Art. New York, 1954.

Schneede, U. M. *George Grosz: Der Künstler in seiner Gesellschaft.* Cologne, 1975.

Schuster, P. K. (ed.). *George Grosz: Berlin — New York.* Exh. cat. Nationalgalerie Berlin. Berlin, 1995.

Cain or Hitler in Hell, 1944

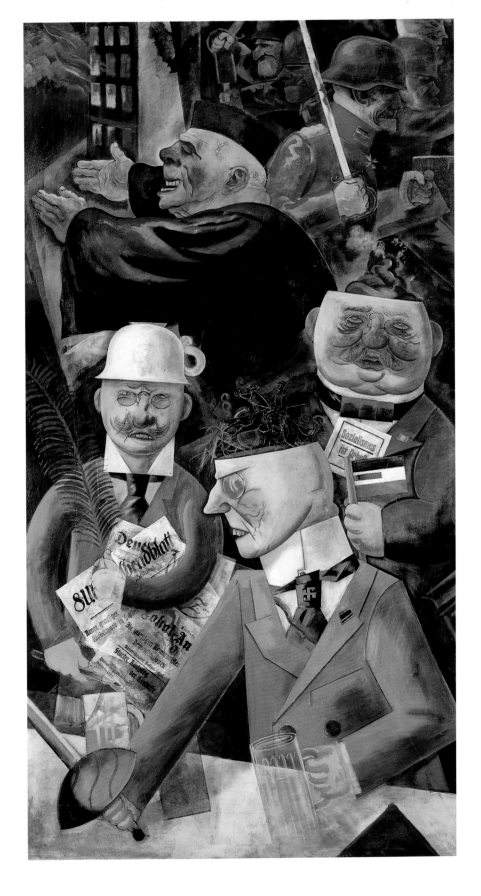

Georgia O'Keeffe

Black Iris II, 1926

It would not be advisable to take Georgia O'Keeffe's flowers — poppies, roses, lilies, irises, camellias, or arums — to a tea party. They would dominate the conversation, reducing everyone to silence and diverting their attention to other — more decadent — thoughts. There is something shameless about her flowers. In reality, all she has done is to exaggerate the basic forms found in nature, which are beyond shame: labia and lobes, pistils and stems, concavities and convexities, "nature's fantastically and luxurious sexual advertisement," with all the analogies that exist between plants and the human body. It is all the more surprising that the artist used vehemently to defend herself when asked about the obvious analogies contained in her works — especially considering the universalist view of nature, ranging from the sensual to the spiritual, which her works convey. **W**hen Georgia O'Keeffe began, in the 1920s in America, to portray one or two enlarged cut flowers on canvases some 36 x 30 in. in size, she unleashed a veritable revolution in still-life painting. Until then, only large objects, such as cathedrals, had been depicted in such dimensions — not flowers. The interior of the calyx of her *Black Iris II* indeed seems to enclose a light-filled space at which we can only guess, because it is surrounded by baroque convolutions of soft, sensuous, sometimes velvety, sometimes waxy, sometimes glassy forms in dignified grays, blues, violets, and blacks. **T**he sheer monumentality of these close-up pictures transforms faithful depictions of nature into bizarre, fantastic images, dramatizing the inanimate and converting precise delineation into decoration. Nature teeters on the brink of becoming art, and in so doing creates a cool, mysterious, and suggestive fascination, which is common to all the 200-odd flower pictures of increasingly abstract perfection which the artist produced over a period of some ten years. **T**he inspiration for this innovative approach — which itself formed a model for others — came from the relatively new art of close-up photography as practiced by the photographers Paul Strand and Alfred Stieglitz (O'Keeffe's husband). Her later work, which ranged thematically from skyscrapers to bleached animal bones to geological formations, also contributed to making her a precursor of American Abstract Expressionism and Color Field Painting. And her independent life-style for many years even provided a charismatic model for feminists.

L. S.

Georgia O'Keeffe. Exh. cat. The Metropolitan Museum of Art. New York, 1988.
Buhler Lynes, B. *O'Keeffe, Stieglitz and the Critics, 1916–1929*. Ann Arbor, 1989.
Eldredge, C. C. *Georgia O'Keeffe: American and Modern*. Exh. cat. Hayward Gallery London. London, 1989.

Jack-in-the-Pulpit VI, 1930

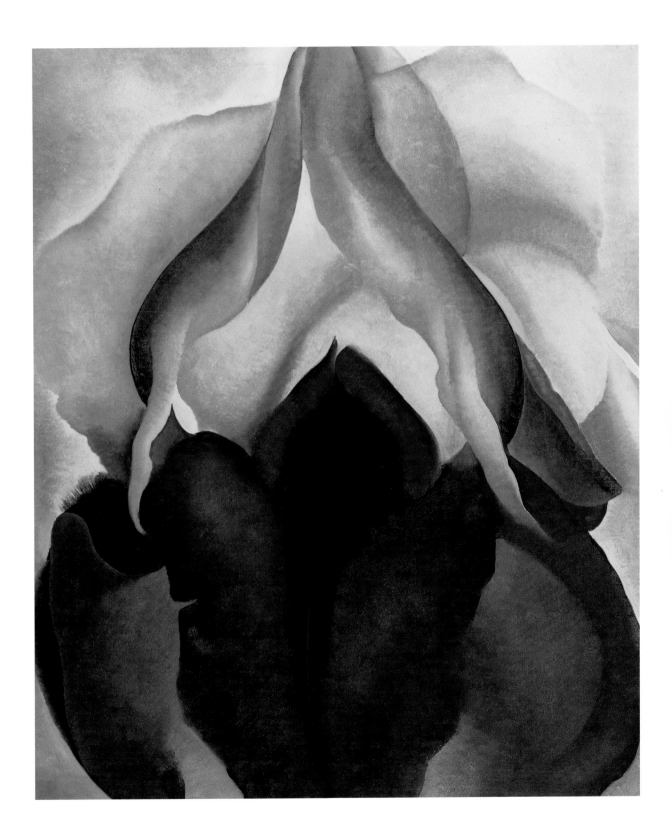

René Magritte

The Treachery of Pictures, 1929

The picture of a pipe seems so straightforward that it might be the signboard of a tobacconist's shop. Instead of the tradesman's name, however, one discovers a line of handwriting, which laconically declares that this is not a pipe at all. René Magritte resolved the apparent paradox by explaining that it was merely a painting of a pipe, not a real pipe. At first glance, the solution to this visual conundrum seems banal. For the artist, however, it involved a semantic-philosophical insight into the conventions of signs. The relations between semantic and iconographic signs, on the one hand, and the things denoted, on the other, are based merely on a set of conventions, not on natural, irrefutable facts. This small painting belongs to a group of semantic pictures, many of which Magritte painted in the late 1920s. During his stay in Paris, he systematically investigated the links between words, images, and objects. The conclusions he drew from his research are contained in the essay he wrote in 1929 with the title "The Words and the Pictures." Everything pointed to the fact, Magritte wrote, that there are few links between the object itself and the thing that represents it. His famous depiction of a pipe may serve to illustrate this. Neither words nor pictures can tell us anything substantial about objects. Objects are beyond their reach. They remain a secret. The artist nevertheless hoped that the observer's perplexity on reading the caption to the picture would help to illuminate this mystery for a brief moment. By calling into question all certainties and things we take for granted in our normal thinking, Magritte invokes the mysterious existence of things. In the light of this, the real pipe makes its presence felt as an invisible third element. In his painting *The Two Mysteries*, dating from 1966, it appears to be present. But appearances are deceptive. The pipe floating freely in space is just as much a picture as the painting on the easel. Only with some reservation may Magritte be counted as a Surrealist. The fact that he did not paint dreams was something he stressed as often as his aversion to psychoanalysis. Instead of drawing on the depths of the unconscious through the agency of automatism, Magritte addressed himself to the exterior world. He was not a painter in the traditional sense, but rather a thinker who used painting as a medium to make his ideas visible. His influence on subsequent generations of artists should not be underestimated. The famous question; whether the American flag painted by Jasper Johns (see page 134) is really a flag or a picture, would be inconceivable without Magritte's pipe painting. The free play of signs and symbols that the philosopher Michel Foucault recognized in Magritte's semantic pictures opened up new worlds for artists such as his compatriot Marcel Broodthaers or the American conceptual artist Joseph Kosuth.

T. H.

René Magritte: Die Kunst der Konversation. Exh. cat. Kunstsammlung Nordrhein-Westfalen, Düsseldorf. Munich, 1996.
Schmied, W. *René Magritte: Die Reize der Landschaft.* Munich, 1989.
Sylvester, D. (ed.). *René Magritte: Catalogue raisonné*, 4 vols. Antwerp and Basel, 1992–94.

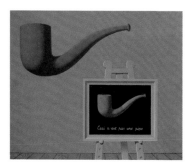

The Two Mysteries, 1966

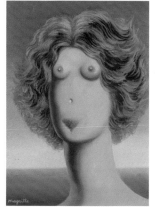

The Rape, 1934

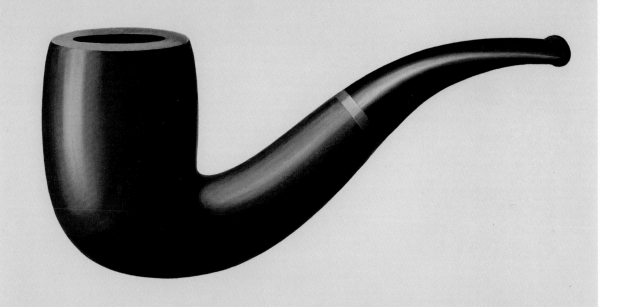

Kasimir Malevich

Black Square on White Ground, ca. 1929

1878 Kasimir Malevich is born on February 23 near Kiev

1895–96 Studies at the Art School in Kiev

1898–1901 Studies in Kursk

from 1902 Attends the Moscow School of Painting, Sculpture, and Architecture

from 1907 Participates in exhibitions of the Blue Rose Group of Moscow Artists; becomes acquainted with Michail Larionov

1910 Participates in the Knave of Diamonds Group exhibition

1912 Takes part in the Moscow "Donkey's Tail" exhibition; travels to Paris, where he becomes involved with Cubism; invited to take part in the second *Blaue Reiter* exhibition

1913–15 Paints illogical, Cubist-Futurist, and Suprematist pictures

1915 His first public showing of Suprematist paintings in the "Tram W" and "0.10" exhibitions in St. Petersburg

1916 Publication of the essay "From Cubism to Suprematism"

1917 Appointed to the Moscow Art School; member of the Fine Arts Department of the Commission for Popular Education

1918 Professor at the State Art and Technology Workshops in Moscow

1919 Succeeds Marc Chagall at the Academy in Vitebsk; subsequently, his main interest is devoted to solving questions of art theory; works with El Lissitzky; publication of "Concerning New Systems in Art"

1922–29 Heads the Art Institute in St. Petersburg

1927 Travels to Warsaw and Berlin to exhibitions of his own work; visits the Bauhaus in Dessau; publication of "The Non-Figurative World"

from 1929 Investigates the social meaning of color

1935 Dies on May 15 in St. Petersburg

The painting *Black Square on White Ground* — from Kasimir Malevich's last stage set for the Futurist opera *Victory over the Sun* (1913) by Alexei Krucenych and Michail Matyusin — is a representation of pure surface (black on white) and pure form (a square). The "contrast of the black square on white [represents] the utmost economy of composition" (Larissa A. Shadova). In this way, Malevich eliminated all figurative elements. With his square and two non-colors, he created the absolute opposite of all naturalistic associations (the sun) and laid the foundations of the "Suprematism [of the] non-figurative world, or of liberated nothingness," the foundations of the "supremacy of pure sensation in the visual arts" (1922–27). This sensation, which is the product of pure spiritual construction and is freed of the compulsion to make concrete statements, can be defined here through the clear geometric form of the dominant black, and through the white, which is not a brilliant white, but somewhat grayish in tone. **M**alevich's signal masterpiece, *Black Square on White Ground*, was, for the artist, the "naked, unframed icon [of his] time," a reflection of the "new reality" of the technological world. The pictorial structures are developed from the ultimate reductions of drawn constructions, the basic elements of which are pure forms: square, rectangle, circle, ellipse, diagonal, etc. Non-figurative art is seen as the realization of cosmic synergy, as a non-purposive form of art, which was regarded as a counterpart to non-purposive nature. Suprematism represents the radical outcome of the process of liberating pictures from their reproductive function, a process that had begun with Paul Cézanne. Suprematism and Malevich's art reached their zenith with the white paintings of his so-called purist phase in 1917–18 — with paintings such as *White on White*. **N**on-figurative art in Russia began with Malevich in 1912–13 and was to exert a great influence on European Constructivist art. Malevich's Suprematist panels, together with his writings (cf. the manifesto on Suprematism written in 1922 and published in 1927), had a profound effect on the theory and practice of avant-garde art in the 20th century, and in particular on the philosophical aesthetic of abstract painting and modern architecture. *L. L.*

Kazimir Malevich, 1878–1935. Exh. cat. National Gallery of Art. Washington, D.C., 1990.
Simmons, W.S. *Kazimir Malevich's Black Square and the Genesis of Suprematism, 1907–1915.* London, 1981.
Steinmüller, G. *Die suprematistischen Bilder von Kasimir Malewitsch: Malerei über Malerei.* Cologne, 1991.
Weiss, E. (ed.). *Kasimir Malewitsch: Werk und Wirkung.* Exh. cat. Museum Ludwig Köln. Cologne, 1995.

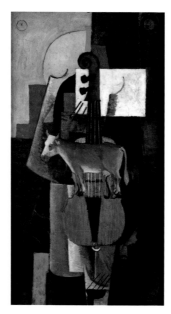

Cow and Violin, 1913

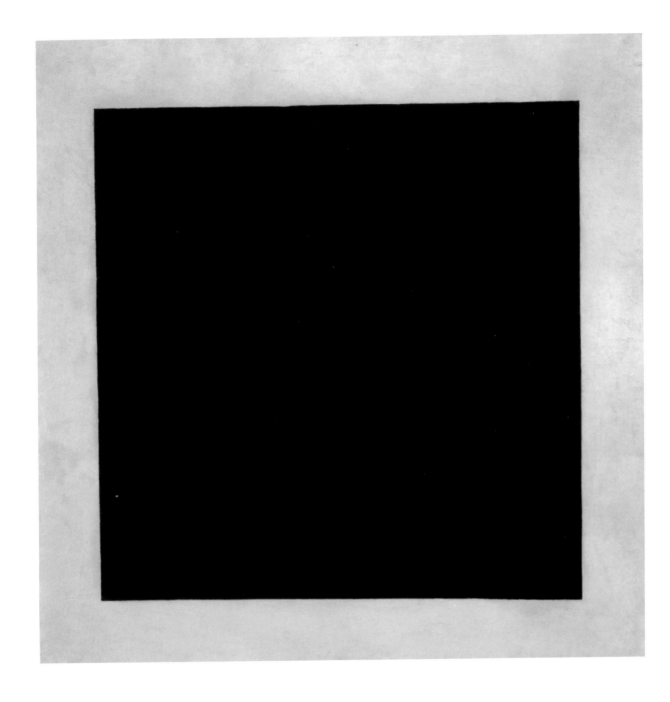

Henry Moore

Reclining Figure, 1929

Henry Moore settled in London in 1921 in order to continue studies that he had begun in Leeds. On the advice of Jacob Epstein he regularly visited the British Museum to study the art of non-European cultures. He was especially impressed by pre-Columbian Mexican works of art. During a stay in Paris in 1925, Moore saw for the first time a plaster cast of Chacmool, a Mayan rain god from Chichén Itzá, which was on display in the Palais Chaillot. (The 12th-century original can be seen in the National Museum of Anthropology in Mexico City.) This figure had already caught his attention in a photo published in a German magazine. He was so fascinated by it that its formal structure would become recognizable in many of the reclining figures which are a central theme in his oeuvre. In his essay "Primitive Art" (1941), he wrote about the significance of ancient Mexican art for his work: "Mexican sculpture, as soon as I found it, seemed to me true and right…. Its 'stoniness,' by which I mean its truth to material, its tremendous power without loss of sensitiveness, its astonishing variety and fertility of form-invention and its approach to a full three-dimensional conception of form, make it unsurpassed in my opinion by any other period of stone sculpture." The limestone figure of Chacmool lies with its weight resting on its arms. The knees are bent and the head is turned at a right angle to the body. From March to May 1929, Henry Moore sculpted a reclining figure of brown Horton stone in which his fascination for the formal structure of the Mayan rain god is clearly expressed for the first time. Here, finally, the Mexican influence is fully assimilated in his work, even if fundamental differences between the figures cannot be overlooked. Thus he transforms the model into a female figure and softens its hieratic severity. One arm is raised and supports the head, softly-formed breasts rise from the torso, and the legs are bent and rotated to the side, corresponding to the movement of the head and resulting in a more natural position. Through the rotation and position of the bent legs, the figure gains a formal rhythm which has something of "the energy and power of large mountains." Already in 1926 Moore created several recumbent figures which seem to be studies for the formal structure of the *Reclining Figure* of 1929. In the relief *West Wind*, which he made in 1928 for the administrative offices of the London underground system, the formal structure of the 1929 figure is already fully developed, as a sketch from 1928 makes clear. In the year following the creation of the 1929 *Reclining Figure*, Moore created another five reclining figures which are like variations on a theme and which are increasingly free interpretations of the original model's forms. Although Henry Moore cannot be counted among the great innovators in sculpture of this century, we must consider his work, in which the exploration of the human form is the artist's central theme, as some of the finest and most important achievements of 20th-century sculpture. *I. N.*

Garrould, A. (ed.). *Henry Moore: Drawings, Catalogue Raisonné*, Vols. V, VI. London, 1991.
Grohmann, W. *The Art of Henry Moore*. London and New York, 1960.
Henry Moore: Complete Sculpture, 6 vols. London, 1944–88.
Hofmann, W. *Henry Moore: Schriften und Skulpturen*: Frankfurt am Main, 1959.

Seated Woman in a Shelter, 1941

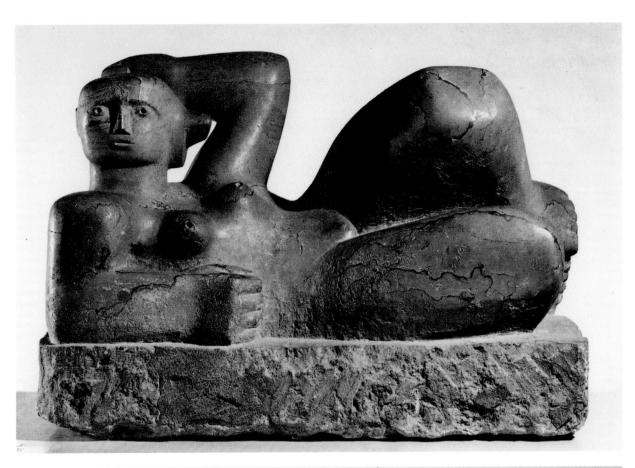

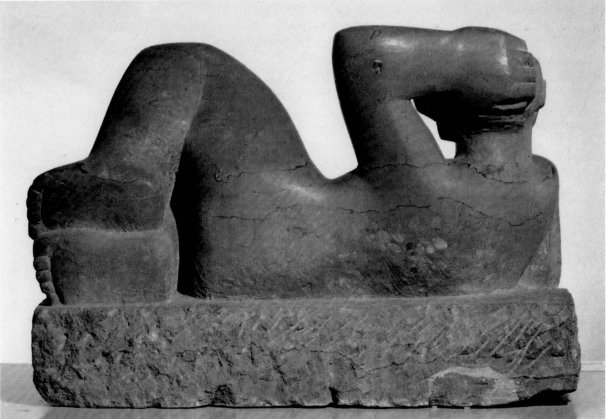

Lyonel Feininger

Market Church at Evening, 1930

The German-American Lyonel Feininger, who was born in New York, moved to Germany at the age of seventeen in order to study art. Only a few years later he was drawing caricatures and illustrations for both German and American newspapers and magazines. He exhibited jointly with the artists of the "Blaue Reiter" and "Brücke" groups from 1908, and in 1919 Walter Gropius summoned him to the Bauhaus in Weimar as a master of painting and graphic arts. **A**mong Feininger's most important works is the *Halle* cycle, a series of eleven paintings, twenty-nine drawings, and a woodcut that he created on commission for the local magistrate in 1929–30. The town placed a studio at his disposal in the tower of the Moritzburg, and later bought the entire series. **F**eininger approached his theme in an unusual manner for a painter, namely via the medium of photography. During his wanderings with a camera he always kept in mind the potential of a scene for later conversion into a picture. "There is sharp sun — colossal motifs are built up from the hard shadows and brilliantly lit surfaces — a new flatness of space results." Feininger was not just concerned with recording a certain subject so that he would remember it and have constant access to it; even in his photos he was seeking artistic effects that he could then seize on and develop further in pictures. For this purpose, too, he photographed against the light and took multiple exposures, techniques that at that time — in Feininger's words — "a photographic man of honor" would not have used. Even if he eventually rejected the method of painting from photographs because it was threatening to take him too far away from painting, it was an important experiment, and completely within the Bauhaus approach of using different types of artistic means and of employing various media. **F**or the painting *Market Church at Evening* there is a preliminary photograph, as well as a few drawings, in which Feininger lays the groundwork for the crystal-like breakdown of the subject. By treating all the elements of the picture as equals in artistic terms, Feininger "de-materializes" the architecture and the human figures and simultaneously "materializes" the deep blue area of the sky. He transforms the picture-postcard motif of the market church into an exciting pictorial composition not only by fragmenting and geometrizing shapes, but also by rotating the architecture slightly out of its axis and by shifting the focal point of the picture through the red-brown color zone of the Roter Turm (Red Tower), partially visible at the right of the painting. **I**n their transparent, crystalline structure, Feininger's architectural pictures mark an important point along the path followed by classical Modern painting from the dominance of the natural model to the autonomy of the subject. *E. H.*

Hess, H. *Lyonel Feininger*. Stuttgart, 1959.

Luckhardt, U. *Lyonel Feininger*. Munich, 1989.

Lyonel Feininger: Städte und Küsten — Aquarelle, Zeichnungen und Druckgraphik. Exh. cat. Kunsthalle Nürnberg. 1992.

Cyclists, 1912

Photograph of the Market Church from the East

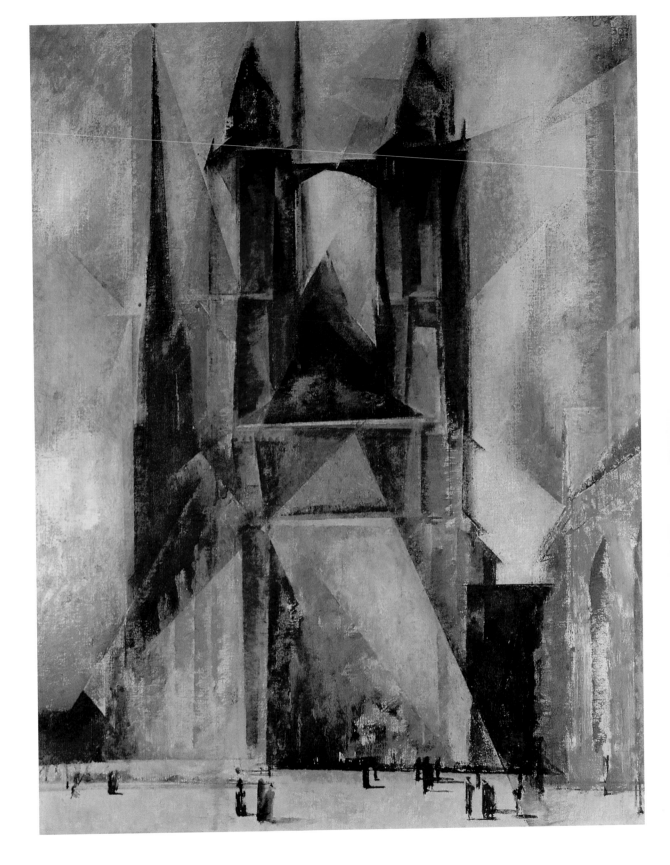

Oskar Schlemmer

Bauhaus Staircase, 1932

1888 Oskar Schlemmer is born on September 4 in Stuttgart, Germany

1905 Studies at the School of Arts and Crafts in Stuttgart

1906–09 Attends the Art Academy in Stuttgart

1911–12 Active as painter in Berlin; *Hunting Lodge in Grunewald*

1912 Pupil of Adolf Hoelzel in Stuttgart

1914 Together with Willi Baumeister and Hermann Stenner paints murals in the main hall of the Werkbund exhibition in Cologne

1914–18 Military service

1919 Founding member of the Uecht group in Stuttgart

1920 Called to the Bauhaus in Weimar by Walter Gropius

from 1923 Head of the stage workshop at the Bauhaus

1923 Designs murals and reliefs for the Bauhaus Workshop building

to 1924 Teaches mural painting and sculpture in wood and stone at the Bauhaus

1925 Sets up and heads the Experimental Theater Workshop at the Bauhaus in Dessau; teaches a course on Man

1928–30 Murals for the Volkwang-Museum in Essen

1929–32 Professor at the Academy in Breslau (Wroclaw)

1932 Teaches at the United State Schools for Fine and Applied Art in Berlin; paints murals for the Bauhaus staircase

1933 Dismissed from his Berlin post

1934 Moves to Eichberg in the Black Forest

1937 Moves to Sehringen near Badenweiler; works by him are shown in the "Degenerate Art" exhibition

1938–40 Works for a Stuttgart painting firm

1940–43 Works in a paint factory in Wuppertal; produces cycle of *Window Paintings*

1943 Dies on April 13 in Baden-Baden

With his painting *Bauhaus Staircase* Oskar Schlemmer created a symbol of hope from a youth spent between the two World Wars. Formerly a Bauhaus master, in 1932 he painted this composition in which he retrospectively summarizes his pictorial vision according to the "New Constructional Thinking." A sense of urgency resulting from the news that the Bauhaus at Dessau was to be closed due to pressure from the Nazis was enough reason for Schlemmer to paint this motif. "It is a scandal that the art world does not rise up and veto this act," he wrote to a friend on July 28, 1932. He wanted to proffer a veto of his own invention and fell back on the idea for a picture he had sketched at the end of his time in Dessau (1928); this was reminiscent of a photograph of Lux Feininger with female students of weaving pictured on the staircase of the Dessau studio complex. But, to turn a pencil sketch into the final color portrayal, via a watercolor version and a large-format "picture plan" on tracing paper, a major conversion process was required. Schlemmer makes it clear how, given the impact of current events signaling an end to the Bauhaus era, this first loosely sketched staircase scene increasingly takes on an explanatory role and intensifies toward a monumental finality. **F**rom the building blocks of his memory of Walter Gropius' boldly functional staircase, Schlemmer creates a pictorial architecture, flooded with light, in which the main tenets of his paintings in the 1920s are brought together. In the white, red, and black color harmony of the triadic central group (the fact that the colors are also those of the German Reich is no coincidence), surrounded by shades of blue in the windowed stairwell, the theme of "Man at the Center of Ideas" is once again combined with "Construction for the Future." **T**wo figures in profile lead our eye to a trio of rising figures viewed from behind; the former enter the picture from either side and introduce a dynamic feeling of movement. The upward striving of the figures climbing the stairs, which seems to be accelerated in the small figure above right, is countered by the strong diagonal of the banister. This results in a triangular spatial tension complemented by the central group in slight *contrapposto*. Two additional figures counter the upward movement almost unnoticed: the peripheral figure to the top right, on the point of descending, and the youthful figure seen from the front. It is hard for us to say where this figure comes from or is heading to, given its near-weightless dance-like pose. One final figure is present, lurking in the shadow behind the lowest window in the stairwell; it is looking towards the central figure of the rear-facing trio. This opens up the architecture into an imaginary free space, just as the picture space is conceived as a continuation of the actual room itself. **A**nd so a purified model is held up against everyday reality as a symbol of youthful striving toward a better future. At least Schlemmer managed to preserve the fundamental utopian concept of the Bauhaus as a "philosophy of life". **S**hortly after its completion, the painting was bought by the architect Philip Johnson for New York's Museum of Modern Art; hanging alongside Beckmann's triptych *Departure*, it has served as one of the two leading examples of German 20th-century painting in the collection. It also stimulated the artist Roy Lichtenstein to paint *Bauhaus Staircase Paraphrased* in 1988. *K. v. M.*

Oskar Schlemmer — tanz theater bühne. Exh. cat. Kunstsammlung Nordrhein-Westfalen. Düsseldorf, 1994.
Grohmann, W. (ed.). *Oskar Schlemmer: Zeichnungen und Graphik, Œuvrekatalog.* Stuttgart, 1965.
Von Maur, K. *Oskar Schlemmer.* vol. I: *Monograph,* vol. II: *Œuvrekatalog der Gemälde, Aquarelle, Pastelle und Plastiken.* Munich, 1979.

Mythical Figure, 1923

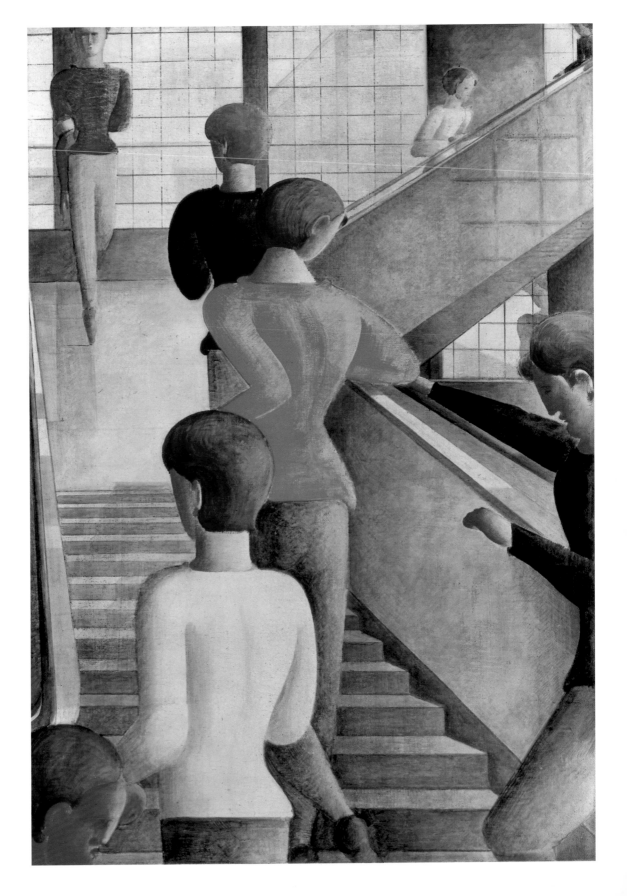

John Heartfield

1891 John Heartfield is born Helmut Franz Joseph Herzfelde on June 19 in Berlin

1908–11 Studies at the Kunstgewerbeschule in Munich

1913–14 Studies at the Art and Crafts School in Berlin's Charlottenburg; first contacts with Herwarth Walden and Pfemfert

1914–15 Military service

1915 Meets George Grosz for the first time

1916–17 In an anti-war gesture, he adopts the name of John Heartfield; together with his brother, Wieland Herzfelde, he founds the journal *Neue Jugend* and the Malik publishing house; commences a close working relationship with Grosz

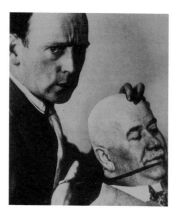

1918 Joins the Berlin Dada Society; becomes a member of the German Communist Party (KPD)

1919 Takes part in the first Dada exhibition in the Kunstkabinett Neumann in Berlin; together with Herzfelde and Grosz, he founds the satirical journal *Die Pleite*; creates Dadaistic collages (*Monteur Dada*)

1920 Dada performances with Raoul Hausmann, Baader, etc.; takes part in the First International Dada Fair in the Burchard Gallery, Berlin

from 1920 Designs stage sets for Piscator's *Proletarian Theater*

to 1922 Head set designer for Reinhardt stages in Berlin

1922 Editor and designer the satirical Communist Party journal *Der Knüppel* (*The Cudgel*)

1924 Creates the photomontage *Fathers and Sons — ten years on*; co-founds the "Rote Gruppe" (Red Group)

from 1927 Works for the Communist Party's Graphics Section, designs posters

1929 Takes part in the International Werkbund Exhibition "Film and Photo" in Stuttgart; works with Kurt Tucholsky on the book *Deutschland, Deutschland über alles* which contains both text and pictures

1930 Begins working on the *Workers' Illustrated Journal* (AIZ)

1931–32 First stay in the Soviet Union

1933 Emigrates to Prague

1935 Exhibits in Paris

1938 Flees to England

1939 Exhibits in London; becomes a member of the "Freier Deutscher Kulturbund"

1940 Imprisoned

1950 Returns to Germany; works as a book designer and stage-set designer

1962 Publication of Wieland Herzfelde's monograph on his brother

1968 Dies on April 26 in Berlin

During his exile in Prague from 1933 to 1938, John Heartfield created 235 photomontages, including one a week in the form of a copperplate photogravure for the *Arbeiter Illustrierte Zeitung* (*AIZ*). The aim of all these works was to expose and indict the social demagogy of Fascism, the visual propaganda of which — disseminated through seemingly authentic press photos — implied a historical truth. Heartfield pursued his goal by combining parts of different photos with each other, sometimes altering the scale in the process; by juxtaposing the past with the present; and by introducing X-ray pictures, paintings, drawings or occasionally even posed photos created according to his own precisely drawn pencil sketches. These works were always a reaction to some topical political event, such as the Reichstag fire trial or the Spanish Civil War. The surprising and incredible nature of the visual ideas precludes any confusion with manipulated or forged pictures. Because they were accompanied by short descriptions — often written into the works themselves — and as a result of the satirical allegory and antithetical grotesque they contain, Heartfield's photomontages are still comprehensible today without any historical explanations. **H**eartfield was influential in shaping the avant-garde Dadaist movement. Like George Grosz, Raoul Hausmann, and Hannah Höch, he experimented with collage, montage, and photography. In 1919, together with Grosz, Heartfield created the first Dadaist collages; and in 1924, he developed the first photomontage on the history of his times, anticipating the slogan he was later to formulate: "Use photography as a weapon!" (Franz C. Weiskopf, *AIZ* 37/1929). He attained the peak of his powers as an exponent of political photomontage in 1933–34. **H**eartfield elevated photomontage to the status of a classical genre of 20th-century printed art. The originality of his work does not lie in the skills of hand cutting and pasting, but (as in the case of Max Ernst's collages) in the printed graphic end product. Heartfield's aim was not an elitist work of art, but mass distribution in newspapers and books. This kind of art acquires a new functional definition: "Instead of being based on ritual, it is based on a different experience; i.e. it is based on politics" (Walter Benjamin). Heartfield exerted an influence on a number of mass media, such as magazines and posters, and on the art of books. *L. L.*

Revolution und Realismus: Revolutionäre Kunst in Deutschland, 1917 bis 1933. Exh. cat. Staatliche Museen zu Berlin. Berlin, 1978.

Evans, D. *John Heartfield, AIZ/VI 1930–38.* New York, 1992.

Heartfield, J. and K. Tucholsky. *Deutschland, Deutschland über alles.* Berlin, 1929.

Berlin Calls for the Olympics, 1936

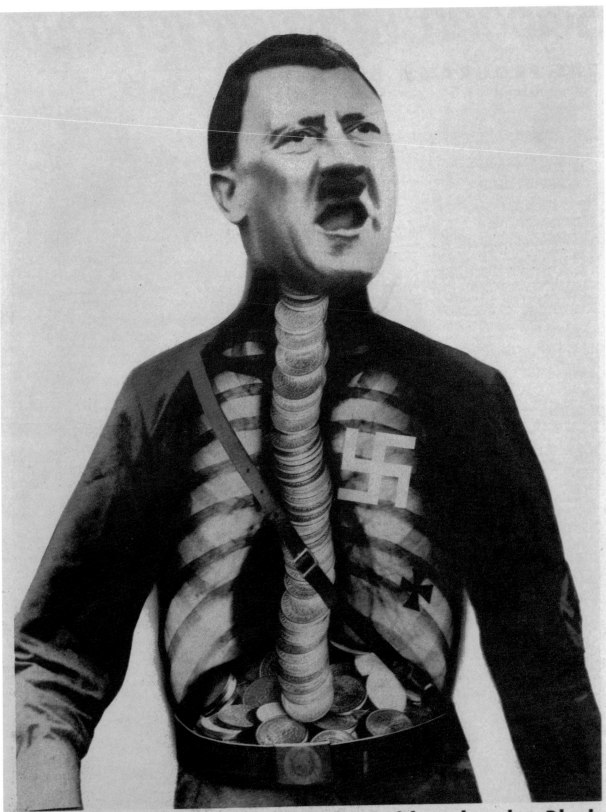

ADOLF, DER ÜBERMENSCH: **Schluckt Gold und redet Blech**

675

Balthus

The Street, 1933

"I used to want to shock, but now it bores me." Balthus, who was often accused of having "a fanatic interest in nymphomania," was successful in his aim of provocation. His depictions of young women in lascivious poses did indeed shock visitors at his first exhibition in Paris in 1934. For many years, no one dared to buy *The Street*, a generally acknowledged early masterpiece. Only in 1937 did the art dealer James Thrall Soby purchase the painting and pass it, his brow beaded with nervous perspiration, through American Customs. Later, fear that his nine-year-old son's playmates might report the picture to their parents forced him to take the painting off the wall. Today we cannot quite understand what was so scandalous about this scene — a city street, in which a young man grabs a young girl between the legs — which filled Balthus' contemporaries with such indignation. Balthus even changed the picture to make it somewhat more acceptable by painting over the man's hand and repainting it in a less provocative position. **W**hat, then, is it about this work that we still find so disturbing today? At first glance it shows nothing more than "a peaceful morning in a peaceful neighborhood in which peaceful citizens go about their business" — rue Bourbon-le-Château in Paris' fifth arrondissement, where Balthus had his studio. In the street we see two women, one carrying a child, a girl playing with a ball and a racket, a young boy, the wooden cut-out of a cook set outside a restaurant, a workman, and the aforementioned young man and girl. Yet in contrast to the first, still quite impressionistically rendered 1929 version of *The Street*, which does in fact express calm and serenity, the scenery of the 1933 painting seems strangely frozen, the individual figures are isolated and lifeless, the light is cold, even leaden. No figure meets or makes eye contact with another. Strangely surreal gestures and facial expressions mark an utterly unusual moment which we would normally never register consciously among the other moments. Is this a picture puzzle out of a dream? Balthus, the great voyeur, always withdrew from voyeuristic interest in his own person: "Balthus is a painter, about whom *nothing is known*. Let us now turn to his paintings. Greetings, Balthus."

E.F.

"When Balthus began work on *The Street*, he was still strongly influenced by the painting of the Quattrocento, which had impressed him during a trip to Tuscany in 1927. The same little man with the round head and wide, staring eyes who is walking towards us in a rather robot-like manner in *The Street* emerges out of the background in the fresco in the Florentine church of Santa Maria del Carmine — in which Masaccio depicted the story of Theophilus in 1427 — just like he is emerging out of the background of Rue de L'Echaudé on a summer afternoon in 1933. This figure seems to belong to this momentary snapshot of the atmosphere of pre-war Paris as much as to a caesura in the history of painting. **T**he girl with the half-raised arms and spread fingers is depicted in the same gesture, full of tension, as the figure with blond curls that Masolino had painted in Castiglione d'Olona five centuries earlier. The girl is trying to evade the grasp of the young man, and her profile reproduces the security and classical purity of a maidservant of the Queen of Sheba, as painted by Piero della Francesca in Arezzo."

Jean Clair

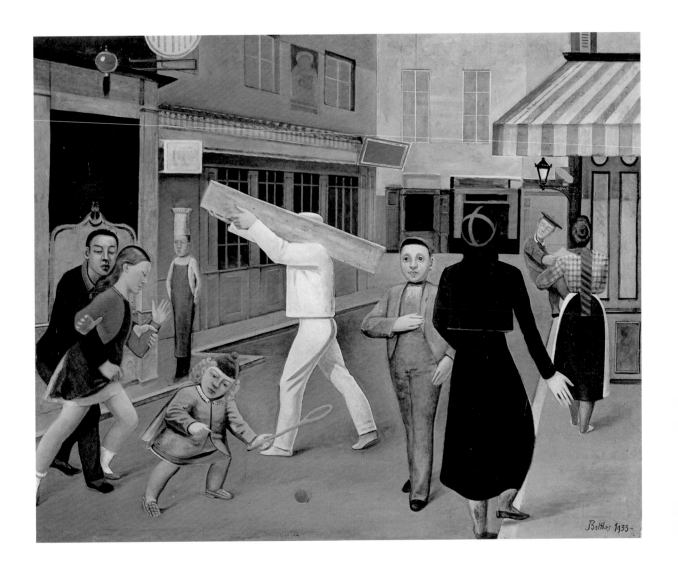

Fernand Léger

The Two Sisters, 1935

In their unbudging pose, Fernand Léger's monumental pair of women stand as if firmly rooted in place. Their massive bodies seem almost to burst the bounds of the picture. Léger's depiction lacks virtually everything one might expect of a pair of nudes. There is no trace of feminine charm, no sense of eroticism, not even warm-toned flesh. Devoid of all individuality, with their block-like, thickset bodies and bulging, deformed extremities, the two heroines resemble some archaic monuments of a long-forgotten age. Facing the observer in motionless solemnity, they stand waiting in front of a sunny yellow planar background that lends their massive bodies an even greater sense of volume. They might almost be assembled from a set of parts. Their simple, bold contours dominate the picture without any hint of aestheticizing *peinture*. Forms, colors, and lines recur, adopt a common rhythm and thereby create an impression of fellowship, affection, and solidarity. This impression is strengthened by the act of presenting the flower. In Léger's picture, the flower is not, in the first instance, a symbol with an iconographic content. It represents a *contrast des formes*, a contrast that emphasizes the formal differences in a most exciting manner. The prickly thorns and the small-scale forms of the flowers and the branching stem appear fragile and ephemeral — one might even say, nervous and aggressive — seen against the background of this gigantic pair of women. After 1910, Léger developed his own concept of Cubism based on the ideas of Cézanne. He attempted to dissect the objects in his pictures into cylindrical volumetric elements or "tubes" and to emphasize contrasts of form. Léger, who had an unshakable belief in a future socialist society, profoundly mistrusted anything emotional, irrational. His figures are devoid of all emotions. They are stereotypical representatives of a collective order. *The Two Sisters* was painted at a time when Léger was busy executing commissions for theater sets and murals. The basic theme of these works is solidarity amongst the anonymous members of a mass society.

W. Spr.

Fernand Léger. Exh. cat. Kunsthalle der Hypo-Kulturstiftung München. Munich, 1988.

Kosinski, D. (ed.). *Fernand Léger: The Rhythm of Modern Life.* Munich, 1994.

Schmalenbach, W. *Fernand Léger.* New York, 1976.

The Builders, 1950

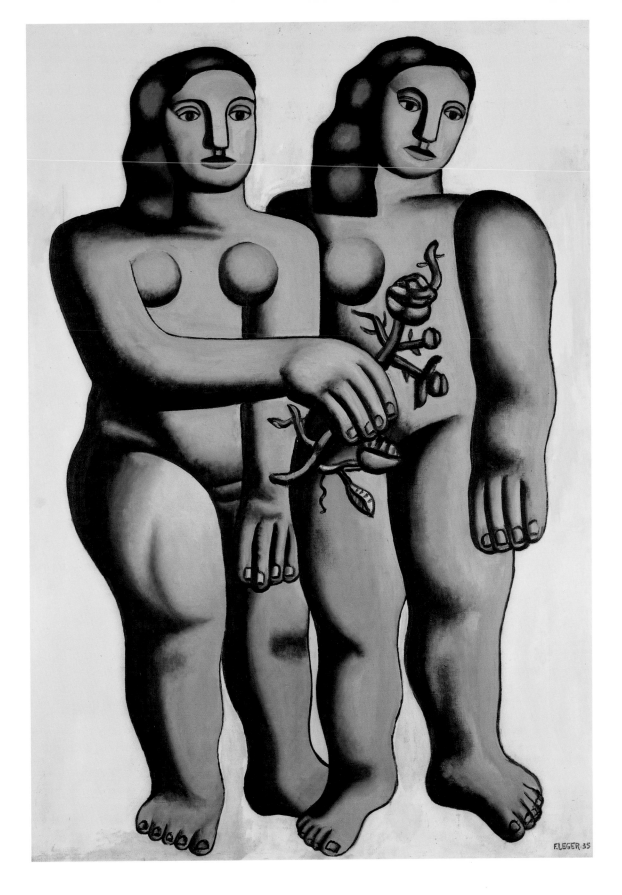

Georges Rouault The Old King, 1937

In Georges Rouault's early work, aspects such as fear, the unremitting depiction of the weakness and frailty of mankind and the, at times, pitiless reality of human existence prevail. Rouault portrays prostitutes, small-time crooks, people in flight, refugees, the squalor of the suburbs, the misery of mothers with large families, and the life of wandering show people and gypsies. All of them he depicts in somber colors, often with vehement brushwork that gives expression to a sense of brutal ugliness. Rouault's aim is not to shock, not to initiate a formal revolt. It is an inner outcry — this is the way he has to paint. That is why the claim these works make is absolute, the accusation unrelenting. Implicit to this revolt against the disarray of the world, however, is a search for the true order that underlies all things. Contained in Rouault's revulsion at deceipt and lies is a wish for absolute truth. In his expression of horror at the disfigured and the maimed is a yearning for an unassailable harmony. Rouault's art is like an unremitting accusation against the *Zeitgeist*, against social ethics. Even in these early pictures, it is evident that he is searching for a type, a prototypical, individual figure; and his questions are not sociological, but of a fundamental nature. His concerns are the fallen state of the human race, the burden of sin, and the profound deformation of man's being — as his pictures of prostitutes, for example, show impressively. Around 1911–12 Rouault's vision undergoes a change. The previous contrast between coloration and draftsmanship, which had proved so effective stylistically, is abandoned. A subdued sense of harmony reveals itself in his work — painted, however, in increasingly bold colors — and Rouault begins to seek the inner structure of beauty. As in a slow process of maturation, through constant repetition and, on occasion, with an insistence bordering on obduracy, he now attempts to attain a greater degree of validity, a state of inward growth, so to speak, to heighten the universality of his statement and to intensify his expression. In terms of the content of his pictures, Rouault manages to achieve the desired objectification through the Incarnation and the Passion of the Son of Man, which become the focus of his thinking and through which human existence, including the aspect of sorrow, acquires a meaningful dimension and dignity. The formal process of objectification occurs through a compression of forms and lines, through a restriction of his works to a few large-scale pictorial elements and a few expressive gestures and poses on the part of the persons portrayed, through the avoidance of narrative elements, through the exemplary nakedness of the figures, who now reveal a purely human aspect stripped of all superficial attributes; and finally, more and more, through Rouault's concentration on the human face, which becomes the summation of a personality, and in a quite special way on the face of Christ as the absolute summation of human attributes, as the true image of man. Thus, the *Sainte Face* comes to assume a central role in Rouault's later work. *S. K.*

Chapon, F. and I. Rouault. *Georges Rouault: Œuvre Gravé*, 2 vols. Monte Carlo, 1978.
Georges Rouault: The Early Years, 1903–1920. Exh. cat. The Royal Academy of Arts. London, 1993.

Head of a Tragic Clown, 1904

Meret Oppenheim

Object: Breakfast in Fur, 1936

Meret Oppenheim frequently used to recount how her famous fur-lined cup came into being: it was a whimsical tale that even involved the magician Picasso. Despite her rapid *succès de scandale* in the Paris of the 1930s — thanks to Man Ray's nude photographs of her — the young painter had to struggle to earn a living with fashion and decorative work. She had the idea of creating bracelets made of metal and covered with fur for Schiaparelli. These creations were much admired by the artists who used to frequent the Café de Flore, including Dora Maar and Picasso, and the latter began to speculate on other objects that could be covered in fur. "This saucer — and the cup too ..." suggested Oppenheim, whereupon, inspired by the idea, she went out and bought a cheap cup, saucer, and spoon, covered them with Chinese gazelle hide, and showed them in 1936 in two Surrealist exhibitions. The artifact reduced to a monster soon ended up in the Museum of Modern Art in New York, whose director, Alfred Barr Jr., realized it was to become a milestone in 20th-century art, an icon caught between Dada and Pop Art, in which artifacts were removed from their ordinary contexts and converted into aesthetic, demonized, ironic — and ultimately banal — objects through a process of alienation. The metamorphosis of an everyday artifact with pleasant associations into a hairy object with animal overtones, mocking its former purpose and implying a "function" of another kind, met with a mixture of shock, irritation, and annoyance — despite its playful, witty presentation. It triggered, of course, all sorts of tantalizing erotic associations, which André Breton subtly expressed in entitling it *Déjeuner en fourrure (Breakfast in Fur)*, with its reference to Manet's frivolous painting *Le Déjeuner sur l'herbe* and Sacher-Masoch's book *Venus in Furs*. Oppenheim's work during this period is full of socially critical overtones and psychological traps — often of a sexually pathological nature — that alternate between esprit, irony, poetry, and melancholy. The white, stiletto-heeled shoes served up like chicken thighs in paper frills and entitled *My Nurse*, or the *Stone Woman* on the beach, whose body continues into the water in the form of a mermaid, are Surrealist aphorisms that nevertheless offer wide scope for interpretation. Even in the later stages of her artistic development, Meret Oppenheim remained highly individualistic, independent, and mercurial. It was, therefore, all the more unfortunate that for decades the public associated her with the fur-lined cup. In 1970, when a gallery owner requested her to produce it in multiples, she made it into a kitschy souvenir — thus sardonically bridging the gap between Surrealism and Pop Art.

L. Sch.

Curiger, B. *Meret Oppenheim: Defiance in the Face of Freedom.* Zurich, 1990.
Meyer-Thoss, C. *Meret Oppenheim: Buch der Ideen, Frühe Zeichnungen, Skizzen und Entwürfe für Mode, Schmuck und Design.* Bern, 1996.

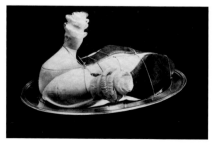

My Nurse, 1936

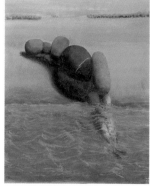

Stone Woman, 1938

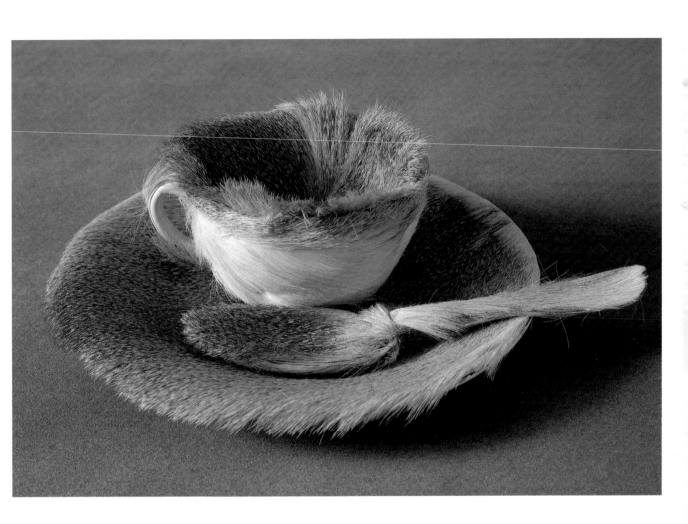

Salvador Dalí

Soft Construction with Boiled Beans, 1936

The epoch of the two World Wars and civil war in Europe made Spain between 1936 and 1939 the showplace for an ideological test of nerves. The painting *Soft Construction with Boiled Beans*, which already for its first showing in New York in 1936, bore the additional title *Premonition of Civil War*, fulfills a criterion of all important art: personal artistic language proves to be as if predestined to express the spirit of a particular time and country. The individual development of the artist — a shift from an obsession with carnality and eros to a type of death wish — coincides with a collective development. Along with Picasso's *Guernica*, Salvador Dalí's work can be counted among the few historical paintings of the 20th century. While Picasso's painting represents a reaction to a particular date — April 26, 1937 — *Soft Construction with Boiled Beans* is the illustration of a prophecy. Dalí diagnosed the early symptoms of a country at war. The Spanish army did not rise up out of the blue under General Franco on July 17, 1936, against the parties of the popular front. They were motivated by the assassination of the monarchist politician Calvo Sotelo on July 13, to whom the Communist, Ibárruri, had called out in parliament: "That was your last speech!" The elections of February 16, 1936, had resulted in a polarization of right and left and a general disappearance of a political center. In the following months, the revolutionary situation escalated with cases of arson and assassination attempts. On July 25, in Bayreuth, Hitler authorized the deployment of transport planes to back Franco. Dalí's allegory of Spain shows the body of the people deformed by extremist movements; its center is markedly empty. At the lower left, a doctor tries resuscitation by cardiac massage, but in vain. **W**ith both an anarchist and a monarchist soul in his own breast, Dalí could understand the war as the struggle of powers which oppose each other yet ultimately belong together. Chaos battles against order, hardness against softness, the raw against the cooked, biology against geology, farm workers against powerful landowners, red against white, republic against nation. White beans and excrement are sarcastic symbols of politics as a flatulent process concentrating on working lunches and on that which comes out afterwards. With merciless clarity Dalí denounces the wildly fanatic cruelty, the carnage, the atavistic barbarianism of the civil war — a country tearing itself to shreds.

R. Sch.

400 obras de Salvador Dalí, 1914–1983. Madrid, Barcelona, 1983.
Descharnes, R. *Salvador Dalí*. Cologne, 1974.
Descharnes, R. *Salvador Dalí. Sein Werk — sein Leben*. Cologne, 1984.
Schiebler, R. *Dalí: Genius, Obsession and Lust*. Munich, 1996.

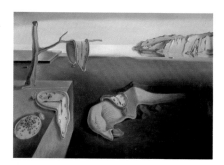

The Persistence of Memory, 1931

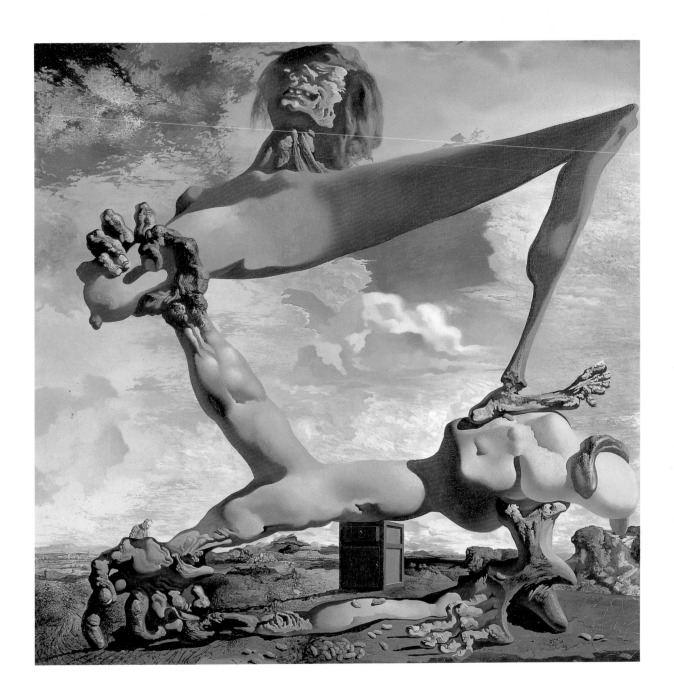

Max Beckmann

Departure, 1932–33

When Max Beckmann began his first triptych at the age of fifty in May 1932, he was at the zenith of his success: large retrospective exhibitions and important museum purchases of his works had made him one of the most prominent German artists of his time. Apart from his home in Frankfurt, where he held a professorship at the renowned Städelsche Art School, he had an apartment and studio in Paris. The choice of the monumental triptych format is an expression of Beckmann's confidence that he was mature enough as an artist to handle major programmatic works. A year and a half later, as he was completing *Departure*, the situation had totally changed. He had been dismissed from his professorship, and the Nazis had forbidden him to exhibit his works. He was finally forced into exile in 1937, although his position as an artist was clearly no longer questioned. With *Departure*, Beckmann created a new genre for his art. Triptychs — ten in all, of which one was to remain incomplete — became from then on a type of *leitmotif* in his work. *Departure* shows a world of glaring contrasts, dealing with contemporary history, the battle of the sexes, and myth. Scenes of violence and bondage take place in windowless interiors on the side wings of the triptych. On the left, a torture scene seems to allude to the contemporary socio-political situation; on the right, the violence and oppression committed by human beings against each other are metaphorically linked to the relationship between the sexes. The central panel contrasts these scenes of disaster with an image of shining blue and infinite distance as an illustration of mythic timelessness. The archetypes among the boat's crew embody different aspects of this vision of deliverance and present basic elements of the human pysche: the warrior in his deep red cloak and masked anonymity as an archaic, carnal being; the king in cool blue as a personification of civilization, rationality, and sovereignty. A young mother and child act as intermediaries between these two poles, an allusion to the Christian Madonna as a religious ideal of redemption. With her Phrygian cap, however, the woman is at the same time a secular symbol of freedom from the time of the French Revolution. Finally, the water signifies purification, a new beginning — a symbol that has been handed down in the Flood myths of the most diverse cultures. *Departure* is one of the first mythological pictures that Beckmann created after his socio-critical works immediately following the First World War (compare, for example *The Night*) and his "Neue Sachlichkeit" phase during the 1920s. Such pictures were to become ever more important in his oeuvre. Compared to the works of — for instance — Picasso, Beckmann's works not only deal with the theme of myth, but in their pictorial language also make use of mythological structures. In this sense, they not only illustrate myths but are mythical pictorial inventions in their own right.

R. S.

Beckett, W. *Beckmann and The Self*. Munich, 1997.

Schulz-Hoffmann, C. (ed.). *Max Beckmann: Retrospective*. Exh. cat. Munich, 1984.

Self-Portrait, 1950

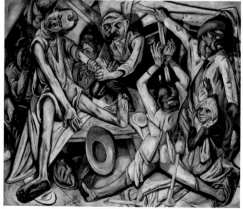

Night, 1918–19

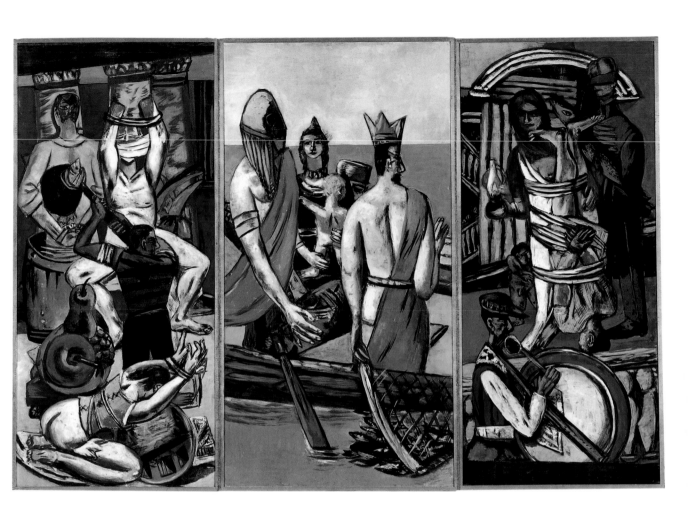

Pablo Picasso
Guernica, 1937

For Biography and Bibliography see page 28

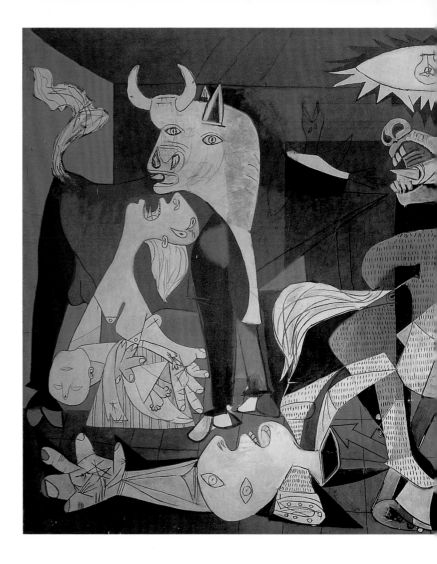

The painting *Guernica* holds a special status among the works of Pablo Picasso. Here, the art of the 20th century, which had for the most part turned away from narration thanks — not least — to Picasso himself, seemed to rediscover a form with which to illustrate political situations. In the art of this century there are only a few pictures that stand apart to such an extent. It is a history painting, linked by its title to a particular event which, in the anonymity of the cumulative disasters of our century, might otherwise have disappeared into oblivion. The news of the bombing of the Basque city of Guernica in 1937 challenged Picasso to paint a picture which would be a clear declaration of his sympathy for the republican cause. He knew that he could not avoid this task presented to him by contemporary history. **P**icasso prepared for his painting with numerous sketches. For those who wish to fathom and trace the logical development of the picture concept, the thematic material that first catches the eye gives no references to link the painting specifically to what happened in Guernica. A horse, a bull, a woman carrying a light, Pegasus leaping from the flank of the mortally wounded horse: these are all motifs which were already familiar in Picasso's work and which were predominant, above all, in his drawn and printed work of the mid-1930s. What seems decisive, however, is the new way in which Picasso now uses these elements. He makes use of Cubism. With it, he contrasts the message of the painting's contents — the individualization of faces, which are traceable in some sheets of work from the 1930s — with that which Cubism of necessity accomplished:

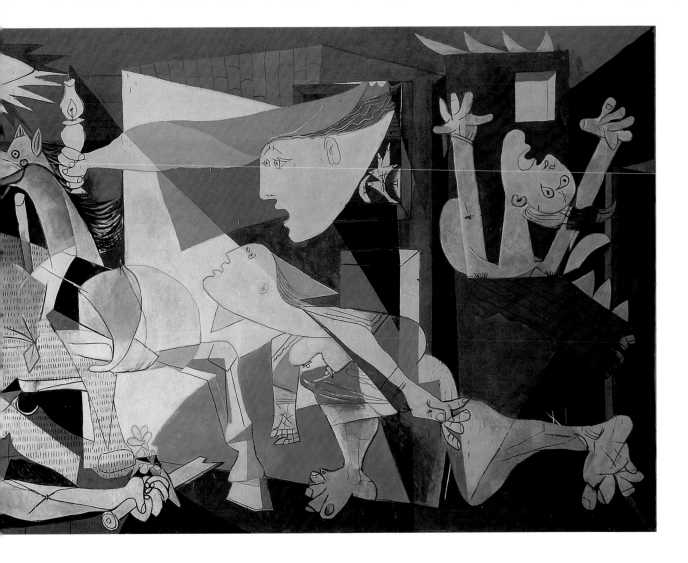

an anti-realistic transformation of real forms. This return to Cubism was new, the result unusual.　　We must continually remind ourselves that, with *Guernica*, Picasso was carrying out a state commission for the first time, and that he created this picture for a specific place: the Spanish pavilion at the Paris Exposition Universelle, which guaranteed it a massive amount of publicity. 1937 was the year when the city of Guernica was razed to the ground by German intervention troops. In the same year, the exhibition "entartete Kunst" (Degenerate Art) in Munich pronounced the death sentence against all art movements related to the work of Picasso and the avant-garde. One thing becomes clear from reactions to the painting: as a monumental main painting for the Spanish pavilion Picasso painted a representation which could be termed a requiem, a Passion scene, an image which stands in the tradition of great secular scenes of suffering beginning with Goya's *Tres de Mayo* and continuing with works by Géricault, Delacroix, down to Dix and Grosz. In all of these images the victims are treated as heroes. Victories, collective war gains, give way to representations of individual suffering.　　The scene stands in a light — in colorless grisaille — which symbolizes the eruption of horror. And the longer we observe the picture, the more we feel that something oppressive is expressed in the compressed horizontal picture format itself. Our eye is almost constantly directed upwards, movements are oriented upwards but knock into the upper edge of the picture. Here we do not see the struggle of man against man; the picture is only the documentation of destruction. The cause of this destruction lies outside the picture space, namely — this is communicated by the compressed, narrow, stage-like space — from above the picture. All motifs and compositional elements point to the source of the disaster: the sky, which here is a realm from which not deliverance, but destruction, comes. Thus Picasso gave his response to the historical event. He began with the anonymity of technical annihilation — and the technical aspect of the destruction in Guernica made this painting a negative contribution to the theme of the Exposition Universelle, "Technology in Modern Life." Picasso's painting was a visual criticism of the technology which was otherwise celebrated there. This statement is so strong and original that *Guernica* can with justification be termed a history painting of a new kind, one which recognizes the perversion of the belief in progress and stigmatizes it in view of its disastrous consequences.

W. S.

Max Ernst

L'ange du foyer, 1937

Max Ernst painted *L'ange du foyer* in 1937 while suffering from the shock of the Spanish civil war and the threat of National Socialism. It was a shock which affected his existence. In his autobiographical notes, he wrote: "Cette année 1933. Max Ernst est mis sur la liste des proscrits du régime nazi." The menacing danger which emanated from the Hitler terror is reflected in a whole series of pictures and motifs which appeared in his work throughout the 1930s. 1937 saw another break in his life and work; the "Degenerate Art" exhibition denounced Max Ernst's principal work, *Schöne Gärtnerin*. It was used in this exhibition to illustrate the category "Mockery of the German Woman." The title under which *L'ange du foyer* was originally published, *Le triomphe du surréalisme*, expresses resistance against this aesthetic alienation. Max Ernst's double reaction — to the political events in Spain on the one hand and the cultural policy of the National Socialists on the other — finds expression in this picture. Years later, he explained it as follows: "After the defeat of the Republicans in Spain, I painted *L'ange du foyer*. This is, of course, an ironic title for a kind of steamroller which destroys and annihilates everything that crosses its path. That was my impression at that time of what would happen in the world, and I was right." This information which clearly relates *L'ange du foyer* to an event in world politics is important, although the Communists denied that the Surrealists were thus involved in politics. The avant-garde of this century have abolished the painting of historical scenes just as they have abolished the complex allegorical or narrative program. In this light, it is fascinating to see that the only historical pictures of our age that are worth mentioning are those that seek to grasp their subject not by means of realistic reproduction but through the use of symbolism. When asked about the means used for *Guernica*, Picasso answered "J'ai utilisé le symbolisme." This iconographic method corresponded to the program of surrealist painting. This was the only way of finding an equivalent for terror and panic. The work of Max Ernst remains the most direct indication of the connection between an ecstatic element in painting and anti-civilizatory ideas. *La planète affolée* continues this in the early 1940s. The drip method, which emerged then, served as a technical model for Jackson Pollock and Abstract Expressionism. *L'ange du foyer* follows a series of works in the mid-1930s. The amount of indirect techniques, of *frottage* and *grattage*, used in these decreases. And increasingly, a style of painting becomes dominant which generally characterizes the veristic surrealism of these years. The technique intensifies the penetration of the "household angel," of an apocalyptic being which pounces on the observer. It has a more real and unambiguous appearance than the whirlwinds and hordes of the *grattage* pictures. Against the background of the times, Max Ernst corrects the Nietzschean character of the horde pictures by cashing in on the added value of automatism. *L'ange du foyer* has a clear message. Seen in this way, it is closer to Böcklin's *Die Pest* or Kubin's *Der Krieg* than to Ernst's ecstatic, open early works. *W. S.*

Camfield, W. *Max Ernst: Dada and the Dawn of Surrealism.* Munich, 1993.

Schneede, U. M. *Max Ernst.* Stuttgart, 1972.

Spies, W. (ed.). *Max Ernst: Œuvrekatalog,* 7 vols. Houston, 1975–91.

The Dressing of Bride, 1940

Capricorn, 1948

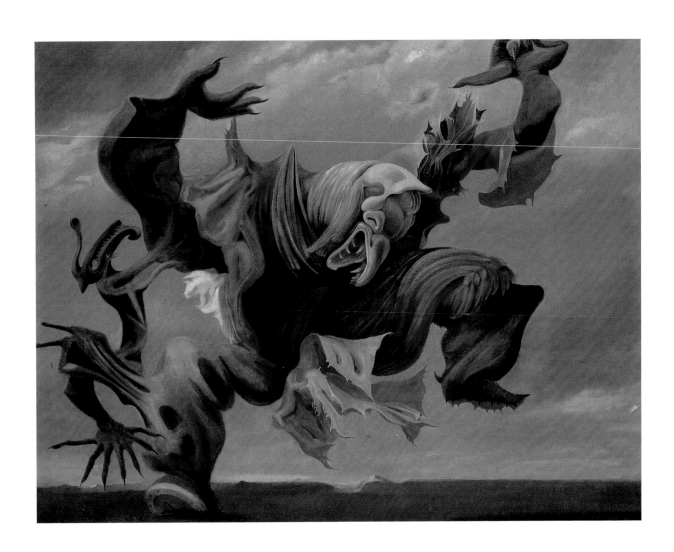

Joan Miró

Sitting Woman I, 1938

Joan Miró's highly disputed painting, *The Farm*, is a key work from his early artistic period. In 1957, thirty-five years after its creation, Miró wrote in a letter to Jacques Dupin — his biographer and friend — that it is his "most important painting from this period" and that it was a source of inspiration to all. In completing this reverberating, stylized genre painting of the countryside in his Paris studio in 1922, Miró brought his early period to a close. He marked the conclusion of his phase of Magical Realism with this confessional painting — a declaration of love for the simple country life and for Montroig, the small village south of Tarragona on the Costa Daurada, which to him was synonymous with his family's country estate, "Mas Miró." This was where the artist, in his youth, discovered nature and rural life, both of which were to impinge on his creative process and ultimately his art. **T**he almost toy-like *Farm* is modeled on the Miró family's magnificent country estate situated in the foothills of the Montroig massif. Miró's mother purchased it as a holiday residence for the family, which otherwise resided in Barcelona, but especially with her son Joan in mind, who at that time was suffering from typhus fever. Thus, from the age of eighteen, Miró spent several months in Montroig every year. This was where he began to paint the model farm with the utmost meticulousness, pedantry, and diligence. For nine months he worked on the painting between seven and eight hours a day, continually making changes to it. Its realism is formalistic, and its distinguishing characteristic is its lifelessness. It depicts nature as if taken from a text book. It would seem that Miró had a picture book in mind. In both style and motif, *The Farm* represents a model farmhouse and everything that would be thought to belong to such an estate is also depicted in the painting — from the various animals, to the well, to the washing basin in front of the Estanca, the great reservoir. To his friend Rafóls, Miró claimed not to have forgotten anything in it. Anyone who examines the picture carefully will undoubtedly agree. Even the small "Caganer" figure is included, the Catalonian equivalent of the Belgian "Manneken-Pis," which, with its trousers down, represents the fertility of the earth. **M**iró was a *homo ludens* and delighted in toys. In his studio at Montroig he had a virtual miniature theater made of paper cut-outs. He grew up with these objects, which gave him a great sense of nostalgic joy throughout his life — even in his later years. **S**itting Woman I of 1938 is an example of how, from these small forms, Miró developed his later characteristic pictorial idiom.

B.C.

Catoir, B. *Miró on Mallorca*. Munich, 1995.

Gimferrer, P. *The Roots of Miró*. New York, 1993.

Jarry, A. *Oeuvre complètes*. Paris, 1972.

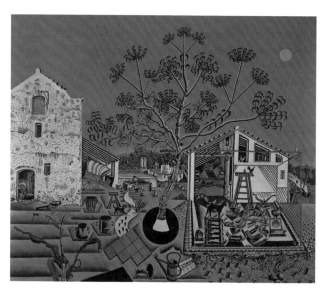

The Farm, 1921–22

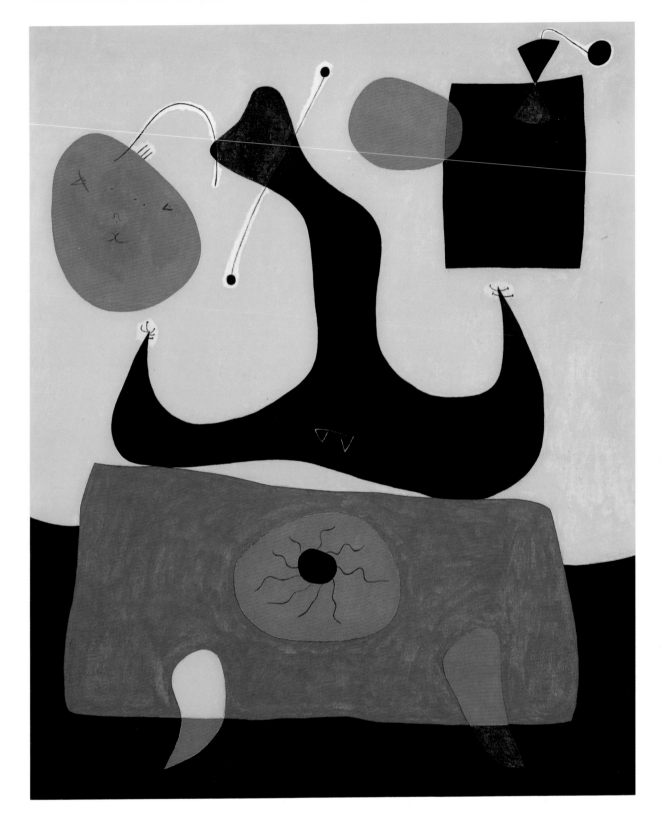

Constantin Brancusi

Bird in Space, ca. 1940–41

In 1933 Constantin Brancusi gave his exhibit in New York's Brummer Gallery — *Bird in Space*, dating from 1925 — the subtitle *Project of a Bird that, Enlarged, Will Fill the Sky*. For a long time Brancusi had had a desire to execute one of his "Bird in Space" sculptural series in an extremely large format. Taken with the appearance of obelisks and the American Statue of Liberty, he wanted to create a sculpture that could be seen from a great distance. The first opportunity to realize this desire arose in 1926. The plan was to place a sculpture around 3.5 meters high in the garden of the Villa Noailles at Hyères on the Côte d'Azur — in the design of which several well-known artists were involved. In a second, even larger project Brancusi proposed a height of no less than 50 meters. But evidently he threw out these plans because of the uncompromising demands he made on the material and surface finish of his sculptures — he thought this might not be carried out properly. The almost eighty-year-old Brancusi turned down the offer of an alternative site in front of the UNESCO Building in Paris when he received a highly polished steel ball as a sample of material and discovered on it a tiny area of damage. **F**or four decades a central theme in Brancusi's work was the bird, the flight of the bird upwardly rising, a symbol of the soul's liberation from matter. In all, the series consists of twenty-nine bird sculptures, all variations of *Maiastra*, the *Golden Bird*, and *Bird in Space*. This is a series searching for the definitive form; as Brancusi said: "Flight has preoccupied me all my life." **L**ike other contemporary artists, he set his search in the archetypal and mythological pictorial worlds. The very title of his *Maiastra* sculptures points to a mythological background: the bird Pasarea Maiastra is found in Romanian folklore, where it bestows health and youth. **P**laced in a garden in Voulangis around 1913 and repeatedly set up in his studio, the statues on their tall pillars are clearly related to Romanian burial columns on which a bird symbolizes the soul rising to heaven. Brancusi's extremely slender, vertical bird shapes emphasize this upward movement. Although the *Maiastra* sculptures still retain the physical form of birds standing proudly upright, the *Bird in Space* and *Golden Bird* sculptures appear completely free of corporeality, representing no more than the upward flight of a bird. **T**here is a further allusion — to the phoenix of legend, which in its rise out of the fire symbolizes eternal rebirth and the relinquishment of the material world. *Bird in Space* reflects this in its ethereal appearance; the highly polished surface, in some versions a shimmmering golden bronze, reflects the light of the sun, the target of the rising phoenix. *A. L.*

Constantin Brancusi, 1876–1957. Musée National d'Art Moderne Centre Georges Pompidou. Paris, 1995.

Geist, S. *Brancusi: Catalogue raisonné, The Sculptures and Drawings.* New York, 1975.

Giedion-Welcker, C. *Contantin Brancusi.* Basel and Stuttgart, 1958.

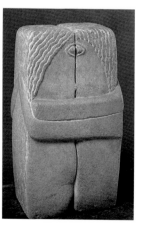

The Kiss, 1912

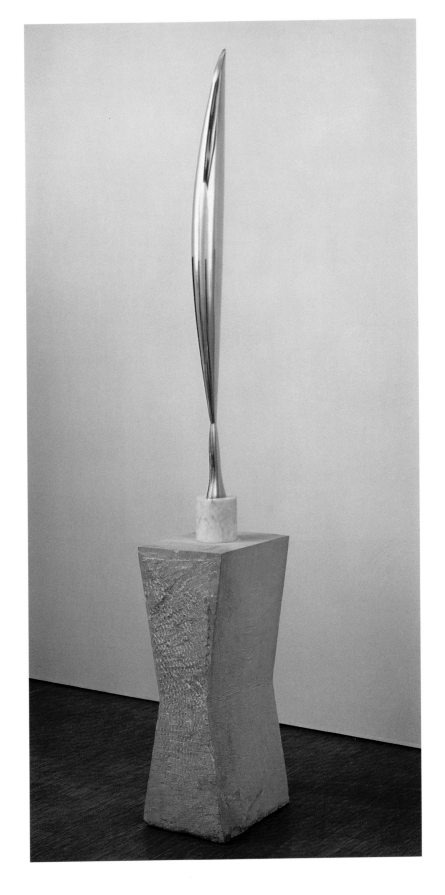

Edward Hopper

Nighthawks, 1942

Nighthawks is one of the few pictures about which the taciturn painter Edward Hopper ever spoke. *Nighthawks*, he said, was his vision of a street at night: not necessarily something especially lonely — a restaurant in Greenwich Avenue at the junction between two roads. "I simplified the scene and made the restaurant bigger. Unconsciously, probably, I painted the loneliness of a big city...." Critics have compared the atmosphere of *Nighthawks* with that of some of Ernest Hemingway's short stories, which Hopper loved. In March 1927, when Hopper discovered Hemingway's story "The Killers" in *Schribner's Magazine* — for which the artist occasionally worked as an illustrator — he wrote: "It is refreshing to stumble upon such an honest piece of work in an American magazine, after wading through the endless stodge of which most of our modern literature consists. In this story, no concessions are made to popular taste, there is no deviating from the truth, no contrived happy end." The two people at the bar do not have much to say to each other. The man with the face of a predatory bird — the nighthawk himself — might be a real good-for-nothing straight out of a *film noir*, as embodied by the laconic figure of Humphrey Bogart. (He too had to do with a strange bird: Dashiel Hammet's *Maltese Falcon*.) This man, his hat drawn, true to style, deep over his face, holds a cigarette in his right hand. Unintentionally almost, he touches the left hand of the woman, who is scrutinizing the fingernails of her right hand. Or is she holding a scrap of paper with a telephone number? At any moment she might toss it away. The barkeeper — is he really the barkeeper, or just a waiter who happens to be washing up? — seems to have made some harmless remark as he is in the habit of doing to entertain his customers: "It's been a long day," maybe, or "Been working late this evening, huh?" Something that requires no answer. Then there is another man, a lone wolf, who weighs his glass (of whiskey?) thoughtfully in his hand. This is Hopper's "silent witness." How does it go on from there? That remains an open question. In Hopper's work, as in Hemingway's story, there is no real solution, and certainly not some bogus ending. Edward Hopper is one of the most important Realists of the 20th century, and not only in the U.S.A. He never had to go in search of specifically American themes. They were part of him. What moved him was the *condition humaine*, the make-up of people in his country and in the age in which he lived.

W. Sch.

Edward Hopper: 1882–1967. Exh. cat. Kunsthalle Schirn. Frankfurt am Main, 1992.

Levin, G. *Edward Hopper.* New York, 1983.

Schmied, W. *Edward Hopper: Portraits of America.* Munich, 1995.

Second Story Sunlight, 1960

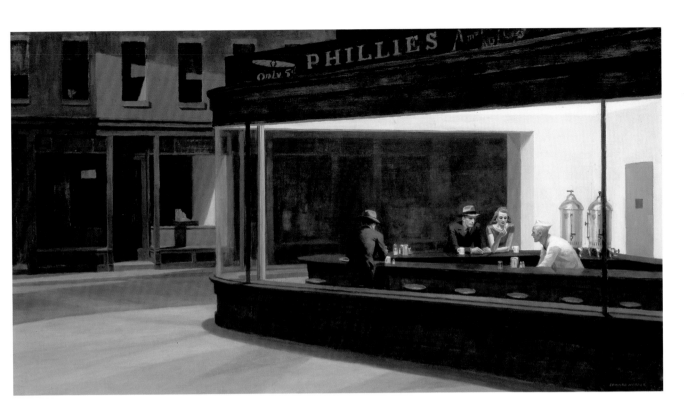

Frida Kahlo

Diego on My Mind (Self-Portrait as Tehuana), 1943

Frida Kahlo's sufferings resulting from a long period of illness, together with her problematic relationship with the painter Diego Rivera, form a central theme of the artist's work, particularly evident in her self-portraits. The portrait she painted of herself in 1943 is an example of this. She wears the impressive headdress of a Tehuana Indian woman as a clear sign that she is the one Diego loves, although it is not possible for her to possess him. Extending in various directions out of this mighty headdress, which dominates almost the entire picture, are fine white-and-black lines. The white lines extend out of the picture and carry positive energy into the world. The black lines surrounding Frida Kahlo's face are rootless, tangled continuations of the veins of the leaves. Enclosed at the center of this network of lines is her stiff, tearless face. From her thick black eyebrows rises the image of Diego. He dominates her thoughts, but his gaze is fixed somewhere far away. He frees himself from her spider's web and leaves her behind, alone and in mourning. Conscious of her forlorn state, Kahlo uses the color yellow, which in her eyes represents madness, sickness, and fear of loneliness. In the mid-1940s, her physical ailments worsened, and she had to undergo surgery on a number of occasions. In response to this, in 1951, she painted a secular retable of herself and the surgeon Dr. Farill in which she is bound to her wheelchair in a windowless room as in a prison. The lines of the floor and the wall place her firmly in the center of the picture. In one hand, Kahlo holds a brush dripping with red paint (blood); in the other, she holds a palette, on which she presents her heart. In front of her on the easel is the oversized portrait of the doctor, who plays the role of a savior for her. In this work, she adopts an important feature of votive pictures: the sick person as a supplicant who places her life trustingly in the hands of the doctor. For Frida Kahlo, there was no dividing line between the worlds of reality and the imagination. By developing her own visual language through the use of symbols, which the observer first has to decipher, she provides an insight into the inception of the pictures, which are directly related to her own life. The elements of her fantastic visual world are drawn from votive painting and from Mexican folk art, with its roots in pre-Columbian culture. Breton's categorization of her work as Surrealist in 1938 is virtually unsubstantiated; for Frida Kahlo never completely severed her ties with reality — she reshaped her own concrete life experiences into visual metaphors.

B. W.

Frida Kahlo: Retrospektive. Exh. cat. Mexico City, 1977.

Herrera, H. *Frida Kahlo. Malerin der Schmerzen, Rebellin gegen das Unabänderliche.* Frankfurt am Main, 1988.

Prignitz-Poda, H. *Frida Kahlo: Das Gesamtwerk.* Frankfurt am Main, 1988.

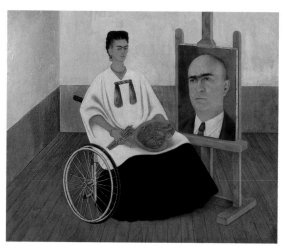

Self-Portrait with Dr. Farill, 1951

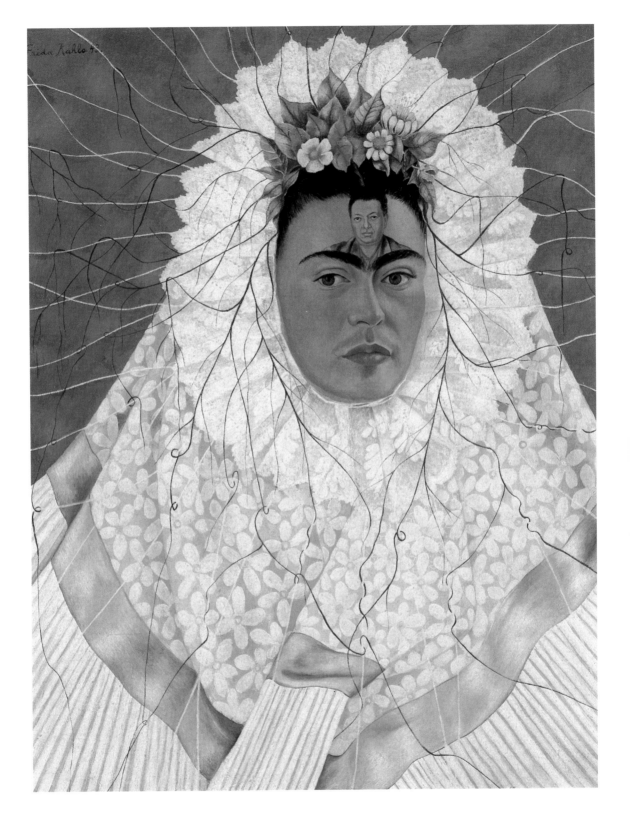

Diego Rivera

The Great City of Tenochtitlán, 1945

Diego Rivera is designated, quite justifiably it seems, as *the* painter of the Mexican people. Like no other, he made Indians, laborers and soldiers the heroes of his work by presenting before their eyes their own proud past and present in monumental, vivid, and powerful murals. For fifteen years Diego Rivera lived in Europe, moving in the circles of the most important artists of his epoch and devoting himself, above all, to Cubism. Not until 1921 did he return to Mexico, where he succeeded in fusing his experiences gathered on the continent together with Mexico's artistic traditions to form a new national art. On the site of the former palace, Moctezuma, stands Mexico's National Palace, which houses the fresco *The Great City of Tenochtitlán*. In this great composition, which blends in masterfully with the surrounding architecture, Rivera conveys a sweeping impression of the history of his people. The frescoes on the stairway, *Epic of the Mexican People* (1929–35), also show important events in Mexican history from the pre-Spanish period up to the present day. The active fighting role which the artist ascribes to the masses and the idealized representations of their leaders express the opinion of a confirmed Communist. In the archway of the upper story, the artist takes up the theme of pre-Spanish Mexico once again, concluding with the Conquista (1941–51). This cycle comprises eleven frescoes, in which two introductory paintings are done in grisaille and the nine main frescoes are each accompanied by grisaille paintings in the lower half. The first and most important mural is *The Great City of Tenochtitlán*, in which Rivera reproduces the life of the Aztecs in an idealized form, with its great abundance and richness. The market of Tlatelulco, its twin town, is seen in the foreground, with a meticulous depiction of Tenochtitlán behind. A mountain range with the Popocatépetl and Ixtaccíhuatl volcanoes completes the picture. The static portrayal of the Aztec capital, along with the pale, almost watercolor-like effect, provides a stark contrast to the hustle and bustle and expressive color of the front half of the picture. A man from the upper strata of society, sitting in a palanquin with a turquoise-colored coronet and fan of feathers, is particularly eye-catching. His gaze is directed towards a beautiful woman, who is richly adorned with lavish tattooing on her legs and valuable jade jewelry; she is crowned by a halo of calla lilies. Five relief-like grisaille panels beneath this composition illustrate sowing, harvesting, the paying of tribute, textile manufacturing, and the processing of important raw materials. The fact that Rivera was also an outstanding Cubist, architect, and historian is, without doubt, of great significance for his later work. But it was not just this which made him the painter of the Mexican people. More than anything else, it was his ability to restore the identity of his people to them and to create a new national consciousness.

A. E.

Diego Rivera, 1886–1957: Retrospective. Exh. cat. Detroit Institute of Arts. Detroit, 1986.

Kettenmann, A. *Diego Rivera 1886–1957: Ein revolutionärer Geist in der Kunst der Moderne.* Cologne, 1997.

Rochfort, D. *Mexican Muralists.* London, 1993.

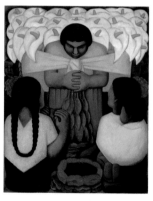

The Day of the Flowers, 1925

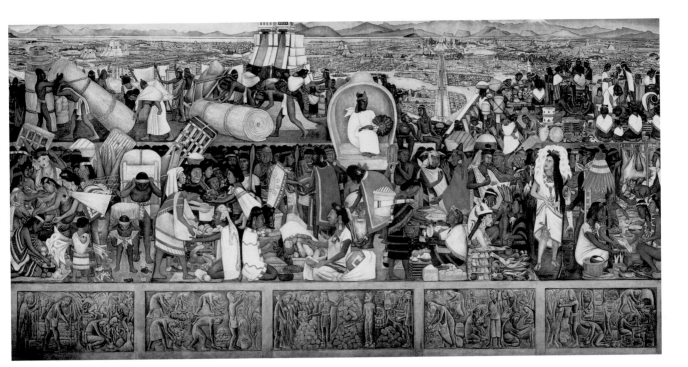

Arshile Gorky

To Project, To Conjure, 1944

1904 Arshile Gorky is born Vosdanik Adoian on April 15 in Khorkom-Vari, Armenia

1920 Flees to Providence, RI, to escape the Turks

1922–24 Attends the New School of Design in Boston, MA

1926 Studies painting at the Grand Central School of Art in New York

1932 Adopts the pseudonym Arshile Gorky

1934 First solo exhibition, in the Mellon Galleries, Philadelphia, PA

1936–37 *Painting 1936–37*

1941 Solo exhibition in the San Francisco Museum of Art

1948 Commits suicide on 21 July in Sherman, CT

When, in 1948, Arshile Gorky died at the young age of forty-four, he left behind him a whole host of questions, which even today have not been adequately answered. Was he a member of the avant-garde in the European sense, or did the New York School begin with him? Did he belong to the last Surrealists, or was he the first exponent of American Abstract Expressionism? He was a man of contrasts, on the one hand passionately dedicated to his Armenian heritage and in love with art of the past and, on the other hand, engaged in a tremendous struggle to give contemporary art a new direction. Gorky's paintings from the 1920s were heavily influenced by the work of Cézanne, from whom he adopted his spatial conceptions and learned to analyze nature in its form, structure, and light. Gorky's need for growth, change, and experimentation manifested itself in a systematic absorption of modern painting, which developed chronologically from the works of Cézanne to the art of his own time. Just as he admired the work of Cézanne, he also turned to Picasso, the artist who earned Gorky's highest esteem and who taught him the most during this creative period: "I followed Cézanne for a long time and now, of course, I am following Picasso." Gorky experienced a fundamental cultural turning point when he moved from rural Armenia to urban America, and this appears to have been the source of his almost manic search for cultural identity, which prompted him to change his name, to constantly stress the ethnic aspects of his person, and to continually emphasize his Armenian heritage in his correspondence. A series of Gorky's letters written to his sister and brother-in-law, with whom he corresponded between 1937 and 1948, document the reflection in his work of this traumatic uprooting. During the 1940s the artist immersed himself in various styles. Consequently, this decade of creative activity can be characterized by its diverse stylistic periods. The paintings of these years reveal the influences of key works from the modern period; Gorky's models at that time were the paintings of Cézanne, Braque, Léger, Miró, and, above all, the multifaceted work of Picasso. His encounter with the Surrealists, especially with the artists Breton and Matta, brought about a further turning point. Gorky believed he had found redemption in the forms and art of the Surrealists. His turning to dream pictures and creating the infinite within the bounds of the finite led to a drastic increase in his artistic output in the final years. Surrealistic elements — metamorphosis, biomorphic forms, unconscious associations, and spontaneous painting — can be identified in his late oil paintings. In their revelation of freedom and the relaxed mood they invoke, Gorky's paintings have become the hallmark of post-war art, of Informalism.

S. P.

Arshile Gorky, 1904–1948: A Retrospective. Exh. cat. The Solomon R. Guggenheim Museum. New York, 1981.
Arshile Gorky, 1904–1948. Exh. cat. Whitechapel Art Gallery. London, 1990.
Rosenberg, H. *Arshile Gorky: The Man, The Time, The Idea.* New York, 1962.

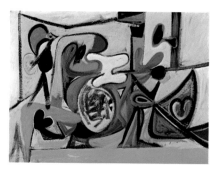

Scene in Khorkom, ca. 1936

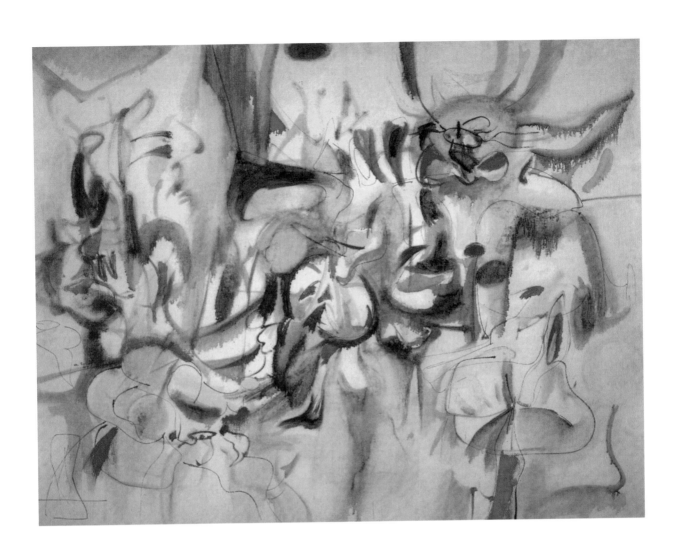

Matta

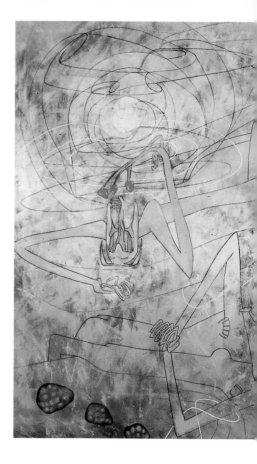

X-Space and the Ego, 1945

In the years following his move from Santiago de Chile to Paris in 1933, Roberto Matta Echaurren traveled across much of Europe. For two years he worked as an architect in the studio of Le Corbusier in Paris until he became an adherent of the Surrealist movement in 1937. Matta's artistic development was marked by the ideas of André Breton and Marcel Duchamp and by the paintings of Yves Tanguy and Salvador Dalí. He was interested in the worlds they opened up and the questions they asked. Because he was involved in the architectural design of the Spanish pavilion at the Paris Exposition Universelle in 1937, Matta was also able to witness the development of the different phases of *Guernica* in Picasso's studio. Picasso taught the young artist that the highest priority in painting should be the depiction of the consciousness of an epoch. In 1939, the Second World War forced Matta to emigrate to the U.S.A., where he stayed until 1949. There he met the older generation of Surrealists and Dadaists. Besides Picasso, he was fascinated by the art and theories of Marcel Duchamp, who had deliberately given up painting because he believed that it could not meet the high demands of this dubious time. Matta tried to combine these two extremes — the desire to become an engaged painter like Picasso, and Marcel Duchamp's doubts about painting as a medium — in his art. "Matta wants to paint the process of thinking, that is to say, movement and change; not objects, but their

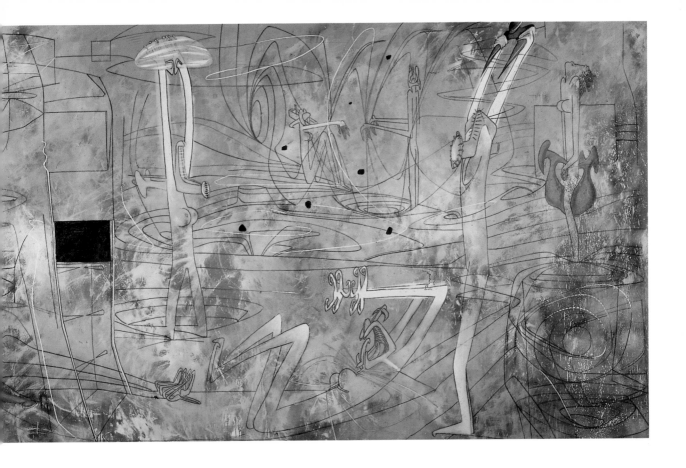

metamorphosis, their processes, their streams of consciousness… That is why his pictures flow; everything seems to be flowing, everything is in relation to something else and in transition. The self-reflecting human becomes a "Homo flux," who is unable to collect his thoughts" (Wieland Schmied). Matta is continuously preoccupied with the vision of a union between human beings and the world, the idea of an anthropomorphous structured cosmos, and the identity of the outer and inner world. His technique is a further development of the "écriture automatique" demanded by Breton in the "First Surrealist Manifesto." Matta created a kind of controlled "écriture automatique," an almost endlessly changeable and flexible array of form and structure. **X**-*Space and the Ego* is populated by headless couples, spinning dizzily in circular movements. Their love act, with genitals armed with teeth and barbs, seems more like a duel. The painting demonstrates once again that, for Matta, history is less an expression of economic or territorial conflicts than of cultural conflicts. In his desire to present the social, political, and historical space, a narrative form has developed that alternates between the bloodthirsty and the caricatural. **T**ogether with Max Ernst and André Masson, Matta's works had an important influence on the then evolving New York School, in its progression from Surrealism to Action Painting and Abstract Expressionism. *S. P.*

Matta. Exh. cat. Musée National d'Art Moderne, Centre Georges Pompidou. Paris, 1985.
Schmied, W. (ed.). *Matta.* Exh. cat. Kunsthalle der Hypo-Kulturstiftung München. Tübingen, 1991.

Rufino Tamayo

Homage to the Indian Race, 1952

1899 Rufino Tamayo is born on August 26 in Oaxaca de Juárez, Mexico

1915 Attends the Escuela Nacional de Bellas Artes in Mexico City

1917–21 Studies at the San Carlos Academy, Mexico City

1921 Head of the Ethnographic Drawing Department of the Anthropological Museum, Mexico City; makes the acquaintance of Diego Rivera

1926 First exhibition, in Mexico City and New York

1926–28 Sojourn in New York

1928–29 Teaches painting at the San Carlos Academy, Mexico City

1929–34 Shares a studio with María Izquierdo

1933 *Allegory of Music and Song*, mural for the Mexico City's Music Conservatory

1938 Settles in New York, where he teaches at the Dalton School

1943 Murals for Smith College, Northampton, MA

1946 Founds the "Taller Tamayo" at the Brooklyn Museum art school

1948 Retrospective at the Palacio de Belles Artes, Mexico City

1949 Moves to Paris

1952–53 Murals for the Palacio de Bellas Artes, Mexico City

1959 Takes part in the "documenta II" in Kassel, Germany

1964 Returns to Mexico

1968 Retrospective at the Palacio de Belles Artes, Mexico City

1980 The Museo Rufino Tamayo is opened in Mexico City

1991 Dies on June 24 in Mexico City

Although Rufino Tamayo occupies an undisputed position in contemporary Western art, he belongs to that group of Latin American artists who continually reflect on the ancient cultures of their continent. Tamayo was a passionate collector of indigenous Mexican art, a fascination that corresponded to his predilection for the figurative, which he sustained throughout his life. However, his depictions of women, men, and children — or, more generally, figures, forms, and heads — have nothing in common with folk-art traditions or archeology and they are highly abstract. Between jointed dolls, robots, and masked figures, they lead an indeterminate existence. Tamayo's *Homage to the Indian Race* is a large-scale mural, several times larger than life, which he painted for the Museo de Bellas Artes in Mexico City. Because it was commissioned by the state, and "intelligibility" was required of the artist, he is unusually explicit in this instance. A woman from his native country is named: an indian woman, the way she might be seen at the weekly market, with the typically thick, jet-black hair, an ankle-length skirt, and her wares. In a whirlwind of movement she appears to be clapping her hands. Contrary to his fellow muralists, Tamayo has depicted the figure in a semi-abstract manner — all further characterizing attributes are eschewed. He relies exclusively on the effect of the painting's picturesque qualities, luxuriating in the vibrant red tones — a feast of color from which one would expect hallucinatory effects and which one would like to think of as being typically Mexican. *Homage to the Indian Race* does not tend towards ideological paradigms (as do the works of Rivera or Siqueiros), but rather it seems to testify to the pride and charisma of the Indios through suggestive, plastic rhythm and color, without remaining apolitical. Tamayo never belonged to those avant-garde artists of our century who excite or seek attention by creating ever more spectacular formal novelties. The stream of Tamayo's creativity flowed quietly while he assimilated influences; for him, extreme pathos always remained on a human scale. It is Tamayo's humanity and integrity of vision which inspire our admiration.

P. S.

Rufino Tamayo: Myth and Magic. Exh. cat. The Solomon R. Guggenheim Museum. New York, 1979.
Rufino Tamayo: Pinturas. Exh. cat. Museo Nacional Centro de Arte Reina Sofia. Madrid, 1988.

Woman in Gray, 1959

Girl, Attacked by a Strange Bird, 1947

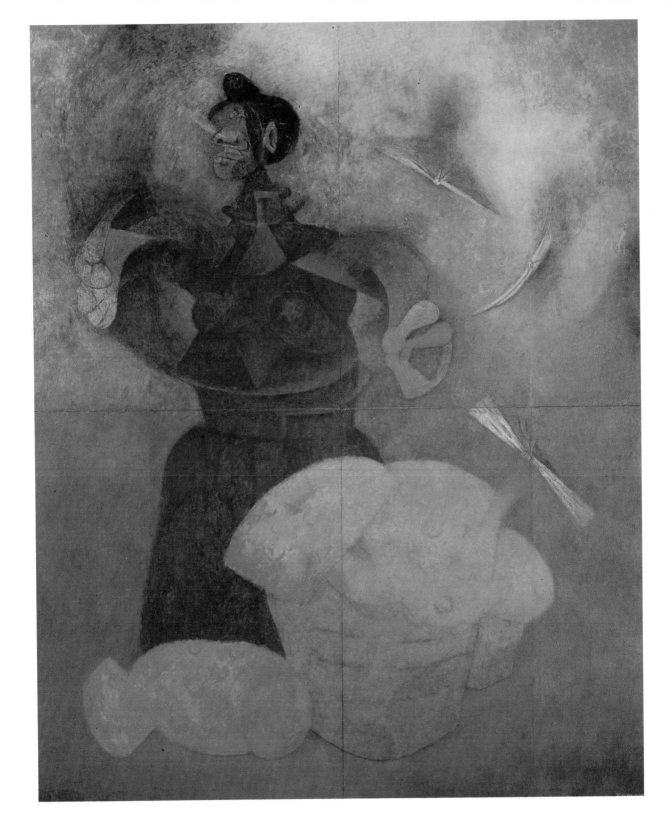

Jackson Pollock

Number 2, 1950

Like many other artists, Jackson Pollock passed through a number of stages in the course of his development, from Expressive Realism to the schematic figurative depiction of mythical ideas. His sudden break with all pictorial traditions, however, cannot be explained in terms of normal concepts of development. In the winter of 1946–47, Pollock laid his canvas flat on the ground and, using a stick, flung emulsion paint in broad sweeps over the surface. This working method, which has no antecedents in the history of art, led to Pollock's "drip" paintings, created between 1947 and 1950. These consist of sprawling networks of lines on an unprimed canvas with splashes of enamel and silver paint. These flashes of color between the skeins of lines accentuate the abstract quality of the picture. At the same time, they also momentarily invoke the ancient tradition of icon painting, gleaming from the canvas like a fragment of memory. The critic Harold Rosenberg coined the term "action painting" for this technique. He was referring to the act of making the energy of a gestural movement visible. Painting had become a field of action through which the artist could give direct expression to his motor energy. This interpretation corresponded with the ideas of the rebellious beat generation, led by the poet Jack Kerouac, which was influential at that time. It was also in tune with the philosophy of Existentialism, according to which a person has to draw his entire strength from the process of "becoming," i.e. from his or her own development. Pollock's short but rapturous life and his tragic death in a car accident were regarded as the parameters of his ecstatic pictorial production. If one frees Pollock from this romantic mode of thinking, it becomes clear that he not only defined abstract painting in a completely new way as a link between process and material, but he also created a new picture space that derives its dynamics from the resonance between line and color, figure and ground, material and light. Pollock did not want to create a picture of energy but to make the process of energy visible in an open, revolving visual model. It was a decision that had far-reaching consequences for art until well into the 1960s on movements such as Arte Povera. *H.D.*

Frascina, F. *Pollock and After: The Critical Debate*. New York, 1985.

Landau, E. G. *Jackson Pollock*. New York, 1989.

O'Connor, F. V. and E. V. Thaw (eds.). *Jackson Pollock: A Catalogue Raisonné of Paintings, Drawings and Other Works*. New Haven, 1978.

Circumcision, 1946

Willem de Kooning

Woman II, 1952

In 1926, the twenty-two-year-old Willem de Kooning arrived in New York from the Netherlands, having traveled as an engine cleaner on a cargo ship without valid documents. At the age of twelve he had attended evening classes for drawing and had later spent many terms studying painting and design at Dutch and Belgian schools of art; but the dream of America was stronger than that of becoming an artist. Nothing came of his designer career, therefore, and de Kooning made a living as a house painter and window dresser, although he felt at home only in the company of artists. It was through another immigrant, Arshile Gorky, that he recognized where his true calling lay. **D**e Kooning became famous with his series of "Woman" pictures, painted in the early 1950s. Suddenly, this modest man found himself the spokesman for a new generation of artists for whom the epithet "action painters" had been coined — a term that was applied in particular to the work of de Kooning himself. The artist always insisted that it was really Jackson Pollock who had "broken the ice," but the female figures that de Kooning unleashed upon the world exerted such an attraction that no one in the international art scene could resist them. **T**he nudes De Kooning paints are viewed not with the eyes of an observer, not "from the outside." In this, he was like Turner, who painted a snowstorm or a capsized ship at the mercy of the waves as someone in the midst of the action, whose viewpoint is constantly whirling round with the elements. De Kooning did not paint portraits: he depicted the sensations another being aroused within him. The figure of the woman merges into the surrounding space. All details vanish. The act of making love is transformed into the act of painting; both are filled with the same passion. **I**f these are erotic pictures, they are full of innocence. Hardly any other artist has ever spelt out the experience of Eros with such innocent directness as de Kooning. In this light, one can understand his remark that oil painting was invented to enable us to re-create flesh. **D**e Kooning's art was the power to depict the forces that drove him to paint. In his opinion, none of his paintings were really finished. There is a pulsating restlessness in them that impelled him forward. While he was working on one canvas, he would feel the next picture urging itself upon him. But was it really a picture? Was it not more a surge of energy, of forces that were pressing for expression through the process of painting, without being congealed into a picture? That explains why de Kooning painted landscapes without earth, dance without dancers. Nothing is final or complete: everything can be carried further; from any point, he could set out on a new trail. This was what gave him the powers of self-renewal into advanced age. **T**he end came in the form of exhaustion. His works from the late 1980s, ornamental labyrinths drawn with the brush, reveal a slow process of leave-taking. The hand continued to paint, but the consciousness gradually withdrew into the darkness of Alzheimer's disease. Creating pictures was the last thing left to him — until finally that gift, too, was extinguished. *W. Sch.*

Cateforis, D. *Willem de Kooning*. New York, 1994.
Rosenberg, H. *Willem de Kooning*. New York, 1974.
Waldman, D. *Willem de Kooning*. New York, 1988.

Untitled, 1957

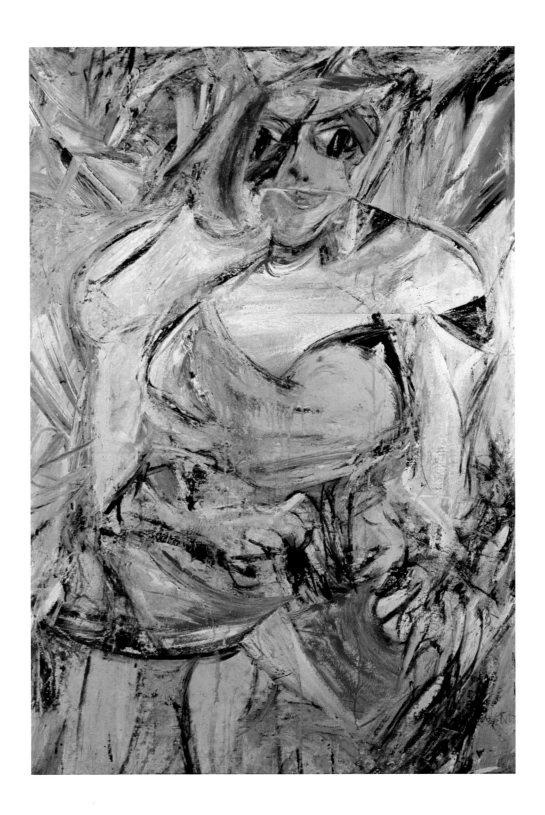

Mark Rothko

Untitled (Yellow, Orange, Red on Orange), 1954

1903 Mark Rothko is born Marcus Rothkowitz in Dvinsk, Russia

1913 The family emigrates to the U.S.A.

1921–23 Attends Yale University, New Haven, CT

1925–29 Studies at the Art Students League in New York

1929–52 Teaches at the Jewish Center Academy in Brooklyn

1935 Founding member of The Ten

1936–37 Works on projects initiated by the Works Progress Administration

1938 Takes American citizenship

from 1940 Uses the name Mark Rothko

1945 Exhibition at Peggy Guggenheim's New York gallery

1947 Teaches at the California School of Fine Arts, San Francisco

1948 Founding member of the art school Subjects of the Artist; works with Robert Motherwell and Barnett Newman

1950 Travels to Europe

1951–54 Teaches at Hunter College, City University of New York

1958 Commissioned to paint a mural for the Seagram Building, NY

1961 Retrospective at the Museum of Modern Art, NY; commissioned to paint a mural for Harvard University, Cambridge, MA

1964 Commissioned to paint a mural for a chapel in Houston, TX (dedicated in 1971)

1970 Commits suicide in his New York studio on February 25

With its large and hypnotic fields of color, *Untitled* represents the essence of Mark Rothko's mature style. A leading member of the American Abstract Expressionist movement, Rothko reached his singular idiom — in which rectangular presences are incorporated into or hover over an ambiguous ground — after a long artistic odyssey. From the mid-1920s onwards, Rothko explored various artistic trends, including Realism, Expressionism, and Surrealism. However, by 1950, even these possibilities seemed too limiting in his search for an art that would engage the spectator and convey basic human emotions. Thus, Rothko, in his own words, eventually "pulverized the familiar identity of things" to achieve "the simple expression of the complex thought." The resultant images may appear utterly abstract, but they retain faint memories of the artist's earlier preoccupation with the figure and its surroundings. Facing the viewer with the kind of upright, direct, and symmetrical poise associated with the human body itself, the brilliant veils of *Untitled* seem to float and expand of their own accord as we contemplate them. Yet this movement is arrested by the starkness of design: a format often reduced to some two or three planes that at once evokes an enigmatically blank window or facade and an elemental landscape divided into sky, land, and sea. Rothko's paintings unfold over time in a counterpoint of flatness and depth, motion and stillness. And as if to echo that drama, the two main areas of the composition — a hazy gold set above a denser red — vibrate against each other like notes in a musical chord. Rothko's technique also emphasizes this play of opposing forces. Whether his palette is vivid or somber, the pigment is almost always soaked into the canvas so that the picture has the weightless intensity of a mirage. Saturated with light — one of the most ancient symbols of the spiritual — *Untitled* weaves subtle tensions into the bold forms of 20th-century abstraction. *D. A.*

Chave, A. C. *Mark Rothko: Subjects in Abstraction*. New Haven, 1991.
Glimcher, M. (ed.). *The Art of Mark Rothko: Into an Unknown World*. New York, 1991.
Mark Rothko, 1903–1970: A Retrospective. Exh. cat. The Solomon R. Guggenheim Museum. New York, 1978.

Antigone, ca. 1941

Robert Rauschenberg Bed, 1955

1925 Robert Rauschenberg is born Milton Rauschenberg on October 22 in Port Arthur, TX

1946–47 Studies at the Kansas City Art Institute

ca. 1948 Adopts the first name "Bob," which later becomes "Robert"

1948 Studies at the Académie Julian in Paris

1949 Attends Black Mountain College in North Carolina; Josef Albers is among his instructors; meets Merce Cunningham, John Cage, and Cy Twombly

1949–52 Studies at the Art Students League in New York

1951 *Automobile Tire Print* with John Cage; first solo exhibition, at the Betty Parsons Gallery in New York

1953–65 Designs sets and costumes for the Merce Cunningham Dance Company; "Combine" paintings

1958 First exhibition at the Leo Castelli Gallery, NY

1958–60 Illustrations to Dante's *Divine Comedy*

1963 Retrospective at the Jewish Museum, NY

1965 *Spring Training*

1966 Makes the film *Canoe*; with the scientist Billy Klüver he sets up Experiments in Art and Technology

1968–71 *Mud Muse*

1971 Founds Untitled Press, Inc. with Petersen

1974–76 Works with Robbe-Grillet on the book *Traces Suspectes en Surface*

1982 Sojourn in China

1985 Launches ROCI (Rauschenberg Overseas Cultural Interchange)

1991 Retrospective at the National Gallery of Art, Washington, D.C.

Lives on the Island of Captiva, Florida

Necessity is the mother of invention. In 1955, when Robert Rauschenberg found himself without a canvas on which to start a new painting, he simply took a sheet from his bed. This simple idea gave rise to a great conceptual work and caused a furore in the 1950s. Rauschenberg not only painted the sheet in a series of spontaneous gestures; he used a pillow and a typical American quilt and proceeded to work on them as well. In so doing, he radically challenged the sublime pretensions of the traditional painted picture. Although the *Bed*, which was originally unframed, can be hung on a wall, and the lively formal interplay of oil painting and pieces of material is clearly reminiscent of the language of abstract art, the work as a whole remains the same utilitarian object that it originally was, namely a bed. **R**auschenberg had given the name "combine" painting to this hybrid form of art a year earlier. In addition to his *Bed*, he created more than eighty such paintings between 1954 and 1962 in which he used photos, pieces of furniture, stuffed animals, and illuminated light bulbs. These works were preceded by smaller studies in which the artist used various materials and collage techniques. As in the case of some of Kurt Schwitters' works, these studies were in the nature of an homage to simple, already used artefacts, a poetry of discarded objects. Only with the large-scale combine paintings created after 1954, however, did the artist succeed in overcoming the transcendental pathos of contemporary New York painting and in confronting the existential character of Jackson Pollock's "drip" painting with an enthusiasm for the things of everyday life. Suddenly, blots, streaks, and splashes of paint were no longer an expression of individual experience but tokens of a world that had been used and soiled by anonymous people. **I**n this respect, Rauschenberg's "combines" can be understood as depictions of civilization, pictures that go beyond the individual areas of painting and the history of the materials and make reference to the basic phenomena of Western culture. From 1960 onwards, this theme assumed an even greater immediacy. In works such as *Pilgrim*, what had hitherto been self-contained studies became an open space for art that one could enter as an observer and (seemingly) use. **T**he striking use of simple, real objects such as a bed and a chair was also a demonstrative declaration of the dissolution of the borders between "high" and "low" forms of art, between fine art and everyday culture. That is why Rauschenberg may be regarded as the true father of American Pop Art and, generally, as the pioneer of postmodern object art.

J. J.

Cowart, J. (ed.). *ROCI — Rauschenberg Overseas Culture Interchange*. Exh. cat. National Gallery of Art Washington, D.C., Munich, 1991.

Forge, A. *Rauschenberg*. New York, 1969.

Kotz, M. L. *Rauschenberg: Art and Life*. New York, 1990.

Robert Rauschenberg: The Early 1950s. Exh. cat. The Menil Collection, Houston. 1991.

Retroactive II, 1964 *Bed*, 1955

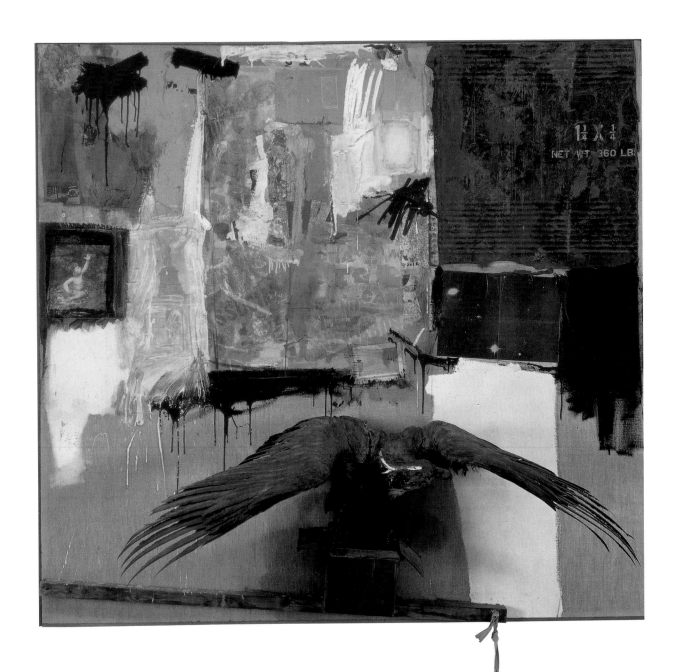

Arnulf Rainer

Cross, 1956

A *leitmotif* is apparent throughout Arnulf Rainer's work: blindness, extinction, death. He started to produce blind paintings in the early 1950s, and had moved on to black "over-paintings" by the end of the decade. A subsequent phase of involvement with the paintings of the mentally ill was followed in the last decade by a preoccupation with portraying the dead, death masks, the faces of the dead. This drove him on to question and deal with the expression of death itself — to conceal it, to extinguish it, to shrug it off. Rainer's work untiringly states that everything is vanity; it is a constant monologue regarding death, that inescapable fundamental defining of our existence. For him, death is no harmonious ritual, no golden, sacred ceremony; instead, it is something loathsome that alters and destroys everything. His earliest strivings concerned death — to get up close to it, to spend his life in its proximity, to conceive it. He wanted to stage-manage it, to go through this experience ahead of time, to anticipate it. Dissatisfied with himself, not afraid of failure — and going beyond failure — Rainer is more intensely disturbed than Bacon or Soutter, the most agitated artist since Van Gogh, according to Antonin Arnaud, who sees him as suffering, abandoning, and ultimately destructive. His work received a fresh impulse in the 1960s thanks to his intense interest in the art of the mentally ill and the worlds of the insane, subjects to which he has always been drawn. He started by collecting examples of the work of the insane, became preoccupied with their poetry and their grimacing, and experimented with drug-taking. His works became overwhelmed with imagery of "singular beings and insane worlds." Fresh abysses opened up before him, led him to shudder, engaged his fascination, demanded his involvement. He started trying out some grimaces with his own face, over-painted photographs or left them untouched, scratched in frightful "face corrections": faces that look evil, faces that find their own gaze repugnant. And yet these grimaces offer us an opportunity of circumventing hypocrisy, a chance of being truthful. As with earlier works from the realm of the fantastic, Rainer now attempts to add grimaces to his new work — drawings, paintings, and photographs — and so to make them unbearable, leaving extinction and over-painting the only remaining escape. His work is thus left suspended in a dialectic tension between chaos and nothingness, ugliness and concealment, screaming and silence. Out of a deeply rooted sense of self-dissatisfaction and by suffering through his work, Rainer is bound up with his own era, an era he himself helped define. This was an era of asceticism: Rainer never regarded this as a mere "aesthetic" concern, but always as something "existential." In defining the Austrian contribution to this era, we might imagine Rainer at the forefront — through his achievement of turning an aesthetic process into something existential, and in supplying answers to contemporary concerns in a way few others have done, with the possible exception of Antoni Tàpies in Spain and Joseph Beuys in Germany. Rainer has managed not only to counter reality, but also to intensify our experience of reality, even if this has been achieved by pulling the ground from under our feet.

W. Sch.

Arnulf Rainer, Malerei 1980–1990. Exh. cat. Saarland Museum Saarbrücken. Stuttgart, 1990.

Catoir, B. *Arnulf Rainer: Übermalte Bücher.* Munich, 1989.

Hofmann, W. "Masken," in: *Arnulf Rainer: Totenmasken.* Salzburg, 1985.

The Back and Forth of Courage, 1982

Antoni Tàpies

Porta metál.lica i violí, 1956

In 1956, three years after his first stay in New York, Antoni Tàpies created his first object sculpture, *Porta metál.lica i violí* (Metal Shutter and Violin). His first matter paintings made from discarded materials were produced at the same time; one of these was *Gray Relief, No. V*. In this picture, Tàpies used the motif and relief of a metal shutter to create its art equivalent; he did this with such accuracy that both picture and object are identical in format. Though picture and object group are in no way intended to portray alienation, *Porta metál.lica i violí* does represent a found object taken to the extreme. From the aesthetic point of view, it also remains a real object referring back to itself, in the "New Realistic" sense: an old, slightly rusty and dented metal shutter, just like you might find today covering almost any window in those little, long-established shops in the heart of old Barcelona after closing hours. Tàpies did not exactly stumble across this motif. He had sought it out with a definite idea for a work of art, a commission, ironically enough, as a window ornament for one of the elegant fashion stores in the Passeig de Gràcia. The store, urged on by an art critic, was making an attempt to seek publicity with the help of avant-garde art. *Porta metál.lica i violí* also presents a visually distorted musical symbol: the violin, here with merely two strings, its fingerboard protruding sideways out of the shutter's vertical form. The violin also gives the object sculpture an acoustic, in the sense of a noise, a metallic noise like ill-tuned strings — something we can associate with the shrill squeak of the shutter as we raise or lower it. At this time, Tàpies found "Musique concrète" exhilarating, a musical genre represented in those days in Paris by Pierre Schaeffer and Pierre Henry, to which principally artists and performers, writers and poets were attracted. Musical pieces or *études* consisted of noises made not by instruments but by everyday objects of real life, for example squeaking doors — a frequently utilized noise in the genre. Pierre Henry even composed a special piece for a door, *Variations pour une porte et un soupir*, which had its première in 1963. The composition was dedicated to Arman. Had he been familiar with Tàpies' *Porta metál.lica i violí* at the time, the dedication might well have been bestowed elsewhere. The work was not exhibited for the first time until ten years after its creation. The reason behind its initial showing was a large Tàpies retrospective in the Musée d'Art Moderne de la Ville in Paris in 1973, which led to his name being entered in the annals of art history for the first time.

B.C.

Catoir, B. *Conversations with Tàpies*. Munich, 1991.
Franzke, A. *Tàpies*. Munich, 1992.
Moure, G. *Tàpies: Objects of Time*. Cologne, 1995.

Large Shoe, 1990

Jasper Johns

Flag, 1955

In 1954, the twenty-four-year-old artist Jasper Johns, who had been living in New York for two years, destroyed all his previous works. Shortly afterwards, he painted his *Flag*, with which he broke new ground in the artistic development of modernism. In this work, Johns does not depict a "real" flag hanging on a pole, let alone fluttering in the wind. Instead, he transfers the planar pattern of the Stars and Stripes directly on to the canvas, carefully observing the correct colors and proportions, so that the form of the flag corresponds precisely to that of the picture, with which is identical. It is not a copy of the flag; Johns turns it into a painting. In so doing, he drains the familiar object of its previous meanings and seemingly depicts it for its own sake. In his ensuing pictures, the artist proceeds in a similar way, painting targets, numerals, and letters of the alphabet — all well-known, predetermined forms that he does not have to design. "This allowed me to work on different planes," Johns explains. The first indication of these other planes, i.e. of the artist's true aims, can be found in his special method of painting. Johns employs an encaustic technique, in which wax is used as a bonding agent applied hot to the ground, in combination with color pigment and collage elements (e.g. newspaper cuttings). Once it has cooled, the thin layer of wax lifts from the ground. Its tangible unevenness conveys a suggestive impression of a made object. The sensuous quality of this method of application undermines the familiar, stereotypical perfection of the individual models. Their appearance is changed, and they are elevated to a new plane of significance. The pattern of the American flag or the form of a numeral are so familiar to us that we normally see them without consciously perceiving them — in other words, without being aware of their real form. We experience them as abstract signs. In Johns' pictures, these abstract signs become concrete reality. Independently of this, however, they continue to exist as abstract concepts, as clichés. When we look at his flag, therefore, we cannot escape the impression that it is a made object. The brushwork impresses this upon us. However, at the same time, we cannot resist seeing something familiar, a pre-given object, or having a sense of *déjà vu*. Johns' art exists on the border between reality and idea. His flags, numerals, targets and alphabetical pictures are always both sides of the coin: the general and the unique, collective and individual, familiar and surprising, ordinary and exclusive. As images of images, they allow us an insight into the conditions determining all languages, into the nature of artistic perception. The reality to which Johns gives form and expression lies on the border between image and copy. In this respect, *Flag* forms the starting point of the most spectacular artistic innovations since the war: the revolution of Pop Art. *S. B.*

Boudaille, G. *Jasper Johns*. Recklinghausen, 1991.

Francis, R. *Jasper Johns*. New York, 1984.

Rosenthal, N. and R. E. Fine. *The Drawings of Jasper Johns*. Exh. cat. National Gallery of Art. Washington, D.C., 1990.

Varnedoe, K. (ed.). *Jasper Johns*. Exh. cat. Wallraf-Richartz-Museum Köln. Munich, 1997.

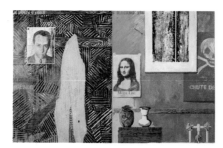

Racing Thoughts, 1983

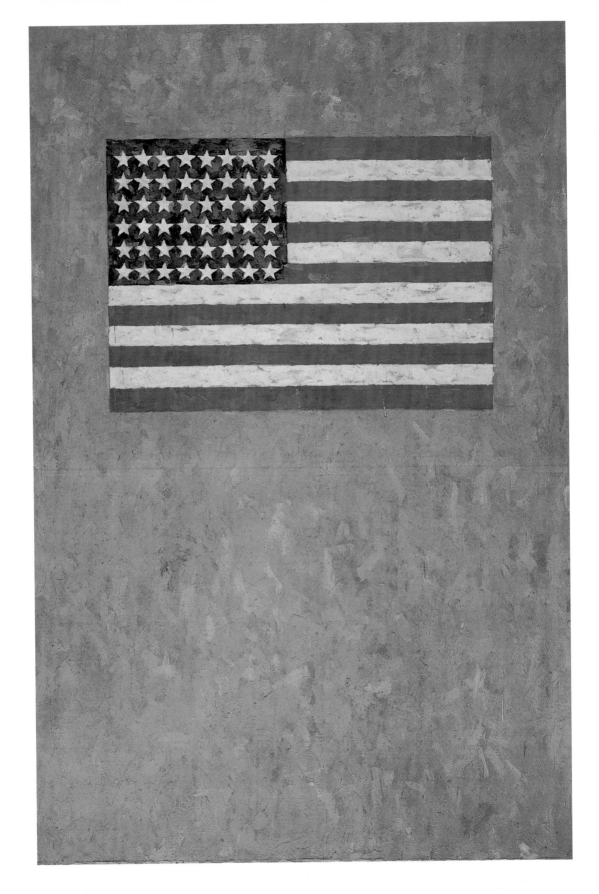

Richard Hamilton

Just What Is it that Makes Today's Homes So Different, So Appealing?, 1956

1922 Richard Hamilton is born on February 24 in London

1934 Takes evening classes in art at Pimlico Further Education Center in London

1936 Takes evening classes in art at Westminster Technical College and St. Martin's School of Art

1938–40 Studies painting at the Royal Academy School

1940 Attends technical drawing courses

1941–45 Works as an industrial designer

1946 Resumes his painting studies at the Royal Academy School

1948–51 Studies painting at the Slade School of Art, London

1950 First solo exhibition, at Gimpel Fils, London

1952 Teaches at the Central School of Arts and Crafts in London; becomes a member of the "Independent Group" at the Institute of Contemporary Arts

1955 Organizes the "Man, Machine and Motion" exhibition at the Hatton Gallery, Newcastle, and the ICA, London

1956 Works together with John McHale and John Voelcker for the "This is Tomorrow" exhibition at the Whitechapel Gallery, London

1957–61 Teaches interior design at the Royal College of Art, London

1957 *Homage to the Chrysler Corporation*

1963 Travels to the U.S.A.

1966 Organizes the exhibition "The Almost Complete Works of Marcel Duchamp" at the Tate Gallery, London

1967–68 *Dreaming of a White Christmas*

Lives and works in Northend Farm, Henley on Thames

Together with Eduardo Paolozzi, Richard Hamilton formed the Independent Group within the ICA (Institute of Contemporary Art), which set itself the goal of providing an artistic reflection of cultural changes in the age of technology. The first fruit of their labors was the exhibition "Man, Machine and Motion," in 1955, which focused on the symbiotic relationship between man, machines, and the mass media (photography). Hamilton's collage entitled *Just What Is it that Makes Today's Homes So Different, So Appealing?*, which he created as a design for a poster for the legendary exhibition "This Is Tomorrow" organized by the Whitechapel Gallery in 1956, rapidly became an icon of European Pop Art. The collage, made up of clippings from popular magazines, brings together all the ingredients of the modern way of life: the media, the cult of the body, ideals of beauty, new technology as part of the stylish modern drawing room. Together with its title, taken from an advertising slogan, the collage reveals the Americanization and fetishism in our lives, and yet, for all its critical overtones, does not attempt to hide a certain sympathy for the trivia of modern culture, which Pop Art was beginning to draw on for its motifs. In his later works, Hamilton created a new synthesis of photographic and pictorial elements, with the unconventional coloring underlining the cryptic nature of the motifs. The English Pop artist is also well known for his exhibition designs.

Richard Hamilton. Exh. cat. The Solomon R. Guggenheim Museum. New York, 1973.
Richard Hamilton: Collected Works, 1953–1982. London, 1983.
Richard Hamilton. Prints: A Complete Catalogue of Graphic Works: 1939–1983. Exh. cat. Stuttgart and London, 1984.

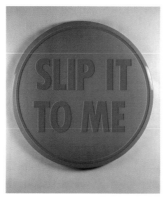

Epiphany, 1964

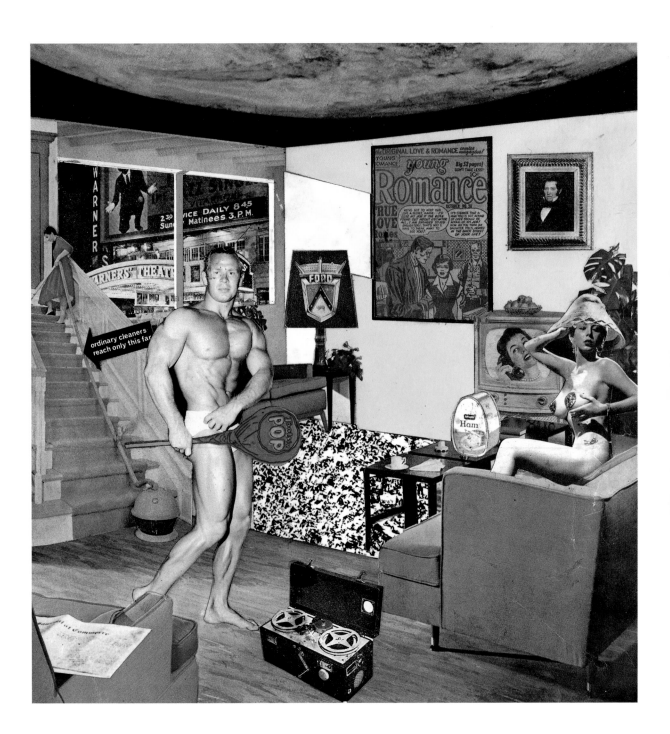

Josef Albers

Homage to the Square, 1957

Josef Albers turned his back on object-based, expressive art as much as two years before he went to study at the Bauhaus. After his training, while he completed the move towards functionalism and consistent constructivism, he taught at the Bauhaus until its closure. Albers eliminated everything that was expressive as a creative tool. He remained an adherent of the strict elementarism initiated by Kasimir Malevich and Theo van Doesburg. In his glass pictures Albers brought together elements that he later divided into two work groups: the appearance of line and color on the surface. In 1928 he stated that he was interested in "economy in relation to the effort involved and best-possible utilization with regard to effect." Albers emigrated to the U.S.A. in 1933. At the Black Mountain College in North Carolina, as a decisive champion of geometrical abstraction, he was an important forerunner for many American artists in their development of experimental art forms. In 1949 he began his montage "Homage to the Square" series. This is devoted to the interaction of color and the analysis of the spatial effect of color on surfaces — an exploration of the universal phenomena of seeing. Albers eliminates all elements extraneous to the picture. He sets the colors onto the canvas homogeneously, without pastosity or any kind of individual "hand." In contrast to hard-edge painting, the zones of color meet without any linear demarcation; the borders of color and form are identical — a further characteristic of Albers' extreme economy of approach. He records the colors he uses, applied direct and unmixed from the tube, on the back of the picture: "I have eighty kinds of yellow alone and forty shades of gray…" Even small interventions in the overall system can produce fundamental changes in the spatial effect of his color squares, as Albers himself emphasizes: "It is like a cook: sometimes she adds a bit more salt, sometimes a bit less. This makes a big difference." The pictures in the "Homage to the Square" series are each made up of three or four colors in three or four squares; they are organized according to a precise geometric system that is scrupulously observed throughout the series. The coloration of the color zones suggests they are in front of or behind one another, whereby changes in the light conditions can intensify, or even reverse, the spatial organization. The lower, narrow color strips seem to be more active than the upper, broad ones, and the imagined staggered depth gives them something of the appearance of steps. "My painting is meditative, peaceful… I seek no rapid effects…. Look, this is what I want: to create meditational images for the 20th century." With his pared-down manner of working and his experimentation with optical perception, Josef Albers may be regarded as a precursor of Minimal Art and Op Art. *A.L.*

Albers: Glass, Color, and Light. Exh. cat. The Solomon R. Guggenheim Museum. New York, 1994.
Gomringer, E. *Josef Albers.* Starnberg, 1973.
Herzogenrath, W. *Josef Albers und der Vorkurs am Bauhaus 1919–33.* Cologne, 1979–80.
Spies, W. *Josef Albers.* Stuttgart, 1971.

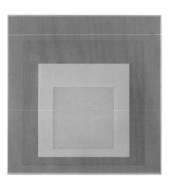

Homage to the Square: "Rising", 1953

Victor Vasarely

Markab-Neg, 1957

Anyone attempting to describe Victor Vasarely's *Markab-Neg* using the familiar, basic concepts of art history such as space or volume would inevitably become entangled in the optical paradoxes of the painting. It is not possible to say exactly where shape ends and ground begins. Are these black lines on a white ground, or white lines on a black ground? The various shapes which form the vertical lines through refraction, breaks, elongation, crossovers and distortions also create the ambiguous shape/ground relationship of the painting, which is intensified by the greatest possible contrast of black and white. The optical instability incites the viewer to visual activity. The aggressive fluidity of the picture surface is not, however, an end in itself: for Vasarely, it is the art form appropriate for the acceleration of life. He thus proves himself to be a contemporary of the characteristic belief of the 1950s and 1960s in technical, scientific, and economic progress: "From now on, ideas and technique in art can only be developed hand in hand with the thinking and the most advanced technology of the time…. We no longer sink into lengthy contemplation. The increased speed in all areas of our existence forces us to be impatient. We seek the immediate, sharp shock of the moment." This utopian demand explains his fame, almost inconceivable today, the overwhelming effect, and the practically global presence of the father of Op Art. If, in the initial phases of his post-war work, Vasarely developed his abstractions through observation of nature, he founded his kinetic works of the Black-and-White Period using the general rules of human perception. His reading on scientific theory confirmed him in his opinion that certainty and uncertainty had become confused. One thus underestimates the content in the language of Vasarely's paintings if one does not see them as an answer to a world which physics has turned into a riddle. These paintings reflect on the loss of certainty about the meaning of space, of body, of time, and of movement. The aesthetic equivalent for this is the multiple coding of the information offered in the picture: Vasarely's preference for dual-aspect pictures and optical interference. His paintings cannot be structured logically because he tends to select shapes which defy consolidation into a definite form. The permanently changing images which we see are incorporeal images which our vision produces, not the actual ones which Vasarely painted. For the first time, the aesthetic effect of the painting is thus due not to the painting itself but to the relationship between the work and the observer: the objective existence of the picture and its subjective effect have been radically ripped asunder. The artist's imagination creates only the physical picture, the stimulating subjects, not the appearance of the "picture."

K. A. S.

Schroeder, K. A. *Vasarely*. Munich, 1992.
Spies, W. *Victor Vasarely*. Cologne, 1971.

Vega 200, 1968

Yves Klein

RE 16, Do-Do-Do, Blue, 1960

Probably no other artist in the 1950s and early 1960s did more to uphold the concept of an artistic avant-garde than Yves Klein. In the seven years of his short creative life, which ended with his premature death in 1962 at the age of thirty-four, Klein created an oeuvre of extraordinary intensity and radiant power, an oeuvre that anticipated some of the most important developments of conceptual and process art, Fluxus and "happenings" — long before they bore these names. He was one of the founding members of the Nouveaux Réalistes and a prime mover of the ZERO Group. Klein saw himself in the tradition of classical modernism. He was an artist who wished to resolve the conflict between abstract and figurative art through a realistic representation of space. Klein's aim was to make visible the "pictorial or cosmic sensibility" of space and its "pure energy." To this end, he used monochrome painting as a means of transcending the traditional concept of pictures and attaining an immateriality in his work that would overcome the separation from (living) space. He had already developed his ideas of monochrome painting in the early post-war years. An unsettled, restless period followed in which he initially went to London, where he learned the basic technique of painting. During a stay of several years in Japan, monochrome coloration manifested itself as the conceptual basis of his painting. At the same time, he came to develop a variety of methods of applying paint, rolling or spraying it on to the surface, rubbing it with sponges, making impressions from the human body to which paint had been applied, treating the surface with fire, exposing it to wind and rain, and so on. He also devised a number of complex strategies for the amusing presentation of his art. In 1955, Klein returned to Paris. In the following year, in search of the color that would satisfy his own pictorial concepts, he developed, in collaboration with a chemist, the blue that he was to patent as International Klein Blue (IKB). His "Blue Period" ensued, and this was to form the focus of his creative work until 1961. The beginning of this period was marked by an exhibition in Milan at which Klein presented eleven pictures of identical form and size, but which he offered at different prices to take account of "the individual sensibility" of the purchasers. *RE 16, Do-Do-Do, Blue*, dating from 1960, belongs to this complex. In this work, sponges soaked in paint appear as elements of predetermined content set on or rather in the monochrome surface. Influenced by the esoteric texts of the Rosicrucian Max Heindel, Klein thereby elevates the sponge to a symbol of the union of material and spirit, exterior world and man. The climax of Klein's dialectic with the sponge relief is his interior design, created in 1958, for the foyer of the music theater in Gelsenkirchen, built by Werner Ruhnau.

U. W.

Yves Klein. Exh. cat. Musée National d'Art Moderne Centre Georges Pompidou. Paris, 1983.

Restany, P. *Yves Klein*. Paris, 1982.

Stich, S. *Yves Klein*. Stuttgart, 1994.

Wember, P. *Yves Klein: Catalogue raisonné*. Cologne, 1969.

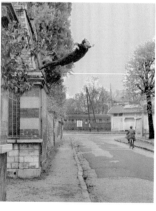

The Newspaper of One Day:
Sunday, November 27, 1960

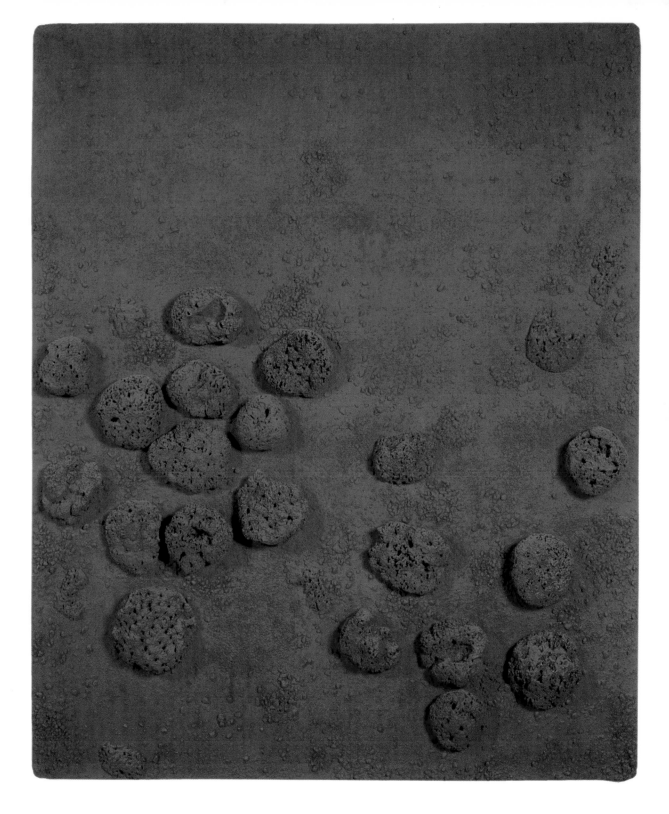

Robert Motherwell

Elegy for the Spanish Republic LXX, 1961

Abstract painting as a possibility of spontaneously recording emotional impulses, the concept of "psychic improvisation," had been developed by Paul Klee and Vassily Kandinsky even before the First World War. It became the focus of the artistic thinking of a group of New York painters gathered around William Baziotes, Arshile Gorky, Willem de Kooning, and Jackson Pollock — among them Robert Motherwell. In the 1940s Motherwell was influenced by the Surrealists André Breton, Marcel Duchamp, Max Ernst, André Masson, and Yves Tanguy, who had emigrated to the U.S.A. from Europe. Motherwell adopted the method of painting they used — automatism, which sought to open up the subconscious as a source of inspiration. Encouraged by Matta, whom he visited in Paris, Motherwell began to paint in the automatism technique around 1940. At first he used collage as a way of expressing himself spontaneously. In 1948 he began a series — "Elegies for the Spanish Republic" — which would remain one of the core themes of his oeuvre. These pictures are distinguished by their common formal basic model, consisting of ovals and vertical bands running across the surface of the picture. The black elements, positioned spontaneously, form an extreme contrast to the white or pale ocher of the canvas. Color is largely avoided. The picture formats assume dimensions of nearly 20 feet; as Motherwell said, "Small pictures are for midgets or tourist souvenirs." On these vast canvases he sets his shapes with powerful brushstrokes. The frontal-seeming black creates tension and a sense of distance; in a few pictures it is as though it wants to drown out totally the white of the ground. "I believe that black and white, which I use best, have a tendency to be the protagonists." These are uncorrected reflections of a lively artistic act with which Motherwell prepares the way for the informal. His oval black areas on a white ground first made their appearance in an illustration of a poem by Harold Rosenberg. A year later, in 1949, they reappeared in the painting *At Five in the Afternoon*, the title for which was taken from a poem by Federico García Lorca describing the death of a friend in a bullfight. "I understand an elegy to be a lament or burial dirge for something that one was very attached to. The Spanish elegies are not "political," they are my own unwavering reference to a dreadful death ... even general metaphors about the contrast between life and death and their interrelationship." Motherwell approached the theme of life and death from constantly varying angles, but always retained his central subject and the principle of the contrast between empty space and the picture image. During the painting process Motherwell developed the final pictorial statement unpredictably to produce harmony or conflict.

A.L.

Pleynet, M. *Robert Motherwell*. Paris, 1989.

Terenzio, S. (ed.). *The Collected Writings of Robert Motherwell*. New York, 1992.

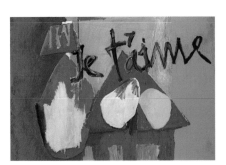

Je t'aime, IV, 1955–57

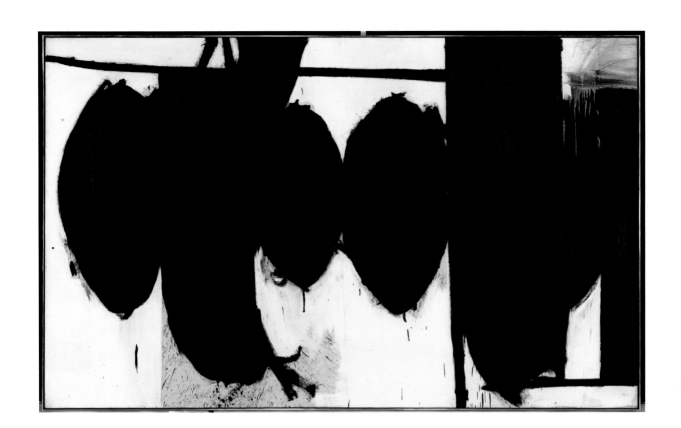

Frank Stella

Tuxedo Junction, 1960

Tuxedo Junction belongs to Frank Stella's early works, as well as to a series of paintings the artist produced between 1958 and 1960 — the so-called "Black Paintings." Just like the remaining twenty-three pictures in the series, *Tuxedo Junction* is strictly formal in its artistic structure. Here, Stella paints diagonal, parallel stripes some two and a half inches thick using black enamel paint to generate two superimposed lozenge patterns; their tips come together in the center of the picture, as well as spilling out over and beyond it in an identical pattern with no obvious end in sight. Stella's concept of an art composition using two black stripes running in parallel offers a whole variety of variations based on other geometrical shapes; these find expression in the "Black Paintings" series, while still retaining the underlying similarities. Stella went on to produce entire series in his later works, with the intention of exhausting a particular visual idea. In accordance with the then new ideas and goals of Minimal Art, Stella stood, right from the beginning of his artistic career, for the concept of the non-representational artwork. In contrast to other Minimalist figures, such as Donald Judd and Dan Flavin, he remained true to the traditional media of the painter. Emphasized in his "Black Paintings" are their stereometric quality, their flatness and their objectiveness. In all of them, he attempts to exclude any signs of a personal style. He is making an emphatic statement against illusionistic and subjective art. At the same time, this first series points the way toward Stella's further artistic development; he uses the fundamental idea behind his "Black Paintings" in a consistent manner, going on to produce later series such as the so-called "Shaped Canvases" through the plastic art of his aluminum reliefs, the "Cones and Pillars." The picture remains an autonomous object, though the strict formalism of parallel stripes he imposes upon it slowly disappears, accompanied by a reduction in his use of the color black. Event today Stella — unlike virtually any other artistic figure — continues his exploration of constantly new artistic ideas which he exhaustively tries out in series encompassing every conceivable variation. *I. N.*

Rubin, W. (ed.). *Frank Stella 1970–1987.* Exh. cat. The Museum of Modern Art. New York, 1987.

Frank Stella. Exh. cat. Haus der Kunst. Munich, 1996.

Richardson, B. *Frank Stella: The Black Paintings.* Baltimore, 1976.

Rubin, L. *Frank Stella: Paintings 1958 to 1965: A Catalogue Raisonné.* New York, 1986.

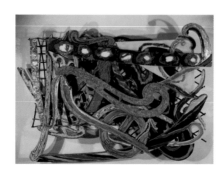

Harewa, 1978

Alberto Giacometti

Walking Man I, 1960

The visitor's every attempt to imitate the bodily movements of Alberto Giacometti's *Walking Man* results in aching muscles and the realization that the artist created something quite different from a realistic representation of a man walking. Both arms and hands hang stiffly next to the hips, both knees are rigidly straight, both feet rest heavily on the pedestal like weighty clumps of earth, even if, under the raised right heel, it is only a question of a "filling" that anchors the leg to the slab. This is a precarious position for the imitator, above all as a result of the sharp forward tilt of the upper body. No human being stands or walks like this. Giacometti by no means worked according to a model from nature but borrowed the compositional idea from *Homme qui marche* (1878), a work by the great French sculptor Auguste Rodin, then developed it to suit his own complex artistic concept. Whereas the muscles of Rodin's figure (a preaching St. John the Baptist), despite the position of both feet planted firmly on the ground, reflect real locomotion in our natural world, Giacometti's *Walking Man* is an incarnation from a metaphorical world, a world beyond — the other world of ancient Egyptian art. The sculpture should be read like a hieroglyph. (Strangely enough, the Chinese character for "person" or "man" resembles Giacometti's *Walking Man*.) The artist first used this motif in 1946 in a sketch for a monument to commemorate a French politician who was shot while being held hostage, in order to symbolize the inspiration he would provide for others even after his death. At that time the motif had yet another meaning. Grouped with other walking men on a single platform (to represent a public square) or contrasted with a *Standing Woman*, it embodies the active man of every day who hopes to attain fulfillment and immortality through a relationship with a woman. Giacometti planned this compositional concept in 1958 for the Chase Manhattan Plaza in New York's banking district. For this project, which was never realized, he created the four much larger than life-size *Standing Women I–IV*, two life-size figures *Walking Man I* and *II*, and a monumental *Large Head*. His concept comes to life not within the halls of a museum, but in an urban space surrounded by passers-by; only then do we comprehend that the *Walking Man* was intended as a stylized, symbolic figure and not as a realistic reflection of nature.

Alberto Giacometti 1901–1966. Exh. cat. Kunsthalle Wien, 1996.

Julier, C. *Giacometti*. New York, 1986.

Lord, J. *A Giacometti Portrait*. New York, 1965; rev. edn., 1980.

Lord, J. *Giacometti: A Biography*. New York, 1986.

Schneider, A. (ed.). *Alberto Giacometti: Sculpture, Paintings, Drawings*. Munich, 1994.

Surrealist Table, 1933

Large Black Head, 1961

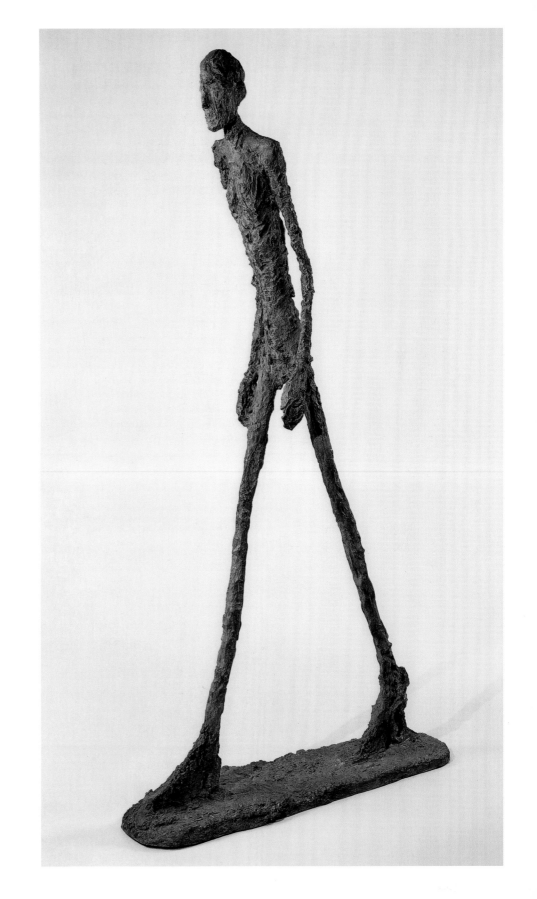

Cy Twombly

Vengeance of Achilles, 1962

This vertical-format picture is dedicated to Achilles, the hero of Homer's *Iliad*. Cy Twombly turns Achilles' revenge into a visual event: in the shape of a gigantic "A," loose gestural lines in the lower section create a pulsating field. The energy thus generated concentrates itself into the tip where red oil paint has been applied in impatient movements, both with the brush and with the fingers. In this concentrated form, the content and emotion inherent in the story are expressed with equal weight. The "A" stands for Achilles, who represents the propelling force in the war between Greece and Troy. At the beginning, he does not want to take part in the struggle, but changes his mind after his friend Patroclus is slain by Hector, the Trojan general. Seeking revenge, Achilles enters into battle and leads the Greeks to victory. Hector is pierced through by Achilles' spear. The picture focuses on the bloody spear tip as well as the aggressive nature of events. And so the ancient epic is rendered contemporary in a subjective fashion, having new life and vigor breathed into it. In other pictures, too, Twombly is concerned with the themes of violence, heroism, and death. He devoted a series of ten paintings to the *Iliad* in 1978. He repeatedly portrays European and particularly Antique culture taken from mythology, works of art, and literature, which provide this American artist living in Rome with a fertile source. This subjective revival of ancient myths had a powerful influence on a younger generation of artists belonging to the avant-garde, especially in Italy. Gestural, often emotionally laden, expression follows the tradition of American Abstract Expressionism. However, Twombly distanced himself from this movement in the mid-1950s, when the drawn line became his most important means of expression, also in oil painting. Moreover, his linkage of script and picture, which relativize the individual and coded expressional systems, distinguish him from his American predecessors. The painting shown here is from the 1960s when Twombly was becoming famous, particularly in Europe. In subsequent work between 1966 and 1972 he investigated the themes of movement and time, which characterize his entire oeuvre, in a more analytical fashion by using minimal color. In his later works, characterized by the themes of passing time and transitoriness, the pictorial quality becomes paramount.

R. L.

Cy Twombly: Retrospective. Exh. cat. Neue Nationalgalerie Berlin. Berlin, 1995.
Bastian, H. (ed.). *Cy Twombly: Catalogue Raisonné of the Paintings*. Vol. I: 1948–60. Munich, 1992.
Szeemann, H. (ed.). *Cy Twombly: Paintings, Works on Paper, Sculpture*, Munich, 1970.

Untitled, 1961 *(Roma)*

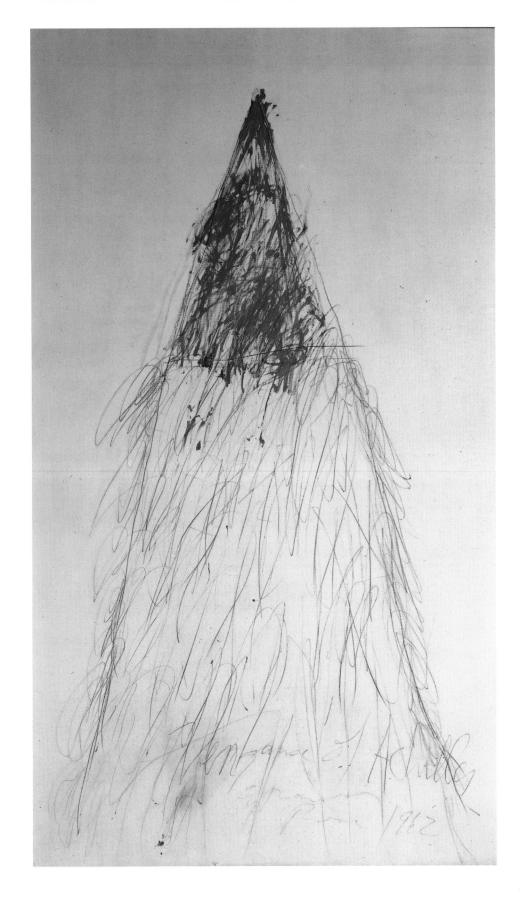

Jean Tinguely

Hong Kong, 1963

Since the mid-1950s Jean Tinguely has been constructing kinetic objects from pieces of scrap, as well as machines, with neither purpose nor function; these have won him worldwide recognition. His early works, in which he made use of unaltered found objects, are characterized by their impermanence and their improvization, as well as by their sensitivity and their disregard for material. The work *Hong Kong*, produced in 1963, marks an important turning point in the artist's career. Prior to this time, his work was generally constructed from light, unchanged found objects which were driven by used, overhauled motors. Now he went on to create large-scale objects in which the sculptural form as a general statement moved increasingly into the foreground. Though still made from scrap, the sculptural nature of these objects came to be stressed through a stricter, more formalized construction and the consistent use of the same matte black color in all the works he produced during the 1960s. The outlines and formal sculptural structure thereby came to the fore. A decisive factor in Tinguely's change of direction was his discovery of smaller and more efficient motors in connection with an exhibition in the Dwan Gallery in Los Angeles. These allowed him to create large-scale sculptures possessing a "superior elegance and integrity of form," like *Hong Kong*; at the same time, they express still further the absurdity of aimless mechanized movement. *Hong Kong* holds a position of special significance among Tinguely's works from the 1960s. Along with *Hannibal*, also made at this time, it is one of the first that we can call an *objet trouvé* (found object) in which a sculptural character nevertheless prevails; this development took Tinguely in the direction of the New Realists. At the same time this work differs from others he created during the period owing to its stressed verticals. Arising from a small base not unlike a pedestal, itself positioned on three wheels and including the rim of a car wheel turned by a motor, two vertical spikes point upward; these terminate, respectively, in an iron wok and in a smaller wheel rim with a spindle welded onto it. The individual components of the sculpture are driven by two electric motors connected by a system of fan-belts; their continuous movements in association with the generated mechanical noises lend the object a sense of mesmerizing poetry. Jean Tinguely, with his kinetic objects and machines, has made a significant and an original contribution to contemporary art. His works have become a synonym for purposeless machinery representing non-development and non-productivity; they simultaneously express his intense involvement with the plight of modern-day man. *M. F.*

Hahnloser-Ingolf, I. *Pandämonium — Jean Tinguely*. Bern, 1988.
Hulten, P. *Jean Tinguely: A Magic Stronger than Death*. Milan, 1987.
Restany, P. *Une vie dans l'art*. Neuchâtel, 1983.
Violand-Hobi, H.E. *Jean Tinguely*. Munich, 1995.

Hommage à New York, 1960

Andy Warhol

Marilyn, 1964

1928 Andy Warhol is born Andrew Warhola on August 6 in Pittsburgh, PA, to Czechoslovakian parents

1945–49 Studies Pictorial Design at the Carnegie Institute of Technology in Pittsburgh; also studies art history, sociology, and psychology

1949 Changes his name to Andy Warhol

1949–60 Works as a commercial artist for fashion magazines, etc. in New York

1952 First solo exhibition, at the Hugo Gallery, NY

1956 Travels around the world

1957 Illustrator for *Life* magazine

1960 First paintings with "pop" motifs: Coca-Cola bottles and figures from comic strips

1962 Turns to silkscreen printing

1963 First films; meets Marcel Duchamp in Pasedena, CA; moves into a loft on 47th Street that will become known as the Factory

1964 For political reasons, his "wanted" pictures, commissioned by the state of New York for the world's exposition at Flushing Meadow are overpainted; first exhibition at the Leo Castelli Gallery, NY

1967 Visits Cannes

1968 Shot and seriously injured by Valerie Solanis

1969 Publishes first issue of *INTER/VIEW*

1972 First portraits

1975 Publishes *The Philosophy of Andy Warhol*

1979 Meets Joseph Beuys for the first time

1987 Dies on February 22 in New York

Every century has certain images which are characteristic of it. For the 20th century, one of these will be the face of Marilyn Monroe, as painted by Andy Warhol in countless variations between 1962 and 1965. Like an icon, the face of the 20th century's "most beautiful" woman regards us in stereotypical form, this idol of the masses, this dream woman who never really existed. The Marilyn Monroe who passed through the gossip columns of every international newspaper, who put on her inimitable smile for the flashlight blitz of the photographers, was an artificial figure, a product of the Hollywood dream factory. The "other" Marilyn, the highly intelligent, sensitive young woman who very soon found herself caught up in a vicious circle, a carousel turning with ever-increasing speed — this woman could not exist. Even today, fantasy and reality continue to merge in numerous monographs. Fact and fiction, it seems, can no longer be separated. And it was the weight of this discrepancy, the tension between her own feelings, her own identity and the incarnate myth, that finally broke her, and in macabre style; with her death, which has never been clarified, Marilyn Monroe took the final step necessary to establish her forever as a cult figure. Death on the one hand and eternal beauty, eternal youth, on the other. This was how the masses wished to see her, not as an aging individual with misfortunes and weaknesses, but as the eternally smiling beauty, the secularized saint of the 20th century. True, one could not pray to her, but one could at least dream about her. Andy Warhol created the model, the icon for this cult. The artist himself was the most original of the protagonists of Pop Art in New York in the 1960s. By immortalizing the trivial icons of the mass-consumer society from Coca-Cola to Mickey Mouse, followed by a series of catastrophe paintings, of electric chairs and suicides, painted in the same apparently impersonal style, he created an unmistakable panorama of our time: on the one hand consumption, on the other transience. Andy Warhol came from the poorest of backgrounds, growing up as the son of Czech immigrants in the U.S.A. At the age of twenty he was already a successful commercial artist and designer. Within a brief period of time, he achieved considerable prosperity, becoming a famous film producer and director; he called his studio "The Factory." He was also a much sought-after portrait painter of the rich and beautiful. He died suddenly on February 22, 1987, as a result of a gall-bladder operation, four weeks after the death of his friend, Joseph Beuys.

E. W.

Ammann, T. (ed.). *Andy Warhol: Werkverzeichnis I. Gemalte Bilder und erste Siebdrucke 1960–62*. Munich, 1992.
Baal-Teshuva, J. *Andy Warhol, 1928–1987: Paintings from the Collection of José Mugrabi and an Isle of Man Company*. Munich, 1993.
Feldman, F. and J. Schellmann (ed.). *Andy Warhol: Prints: A Catalogue Raisonné*. New York, 1989.
McShine, K. (ed.). *Andy Warhol: Retrospective*. Munich, 1989.

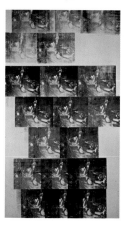

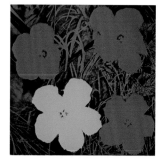

Flowers, 1964

White Car Crash 19 Times, 1963

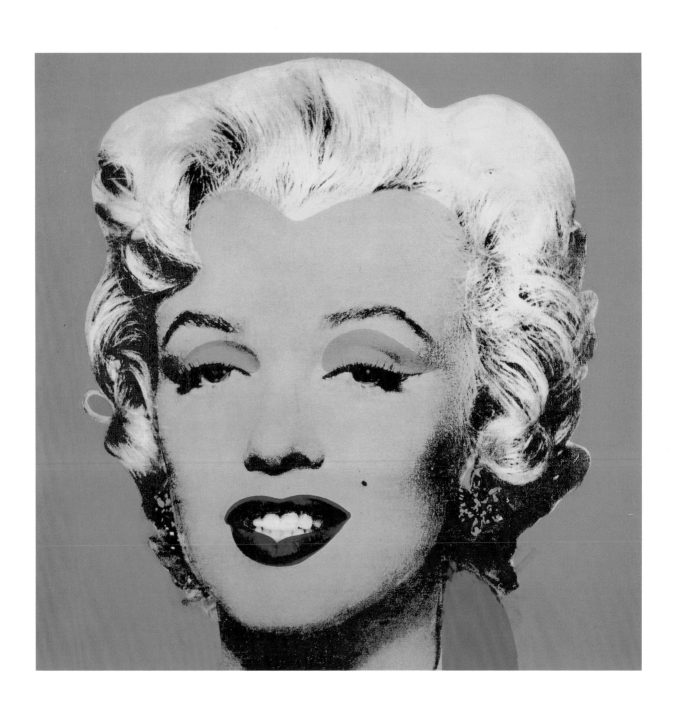

Claes Oldenburg

Soft Washstand, 1965

"I am for an art that does something other than sit on its ass in a museum … I am for the art of sailing on Sunday, and the art of red and white gasoline pumps … I am for the art of scratchings in the asphalt, daubing at the walls … I am for the art of bending and kicking metal and breaking glass, and pulling at things to make them fall down … I am for the art of things lost or thrown away, coming home from school…" These quotes have been taken from a longer, famous statement made by Claes Oldenburg in 1961, which is one of the few written comments made by an artist regarding Pop Art. Oldenburg's world of things is a bizarre combination of trivial objects; objects we use on a day-to-day basis, which surround us, but which we are hardly aware of. These objects are changed by the artist, are robbed of their function to the extent that, at first, we do not recognize them, we experience them as something foreign, and consequently rediscover them. Oldenburg transforms the sharp edges and serial perfection of typewriters, sinks, and light switches by reproducing them in soft plastic materials. All of a sudden they appear to be clumsy or tired, kind or sad: these familiar objects take on human features. A light switch, an object that we switch on and off hundreds of times, that we are no longer even aware of, is rediscovered in a huge three-dimensional shape. A washstand becomes an awkward soft construction that retains nothing of its original function; the faucets are helplessly dangling lumps. "Everyone who wants to be loved wants a flexible world," says the artist. In the 1960s Oldenburg would create several versions of a work: sometimes he would use fabric, other times vinyl. The latter is generally regarded as an unpleasant, unartistic substance. Oldenburg manages vinyl with great virtuosity: he cuts and forms it, and forces it into the shape he wants. By comparison with the objects made of fabric, the vinyl objects, like the washstand here, seem more audacious, louder, and even have a happy, comical aspect about them. The artist's ironic humor is evident in the blue piece of vinyl that represents the water in the sink. Oldenburg's first important group of works was exhibited in 1960 as the environment *The Street*, which consisted of several reproductions of figures and objects made out of cardboard, newspaper, linen, and so on. He became famous as a protagonist of Pop Art through the group of figures known as *The Store*. After 1963 he reproduced domestic objects, including the *Washstand*, often in three versions and in different sizes: a "hard model" made of cardboard, a "soft version" made of vinyl, and a "ghost version" made of fabric. Since the 1970s Oldenburg's interest has shifted increasingly towards monumental sculpture, which has left its mark on cities and squares all over the world. Oldenburg has not only rehabilitated the trivial object and led it to new levels of perception, he has also monumentalized it and set it in a hierarchy-free world of images.　　　　*E. W.*

Claes Oldenburg. Exh. cat. The Museum of Modern Art. New York, 1970.

Claes Oldenburg: Multiples 1964–1990. Exh. cat. Portikus. Frankfurt am Main, 1992.

Bruggen, C.v. *Nur ein anderer Raum / Just Another Room.* Museum für Moderne Kunst. Frankfurt am Main, 1991.

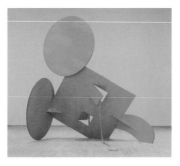

Geometric Mouse — Scale A, 1973

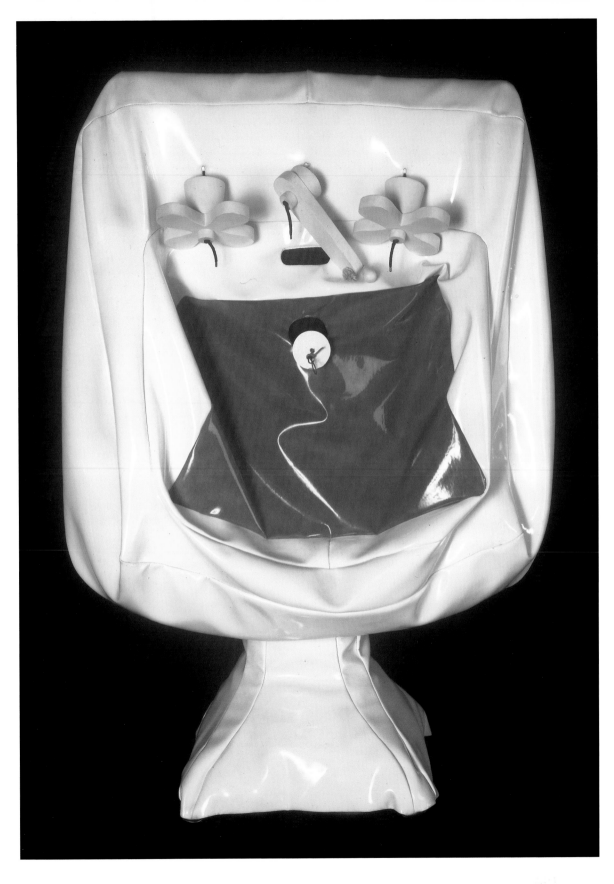

Roy Lichtenstein

M-Maybe (A Girl's Picture), 1965

High art and mass culture: this contrast was called into question in the early 1960s by a new artistic movement — Pop Art — in which everyday occurrences are commented on with cool distance and an apparent lack of individuality using creative techniques from the world of design. One of Pop Art's chief exponents, along with Andy Warhol and Claes Oldenburg, is Roy Lichtenstein. "Is he the worst painter in America?" asked *Life* magazine in 1964. In his early representational pictures, which were influenced by Cubism, Lichtenstein worked with themes taken from American history and folklore. During the 1950s, he turned to Abstract Expressionism but found that it lacked unself-conscious, unrestrained self-expression. After 1960 — particularly through impulses from Oldenburg and Allan Kaprow — he became interested in incorporating elements of commercial art and advertising into his works. He depicted the turning away from the gestural and expressive in art with, among other things, his "brushstroke" paintings. In emotionally charged "action painting," brushstrokes were woven into an explosive mesh of color. Lichtenstein singles them out and presents them as an autonomous and controllable form — devoid of the mark of any individual hand. In his gigantically oversized "brushstrokes," not a single real stroke of a brush is visible. In 1961, Lichtenstein's children asked him if he could enlarge their comic-book figures to an enormous size. "Now I think I started out more as an observer than as a painter, but, when I did one, about halfway through the painting I got interested in it as a painting. I began to realize that this was a more powerful thing than I had thought...." Lichtenstein combines cut-outs from advertisements and mail-order catalogues to create new images. On enormous canvases, he imitates the effect of their simple printing process by painting oversize, colored benday dots on a white background, producing images designed to be seen from a distance. He manually transfers single frames of comic strips, including speech bubbles, or sometimes just a detail from a comic strip, onto vast canvases. Since 1963 he has simplified this procedure with the help of an episcope. Cartoons and comic strips provide him with the most varied images with which to work — from banal love scenes to war scenes. In the process, he creates paintings composed of fields of solid color. Clear, unmixed color areas bounded by thick black contour lines characterize his works. Intermediate hues are produced with benday dots or hatching. Lichtenstein remains largely faithful to his original model, changing only how the image is cropped at the edges, or filling in or removing minor details; a black-haired female character becomes a blonde. Taken out of their context, the words in the speech bubble in *M-Maybe (A Girl's Picture)* become meaningless. Between 1961 and 1965, time and again it was blondes who dominated his pictures. Some friends suspect this was a way of coming to terms with his stormy relationship with his first wife, Isabel, which ended in divorce. *A. L.*

Corlett, M. L. *The Prints of Roy Lichtenstein: A Catalogue Raisonné, 1948–1993*. New York, 1994.

Hendrickson, J. *Roy Lichtenstein*. Cologne, 1988.

Roy Lichtenstein. Exh. cat. Musée d'Art Contemporain. Lausanne, 1992.

Waldman, D. *Roy Lichtenstein*. Exh cat. The Solomon R. Guggenheim Museum. New York, 1994.

Blang, 1962

Joseph Beuys

Eurasia — 32nd Movement of the Siberian Symphony, 1966

Joseph Beuys — considered by his followers to be the most important artist of the post-war era — came to fame through his spectacular "actions" in the 1960s. He would confront his astonished audience with perplexing and complicated rituals, with which he appeared to be making some sort of sacrifice. A large number of his later "objects," which he presented in the form of fetishes or relics as carriers of mystical powers and meaning, were leftovers from these performances. The work depicted here goes back to the action *Eurasia — 32nd Movement of the Siberian Symphony*, which Beuys performed at Galerie 10 in Copenhagen on October 14 and 15, 1966. In the course of this performance the artist drew a cross division on a slate blackboard, indicating the division between East and West that was to be bridged symbolically by this action. Later, he tied a piece of iron to his foot and maneuvered a dead hare, the length of whose legs he had extended with long, thin, wooden rods, through the room towards the East, the direction in which the hare would be traveling. After the performance, Beuys united the board and hare to form an object, completing the complex with bits of grease and felt. Faced with Beuys' objects and happenings, the observer is as baffled as when confronted with Marcel Duchamp's *Bottle Rack*. Mysterious, dark meanings interrelate and demand prior "inside" knowledge which the uninitiated viewer does not possess. In the end, one is confronted with the inadequacy of one's range of experience and consequently forced to open up to Beuys' message of salvation: he thus encourages self-reflection and a revision of one's way of seeing. Beuys wants to heal. His main "material" is the human being. He intends to heal humanity, because the individual in today's Western culture is sick. "The human being must stoop down again and relate to animals, plants, nature, and look up and relate to the angels and spirits," Beuys told his biographer Heiner Stachelhaus. Beuys transcended the role of the artist and deliberately stylized himself as a shaman through his "uniform" (fishing vest, jeans, and felt hat) and his performances. He saw his objects merely as "autobiographical documents.... Whoever understands their meaning turns away from them and towards my ideas. Many already consider my signature a work of art in itself." Beuys views himself as a "seer," a visionary. The messianic mission of the "enlightened" is what drives his performances and his success; it ensures the continuance of his grandiose self-image and allows his faithful community of followers and exegetes to identify with his message. *S. B.*

Götz, A., W. Konnertz, and K. Thomas. *Joseph Beuys: Leben und Werk*. Cologne, 1981.

Grinten, F.J. and H.v.d., *Joseph Beuys, 1936–1965: Ölfarben — Oilcolors*. Munich, 1981.

Romain, L. and R. Wedewer. *Über Beuys*. Düsseldorf, 1972.

Tisdall, C. *Josep Beuys*. New York, 1979.

Verspohl, F.-J. *Joseph Beuys: Das Kapital. Raum 1970–77. Strategie zur Reaktivierung der Sinne*. Frankfurt am Main, 1984.

Elk with Woman, 1957

Gerhard Richter

Ema (Nude on a Staircase), 1966

1932 Gerhard Richter is born on February 9 in Dresden

1949–52 Works as a scene painter and commercial artist in Zittau in the German Democratic Republic

1952–56 Studies at the Art Academy in Dresden

1956–60 Member of the master class at the Dresden Academy

1961 Moves to Düsseldorf in West Germany

1961–63 Studies under Karl-Otto Götz at the Art Academy in Düsseldorf

1963 Happening: *A Demonstration for Capitalist Realism in Düsseldorf*

1966 *Ema (Nude on a Staircase)*

1967 Visiting lecturer at the College of Visual Art in Hamburg

1968–69 Art teacher in Düsseldorf

from 1971 Teaches at the Düsseldorf Art Academy

1971–74 *Color Fields* series

1972–75 Series of *Gray Paintings*

1978 Visiting lecturer at the College of Art in Nova Scotia, Canada

1983 Moves to Cologne

1985 Oskar Kokoschka Prize in Vienna

1986 Retrospective of Richter's complete work at the Kunsthalle Düsseldorf

1988 Exhibition at the Art Gallery of Ontario, Canada

1992 Documenta IX, Kassel

1995 Marries Sabine Moritz, also a painter

1996 Awarded the Golden Lion at the Venice Biennale

2002 *Gerhard Richter: Forty Years of Painting* opens at the Museum of Modern Art, New York

2003 Exhibition at the Deutsche Guggenheim, Berlin

Lives in Cologne

This painting, which depicts a nude descending a staircase, was based on a photo Gerhard Richter took of his first wife. The depiction returns to the traditional genre of female nudes commonly found in the history of art, but which seemed to have disappeared from painting in the 1960s. The picture is a direct reference to Marcel Duchamp's *Nu descendant un escalier*, dating from 1912, which, in its dialectic between abstract and figurative art, has become symbolic of the conflicts of the avant-garde. The representation of the nude figure, in which the sequence of movements is analyzed by spreading out the various parts of the body in a fan-like manner, is turned by Richter into an iconographic depiction of sensuously luminous coloration. At the same time, this is negated by the picture's insistence on its photographic origins. The ambivalence between a belief in the powers of painting and doubts about its scope, which pervades Richter's work, already manifests itself here. Richter began to explore this interplay between pictorial destruction and photographic restitution in 1962, shortly after leaving East Germany. Banal snapshots from newspapers and his own life are transferred to the canvas. It is not the reproduction of photographs in painting that is important, but the criticism leveled at the merging of photographic representation and visual appearance in the context of our media-based comprehension of reality. In Richter's eyes, a picture that seeks to depict reality cannot be complete. In its lack of focus, it reveals our relationship to reality and the limitations of our cognitive abilities. The anti-illusionist blurring technique he employs serves to heighten the fleeting nature of the photographic material and thus prevents an equation of the painting with reality by de-individualizing the subject and creating a critical distance to it. Although Richter places less value on thematic representation than on the intrinsic medial value, the eye is also drawn to the likeness itself, with the result that the claim to reality made by the medium of photography is deconstructed. The stage where reality is communicated by a number of means becomes definable; and the image (as well as the model on which it is based) becomes accessible in terms of its specific media characteristics. The liberation from the ties of Socialist Realism on the one hand and, on the other, the non-figurative style of painting in post-war Germany and the impact of Pop Art make Richter one of the leading artists of his generation. In any discussion on the quality of modern painting, he is an artist who still poses a challenge in his abstract works created after 1970–71. In its heterogeneous nature, his oeuvre, which explores the realm of painting between its reproductive function and self-reflection, can be understood as a systematically versatile artistic undertaking.

P. D.

Gerhard Richter: Aquarelle. Exh. cat. Staatsgalerie Stuttgart, 1985.
Gerhard Richter. Exh. cat, 3 vols. Stuttgart, 1993.
Gerhard Richter, Vols. I–III. Musée d'Art Moderne de la Ville de Paris. Paris, 1993.
Loock, U. and Zacharopoulos, D. *Gerhard Richter*. Munich, 1985.
Obrist, H. U. (ed.). *Gerhard Richter: 100 Bilder*. Stuttgart, 1996.

Atlas, 1962–97

Sigmar Polke

Modern Art, 1968

The painting *Modern Art* from 1968 is a parody on the "truths" of painting. Here, Sigmar Polke presents all the clichés that fulfill the average pictorial expectations of the common observer. It is a painting on whose surface brushstrokes are readily decipherable. It assumes a moderate format and has a title. One can see a balanced composition, in which the most important criteria of modern art are brought together: figurative and abstract elements, geometrically defined as well as free-standing forms, linear as well as expressive application of color. Constructivist motifs are cited from Malevich or Kandinsky, whose intellectualized theories are put into question by means of definitive gestures with an intensely colored violet paint splashed over them. The painting is framed by a white edge, which defines it as a picture. Or is it instead an illustration of a previously existing painting? It looks like an enlarged copy of a page from a book, at the top of which the catchword "Modern Art" is printed for everyone to read. What is original here, what is forged or reproduced? **P**olke never allows himself to be forced into an art-theoretical straitjacket. He goes to great lengths to pose questions about painting, through his painting. In so doing, he carefully dissects common conceptions regarding a given work. Wedged stretchers were made into visible "picture carriers," while patterned decorative material and variable color features became "meaning carriers." Transparency and complexity characterize his way of thinking. With unconventional, ever-new forms of pictorial means, he is able to translate both into painting. Polke's hallmark is his use of benday dots, with which he imitates and derides pictures of current events reproduced in the media. Viewed from afar, the pattern of dots makes up a coherent picture, though his works are illustrations of reproduced pictures of reality. At the same time, the artist gives each dot its own shape by painting each one individually. One must look very closely at his pictures to take note of the disturbing blots — hidden references to reality being manipulated. **S**igmar Polke delights in disconcerting the observer by means of irony and satire, though seldom does he become cynical. "One sees what it is," wrote Polke below one of his pictures, allying himself like a friend with the viewer — though "one" might first have to learn how to see. Then he or she will be able to take in and interpret the apparently trivial content of Polke's pictures in the way the artist intended, in order to break down boundaries and to create space for "the unforeseeable, which is the only thing that is interesting."

A. Er.

Sigmar Polke/Achim Duchow. Exh. cat. Kunsthalle Kiel, 1975.

Sigmar Polke. Exh. cat. Museum Boymans-van-Beuningen, Rotterdam, and Kunstmuseum Bonn, 1984.

Sigmar Polke: Transit. Exh. cat. Staatliches Museum Schwerin, 1996.

Sigmar Polke: Die drei Lügen der Malerei. Exh. cat. Kunst- und Ausstellungshalle der Bundesrepublik Deutschland. Bonn, 1997.

Doll, 1965

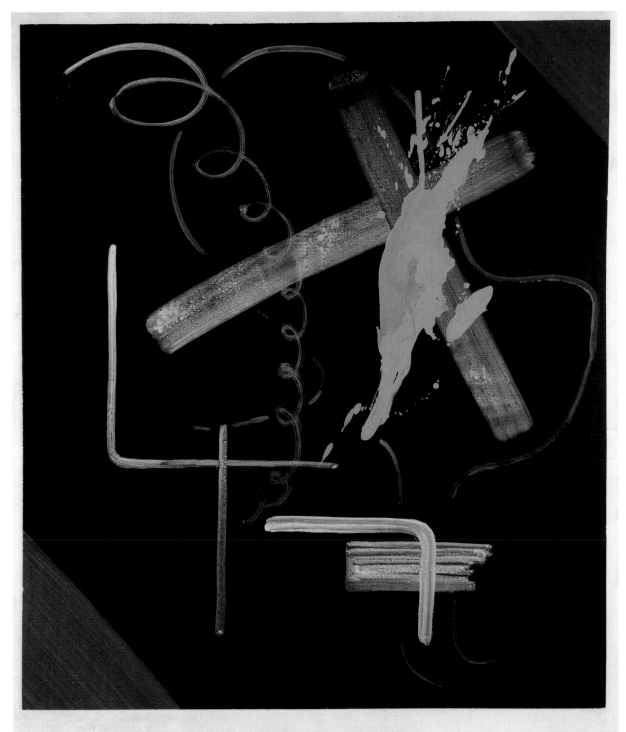

Moderne Kunst

Lucio Fontana

Concetto Spaziale "Attese", 1966

1899 Lucio Fontana is born on February 29 in Rosario de Santa Fé, Argentina

1905 Family settles in Milan

from 1914 Visits a contracting school in Milan

1917–18 Military service; passes his engineering exams

1922 Returns to Argentina; works in the sculpture studio of his father

1924 Establishes his own studio in Santa Fé

1928 Returns to Milan; enrolls at the Brera Academy

1930 Attains the diploma for sculpture at the Brera Academy; participates in the Venice Biennale

1931 First terracotta reliefs and slabs of cement

1934 Excluded from the Parisian artists' group Abstraction-Création; founds his own branch in Milan

1935 With other artists, signs the first manifesto of Italian abstract art

1936 In the summer, intensive study of ceramic work in the workshop of Giuseppe Mazzotti in Albisola

1937 Works for the porcelain manufacturer Sèvres in Paris; first exhibition of his ceramic sculptures, at the Galerie Jeanne Boucher in Paris; becomes acquainted with Constantin Brancusi, Joan Miró, and Tristan Tzara

1939 Returns to Argentina

1940 Moves to Buenos Aires; teaches at the Art School Altamira

1946 Founds the private academy of Altamira together with José Romero, Brest, and Larco

1947 Returns to Milan; signs the "Technical Manifesto of Spatialism"

1948 Designs for *Ambienti Spaziali*

1949 First "buchi" that carry the title *Concetto Spaziale*

1952 First "pietre," objects decorated with rocks

1958 First of the *Concetti Spaziali* that he entitles "Attese" (Anticipation)

1963 Begins the series *Fine di Dio*

1966 Retrospective in the Walker Arts Center, Minneapolis, MN

1968 Dies on September 7 in Comabbio, Italy

1970 Retrospective in the Musée d'Art Moderne, Paris

It was only late in life, after many years of experimentation with varying forms of sculpture, that Lucio Fontana began to work in the two-dimensional medium of painting. In 1958 he began to perforate canvases painted for the most part with a single color, first with holes ("buchi"), later with slashes ("tagli"). *Concetto Spaziale "Attese"* of 1966 belongs to this last, especially comprehensive, group of work by the artist. The emphatic flatness of the monochrome, red-painted canvas is interrupted by twelve vertical slashes. The narrow, elliptic openings which result from the cuts show glimpses of a dark, indefinite "background" which seems to extend endlessly into space. Fontana thus achieves an entirely new artistic formulation for a traditional theme in painting: namely, the representation of three-dimensional space on the two-dimensional surface of a canvas. In doing this he eschews conventional illusionistic methods of representational painting, searching instead — in imitation of sculpture — for ways to produce and make open to experience an illusion of space through the medium of the material itself. The cutting of the picture surface, which had until then been sacrosanct, is therefore to be seen, not as a destructive but rather as a constructive and, at the same time, calculated act. The slashes which seem to open on to infinity create a real space which does not, at the same time, negate the flatness of the canvas. The meaning of the work is to be found precisely in this coexistence of apparently irreconcilable aspects, and in the harmony and balance which result in the overall composition. Already back in the 1940s Fontana had begun to title his paintings *Concetto Spaziale* (Spatial Concept), which pointed to his new preoccupation with an art of space, regardless whether in painting or sculpture. **A**lthough Fontana remains faithful to the traditional medium of painting, contradicting the thrust of his numerous theoretical essays which call for a renewal of pictorial means, the "tagli" — because of their position between sculpture and painting — justify Fontana's fame as an artist of the avant-garde. With them Fontana created a prerequisite for a new, freer use of the canvas as a surface for images.

I. N.

Crispolti, E. and J. v. Marck. *Catalogue raisonné des peintures, sculptures et environnements spatiaux*, 2 vols. Brussels, 1974.

Messer, T. M. *Lucio Fontana*. Exh. cat. Schirn Kunsthalle. Frankfurt am Main, 1996.

Schulz-Hoffmann, C. *Lucio Fontana*. Munich, 1983.

Scultura Astratta, 1934

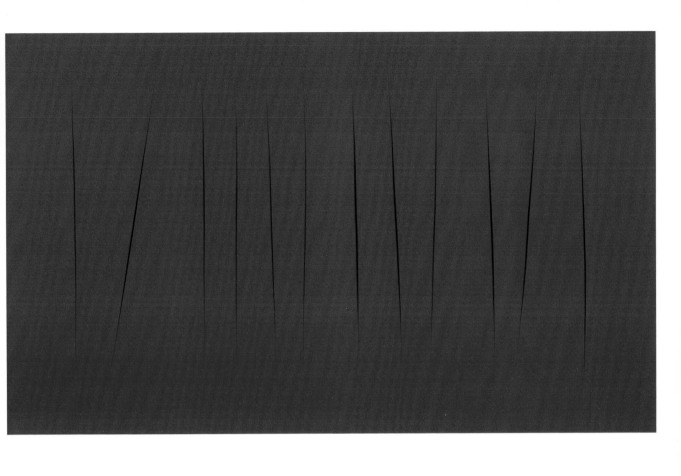

David Hockney

A Bigger Splash, 1967

1937 David Hockney is born on July 9 in Bradford, Yorkshire

1953–57 Studies at Bradford College of Art

1959–62 Studies at the Royal College of Art, London

1961 Takes part in the exhibition "Young Contemporaries"

1961–63 Etching series based on William Hogarth's *A Rake's Progress*

1962–63 Teaches at Maidstone College of Art in London

1963–64 Visiting lecturer at the University of Iowa

1965 Visiting lecturer at the University of Colorado, Boulder, CO

1966–67 Lectures at the University of California, Los Angeles

1967–68 Creates a series of portraits of his friends

1971 Publishes "12 Drawings"

1974 Makes the movie *A Bigger Splash* with Jack Hazan

1975–92 Designs a variety of different stage sets

1988 Major retrospective at Los Angeles County Museum of Art, subsequently shown at the Metropolitan Museum of Modern Art, New York, and at the Tate Gallery, London

1999 Three exhibitions shown simultaneously in Paris: *David Hockney. Espace Paysage* at the Centre Georges Pompidou, *Dialogue avec Picasso* at the Musée Picasso and *David Hockney Photographies* at the Maison Européenne de la Photographie

Six Grand Canyon paintings are part of the summer exhibition at the Royal Academy of Arts, London, where they win the exhibition's annual Wollaston award

Lives in London and the U.S.A

David Hockney is one of the most important representatives of British Pop Art. His move to California at the beginning of the 1960s inspired him to paint a number of swimming-pool pictures. In a series of calm, almost static, snapshot-like views, they evoke an effulgent, laid-back atmosphere that, in this example, is disturbed by "a bigger splash." The picture, precisely constructed from photographs, is painted in acrylics with bright, even areas of color. The splash was added subsequently in impasto. There are no human figures in this uncannily peaceful scene (apart from the swimmer, of course, who is not visible). The landscape, too, is merely a backdrop of secondary importance to a scene of hedonistic leisure culture. The house and the pool are emblems of the Californian lifestyle Hockney has made his own. In view of the other pictures in this series, in many of which there is also a male figure bathing, Hockney would seem to have returned to the ancient myth of the Golden Age. The clinically clean atmosphere should not, however, cause one to overlook the fact that this is merely a reaction "after the Fall." Hockney's idyllic, sensually charged leisure world clashes with the profound social upheavals that took place in the 1960s, from which the artist tries in vain to shield himself. Hockney's perfectly staged visual worlds, for which he also used photomontage and collage, fascinated an entire generation of younger artists who preferred a "freely figurative" form of painting to an abstract art that had congealed into ornamentation. *H. D.*

David Hockney: A Retrospective. Exh. cat. Los Angeles County Museum of Art. Los Angeles, 1988.
David Hockney: Zeichnungen 1954–1994. Exh. cat. Hamberger Kunsthalle. Stuttgart, 1995.
Melia, P. and M. Livingstone. *David Hockney: Paintings.* Munich, 1994.

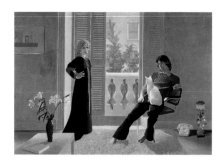

Mr. and Mrs. Clark and Percy, 1970–71

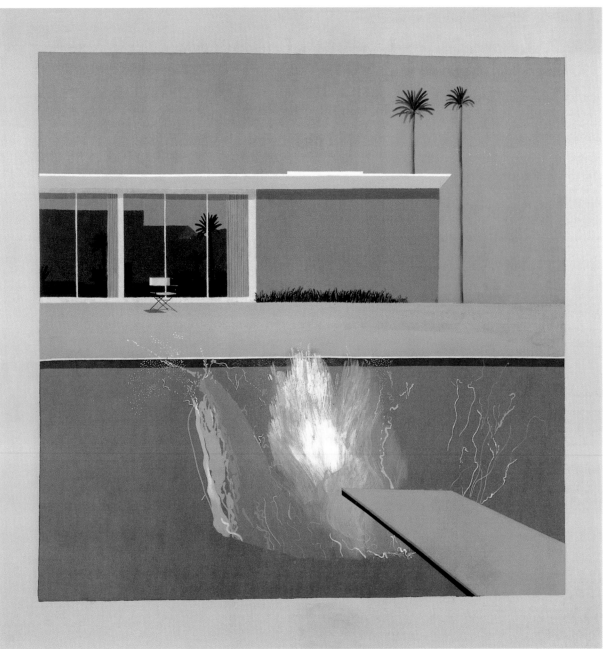

Nam June Paik

TV Buddha, 1974

As if the Korean artist had already foreseen in the 1960s the scarcely digestible flood of pictures that the invention of television would bestow upon us, he took this trophy of progress and, in a series of works, stripped it of sound and picture. In *Zen for TV* (1963), he turned the goggle-box 90 degrees onto its side and set the frequency so that just a pale vertical line was "transmitted" in front of an otherwise dark screen: a purposefully manufactured "interference" designed to evoke in any art lover or TV-hater the greatest aesthetic (malicious) pleasure. In other works, he disembowels the television completely, substituting a candle for its innards of electric circuits and transistors. Pointedly, he goes right against the purpose for which it was intended: instead of the expected stream of pictures and sounds, a self-prescribed asceticism of perception. Nam June Paik's attack is not just directed against the sound- and picture-spitting box, but perhaps also against TV entertainment and TV advertising, TV politics and TV sport — all this during the Cold War period, a time of wild consumption, when TV had long since lost its innocence as a technically neutral object and had become an instrument of mass psychosis. *TV Buddha* shows a development of these basic ideas. In the adjacent picture, it is not possible to see the video camera set up behind the monitor which films the face of the Buddha figure and transmits this to the screen. This "transmission," which has been developed into a still picture, is the subject of the Buddha's "closed-circuit" contemplation. "The observer and the object of observation are one and the same," referring to the highest condition of mystical consciousness. The Korean artist, inspired by the Eastern attitudes of his teacher, John Cage, may well have had this in mind, as well as the equally ingenious suggestion that there could be no more exciting topic for the television than the life of its viewers. **B**ut the very fact that Buddha himself — the incarnation of Emptiness — is sitting in front of the television, the epitome of *maya* (Sanskrit illusion), is irony enough! Paik, a Fluxus artist who made a name for himself in his early days in actions and happenings of a particularly destructive nature, sublimated his criticism of the entertainment industry and information society into such inventive objects, which in the choice of material alone — television sets — revolutionized art. *P. S.*

Decker, E. *Paik: Video*. Cologne, 1988.

Herzogenrath, W. *Nam June Paik: Fluxus, Video*. Munich, 1983.

Stooss, T. and T. Kellein (eds.). *Nam June Paik: Video Time — Video Space*. Exh. cat. Kunsthalle Basel. Stuttgart, 1991.

Family of Robot: Aunt, 1986

Barnett Newman

Who's Afraid of Red, Yellow and Blue, 1969–70

1905 Barnett Newman is born on January 1 in New York City

1922–26 Studies at Cornell University and at the Art Students League in New York

1923–27 Studies philosophy at the City College of New York

1929–30 Continues his studies at the Art Students League

from 1930 Is in contact with Jackson Pollock and Adolph Gottlieb

1931–39 Works as an art teacher at various New York high schools

1941 Attends botany and ornithology classes at Cornell University

1944 Organizes the exhibition "Pre-Columbian Stone Sculpture" for the Betty Parsons Gallery, NY

1946 Organizes the exhibition "The Ideographic Picture"

1948 *Onement I*; founds the art school "Subjects of the Artist" together with William Baziotes, Robert Motherwell, and Mark Rothko

1950–51 First solo exhibition, at the Betty Parsons Gallery in New York

1957 Suffers a heart attack in November

1958–66 *Stations of the Cross* series

1959 Teaches at the University of Saskatchewan in Saskatoon, Canada

1962–64 Teaches at the University of Pennsylvania, Philadelphia, PA

1964 First trip to Europe

1970 Dies on July 4 in New York

Barnett Newman is, along with Mark Rothko, one of the most important representatives of American Color Field painting, a style which split off from the action painting of Abstract Expressionism practiced by the New York School. Newman's early works were influenced by calligraphic surrealism, whereby around 1946–49 the meaning of the abstract pictorial symbols in a mystic-cabalistic context lost importance by comparison with formal problems. After receiving scorching criticism for his first solo show, Newman withdrew from the art scene for many years. By the late 1940s Newman had arrived at a style of painting that employed almost monochrome, but still gesturally structured, color fields crossed by a thin line in a contrasting color. These compositions were soon reduced further to homogeneous, pure color fields in large horizontal and vertical formats. Thin lines, like beams of light, divide up the picture surface of these often gigantic, almost overwhelming fields of color. For Newman, the sculptural process was tantamount to the act of creation. For him the line meant a first, creative stroke in the unformed matter of color, analogous to God's separation of light from darkness. Limiting himself to only a few ordering lines and the primary colors red, blue, and yellow, which gave his last paintings their titles, he hoped to control the chaos of possible forms. This simple pictorial arrangement signified for him a higher truth joined to the mystery of life and death. Newman's radical pictorial simplification is often described as Minimal Art, although, through the artist's Jewish-mystical attitude to reality, his works communicate an entirely different message which is not limited by formal elements. *H. D.*

Imdahl, M. *Who's Afraid of Red, Yellow and Blue III*. Stuttgart, 1971.
O'Neill, J. P. (ed.). *Barnett Newman: Selected Writings and Interviews*. New York, 1990.
Rosenberg, H. *Barnett Newman*. New York, 1978.

Midnight Blue, 1970

Dan Flavin

Untitled (To Virginia Dwan) I, 1971

Dan Flavin's light installation *Untitled (To Virginia Dwan) I* consists of one long, white neon tube to which three shorter, colored neon tubes are attached. They form a type of bridge over a corner of the room and bathe it in light in three colors. The room is thus articulated in a new way, and light, at the same time, becomes materialized through color. In 1963 Flavin had begun for the first time to work with neon tubes — an industrially manufactured material — in diagonal compositions such as this one. The tubes were to become the incunabula of his entire oeuvre, with which he explored the perception of and prerequisites for optical and spatial manifestations of light. The radically reduced, technically anonymous artistic language Flavin developed contrasts with the personal dedication he added as a subtitle for this installation (*To Virginia Dwan*), which assigns the work to a particular person. **A**s a protagonist of Minimal Art, in the early 1960s Flavin, along with other American artists such as Donald Judd, began to distance himself from Abstract Expressionism, the dominant movement on the art scene at that time, as well as from Pop Art's forms of expression. He also felt that the traditional materials and expressive possibilities of sculpture were out of date and no longer in step with the new techniques that were available. In his search for a new type of material to work with, Flavin concentrated on the phenomenon of light, which possesses no true materiality and therefore is not consciously perceived as a medium in its own right. Light, rather, wraps itself around objects; its function is to illuminate them, and therefore it subordinates its own special properties to the object's particular qualities of color and form. With Flavin's light installations, this order of visual perception is reversed: light doesn't illuminate, but shines for its own sake; it radiates without definite boundaries from inside outwards and develops an independent, as yet unrecognized aesthetic as well as an artistic dimension and expressive power. **F**lavin was the first artist to use light as an artistic medium, thereby also stimulating a new approach to this phenomenon. His installations showed the way for the following generation of artists such as Bruce Nauman or James Turrell. *I. N.*

Dan Flavin: Three Installations in Flourescent Light. Exh. cat. Kunsthalle, Cologne, 1973.
Deschamps, M. "Dan Flavin: Situations," in *Art Press* 21, 1, 1988.
Sauré, W. "Dan Flavin," in *Weltkunst* 41, 1971.

Untitled 1996

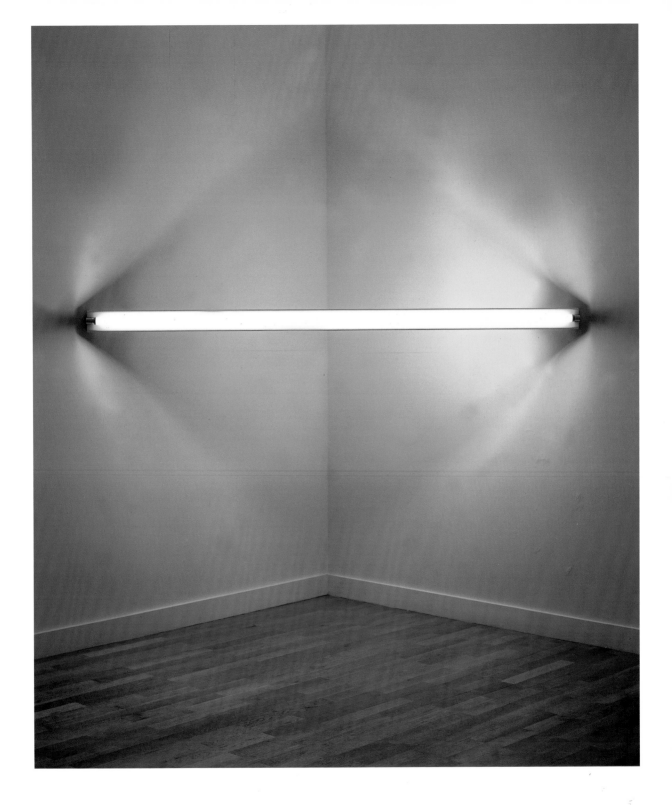

Francis Bacon

Triptych, August 1972

Under the impact of the death of his friend George Dyer, Francis Bacon painted a series of three different triptychs which echo the form of his 1965 *Crucifixion*. They were created between August 1972 and June 1973 and have come to be known as the "Black Triptychs" series. Here, "black" is not so much a reference to the color but rather describes the character of the images, which serve to remind us of our own mortality. The foreground of the *Triptych* of August 1972 is bounded by a wall running parallel to the picture surface; in each of the three panels, this is interrupted by a door opening. Black floods into the picture through these doors. The center panel shows a couple entangled in one another; Bacon derived this image from Eadweard M. Muybridge's wrestlers. But here the expression of the motif is more forced. This is no mere fusion of violence and love-making as Bacon often portrayed. Rather, we are witnessing a fight between life and death. The two bodies are inseparably bound in a deathly embrace. And yet two observers of this scene seem entirely ignorant of what is going on: the seated figure to the right has turned its back on the pair, while the figure to the left has its eyes screwed shut. Both of these are little more than torsos; the black shadows of the doors have caught up with them. Soon, their images will be swallowed up entirely but, for now, they cast flesh-colored shadows on the ground. Or are these really shadows? They appear to be fluid and shapeless; they seem to have little in common with the outlines of the figures. From early on in his career, Bacon reacted in an extremely sensitive fashion to the artistic rhetoric of his era. From his reflections upon and attempts at classifying the preferred styles found in the Modern period, we see in the formal aspects of his oeuvre a near-complete coverage of the major styles of 20th-century art. He plays with traditions, ranging from the radical break, the associative allusion, right through to the unscrupulous copying of individual picture elements. He is also fascinated by the technical media, by film and photography: film conveys movement, photography reflects reality. There is a permanent attempt in his work to capture movement, to incorporate space into the picture, to portray the same scene from different perspectives as though this were the most natural thing in the world. He breaks reality up into fragments and recombines the pieces to make up a collage. In addition, Bacon accords an immense role to coincidence. This is as significant to him as the subconscious is to the Surrealists. It not only formed the source of his inspiration when progress on a work began to falter; it was also a measure of the authenticity of a painting's reality. Bacon also uses a whole range of superb secondary skills: unconventional handling of the paint; the incorporation of parts of the raw, untreated canvas as elements of the finished picture; the confrontation between "blurred" forms suggesting movement and a monochrome application giving surfaces a static appearance; the contrast between evaporating figures with melting shadows and the crisp contours of objects.

W. Sch.

Leiris, M. *Francis Bacon: Full Face and in Profile*. Rev. edn., London and New York, 1993.

Schmied, W. *Francis Bacon*. Munich, 1996.

Sylvester, D. *Interviews with Francis Bacon*. 4th edn., London and New York, 1993.

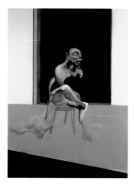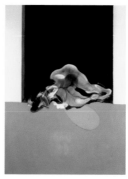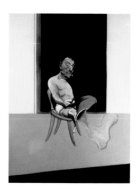

Triptych August 1972, 1972

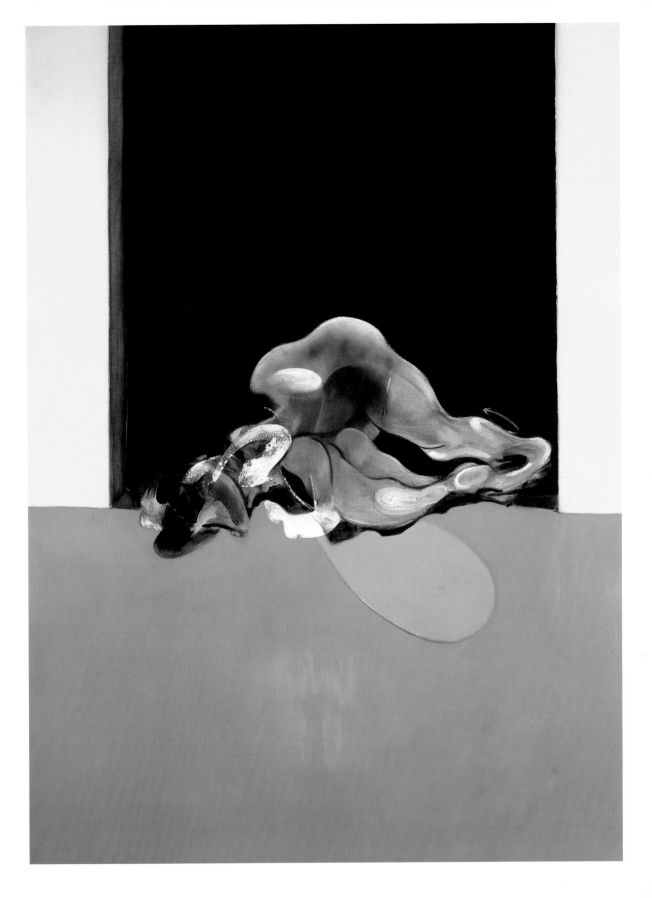

Lucian Freud

Rose, 1978–79

Lucian Freud concentrates on the human form. This is a theme that was shared by the representatives of the School of London: along with Freud, such artists as Francis Bacon in particular, as well as Frank Auerbach, Leon Kossoff, and Michael Andrews. Born in Berlin in 1922, Freud, who emigrated to England with his parents in 1933, is the grandson of Sigmund Freud, the founder of psychoanalysis. Lucian Freud describes his work as "purely autobiographical" in that he only paints people with whom he has a close personal acquaintance. Long sittings for models (150 hours in the case of Baron Thyssen) and the emotional relationship with the model lead to intense involvement with the subject of the picture: "It was not the appearance of the model that I wanted but his being. Not just a likeness as a mimer produces, but an identification in the way that an actor is able to achieve…. The painting *is* the person." In *Rose*, the observer looks down at an angle on to a brutally public presentation of a female nude, with the genital region positioned in the center of the picture. One is reminded of Gustav Courbet's *L'Origine du monde* (Musée d'Orsay). The gesture of covering her eyes made by a woman undressed in public already prefigures in the French Salon paintings of the 19th century (Jean L. Gérome, *Phryne Before the Judges*, 1861, Hamburger Kunsthalle). The gaze of the observer is not returned. Props such as the shoe thrown under the bed and the sheet covering the toes of the right foot and the left leg serve, on the one hand, to increase the impression of nudity of the human body and, on the other, to suggest that a love act may just have taken place. Ten years after the completion of *Rose*, Freud continued the theme of hiding and exposing in *Naked Man on a Bed*, with a male nude presented even more directly to the observer, with hands positioned so as to create a connection between eye and genitals. The male nude is stretched out in a full frontal position with the feet facing towards the observer, following the construction of Mantegna's famous depiction of Christ which was adopted by Christian Schad in his picture *Operation*. Closeness to the new functionalism is particularly noticeable in Freud's early work. For the flesh tones, Freud uses a particular pigment, a charabanc white with a high lead content that he calls "Cremnitz." The color is supposed to look "like flesh itself." "I have always despised *la belle peinture* and *la delicatesse des touches*," wrote Freud. Increasingly, he has turned his concentration towards reproducing the various incarnadine tonal values, in recent years often with life-sized works from head to foot. Although he follows the Realist tradition, for him it is all just about painting in the end. Color should not, however, take over from the subject as an element in itself, detaching itself from the subject and conveying an emotional significance of its own. Freud does not want people to say: "Oh, what was that red or blue picture you did, I've forgotten what was on it." *M. A.*

Lucian Freud, Paintings. The Smithsonian Institute, Washington, D.C., 1987.

Lucian Freud: Paintings and Works on Paper 1990–1991, Exh. cat. Tate Gallery. London, 1991.

Lampert, C. *Lucian Freud: Recent Work*. London, 1993.

Hartley, C. *The Etchings of Lucian Freud, 1946–1995*. London and New York, 1995.

Hicks, A. *The School of London: The Resurgence of Contemporary Painting*. Oxford, 1989.

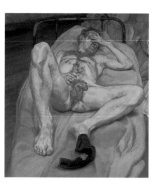

Nude Man on a Bed, 1989–90

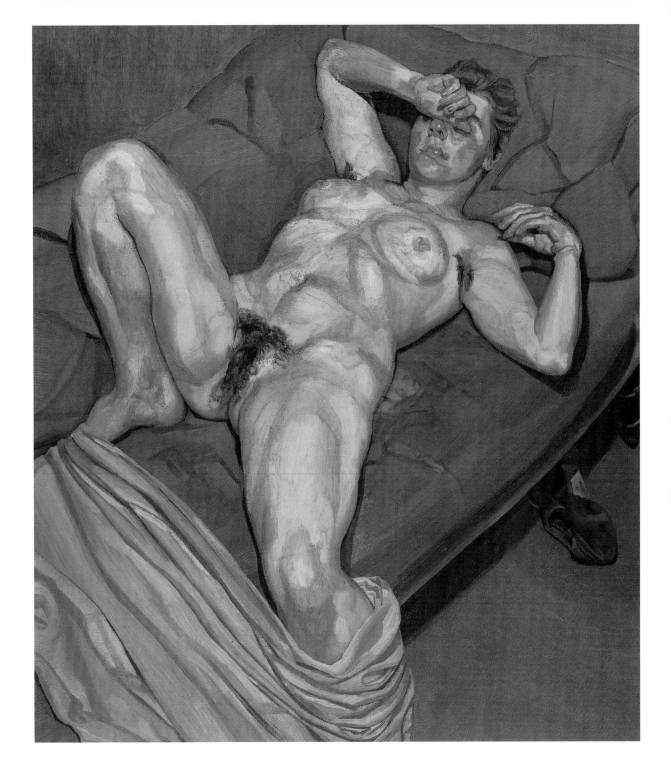

Walter De Maria

Lightning Field, 1977

Walter de Maria's *Lightning Field*, dating from 1977, is one of the key works of American Land or Earth Art, which, since the end of the 1960s, has sought to achieve a new definition and extension of the classical concept of art and its basic assumptions — originality, uniqueness, and materiality. Situated on an isolated plateau in western New Mexico, the *Lightning Field* consists of 400 stainless-steel rods that taper to a point at the top. Laid out in the form of a regularly spaced rectangular grid one mile long by one kilometer wide, the rods form the coordinates of an imaginary horizontal plane. De Maria's *Lightning Field* unites major elements of those large-scale projects that are related to a particular situation or landscape. The leading protagonists of this form of art are, in addition to de Maria himself, Robert Smithson and Michael Heizer. The emphasis that the avant-garde of the 1950s and 1960s began to place on processual aspects — as found in the work of Jackson Pollock, for example, or in Minimal Art — is heightened even further by de Maria. His *Lightning Field* is recreated in ever new forms in a dialogue with the forces of nature; in other words, with the thunderstorms that frequently occur in this region. Its form is subject to constant variation as a result of the changing light and weather conditions. Like the landscape, these are constitutive parts of the work, which, therefore, has no final form. The metal rods, which represent a constant formal element in de Maria's oeuvre — as in *High Energy Bars* (1966), the *Vertical Earth Kilometers* installations (1977) or *Broken Kilometer* (1979) — serve as a link between heaven and earth. They represent a challenge to the energy of lightning. In a short paper he wrote as early as 1960, de Maria emphasized the significance of natural disasters as the "highest form of art." He therewith takes up the tradition of 19th-century American landscape painting, which sought the sublime — and inevitably the awe-inspiring, too — in the expanses of untouched nature. De Maria's *Lightning Field* unites these aspects of beauty and danger. Its aim is an intensification and concentration of our perception, which is based not least on the tension existing between the unpredictability of the forces of nature on the one hand, and the cool materiality of the rods and their mathematically precise rational arrangement on the other. The intensification of our perception and the factor of time are, therefore, the true themes of *Lightning Field*, the many-sided aspects of which can be perceived only after several hours observation. The work is a "test field" of perception, and solitude is a precondition of this; for "isolation," according to de Maria in his description of the *Lightning Field* project, "is the essence of Land Art." *A. W.*

Walter De Maria. Exh. cat. Museum Boymans-van Beuningen. Rotterdam, 1984.
Walter De Maria: Die fünf Kontinente Skulptur. Stuttgart, 1991.

The Broken Kilometer, 1979

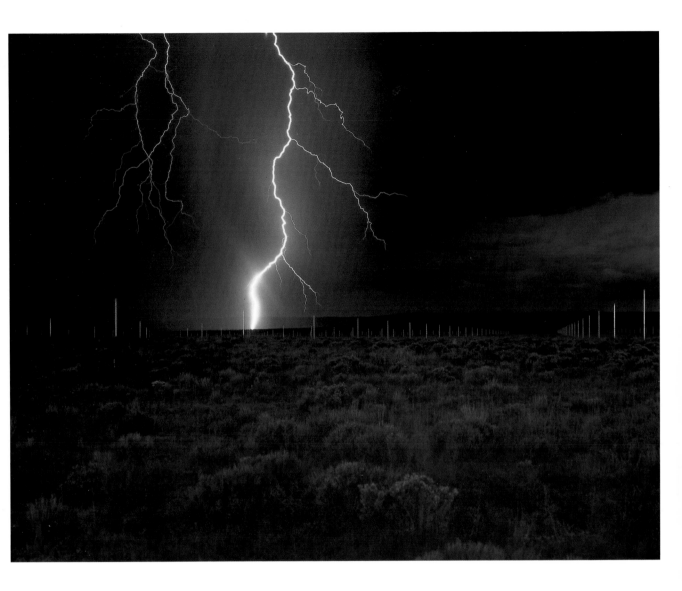

Eduardo Chillida

Wind Comb, 1977

"Like the volume of sound in music, which fills silence with tension — a sense of volume in sculpture would not be possible without the emptiness of space." The work of the Basque sculptor Eduardo Chillida, who calls himself an "architect of emptiness," represents the visualizing of a mutual dependence and intermingling of forms and space, of matter and emptiness. The experience he gained as a student of architecture flows into his artistic creativity, as does his experience of nature — he lives on the Spanish coast with a view of the sea — and his affinity for music. After returning to Spain from Paris in 1951, Chillida began to experiment with wrought iron, which quickly proved to be a suitable material in which to execute his desired forms. The result was a series of linear sculptures which almost have the character of drawings, whose angularly broken, beam-like forms thrust dynamically into space. In the 1960s and 1970s the sculptures, which the artist by then also carried out in wood, stone, and concrete, became more massive, more concentrated and static. The notion of an inner space, like an air-tight box with only a few openings to the surrounding space, became a decisive concept. In recent years the artist has frequently combined the two principles of open and closed forms. Already in the 1970s Chillida had begun to design monumental sculptures for public areas, a logical consequence of his preoccupation with space. The *Wind Comb* in San Sebastián can be seen as the most important and at the same time most personal work of this group. Back in the 1950s Chillida had already conceived a plan to make a large sculpture in homage to his native city and dedicated to the wind and the sea. He produced numerous studies before the project could finally be realized in 1977. In collaboration with the architect Ganchegui, Chillida created a space at the far western end of the bay of San Sebastián, which had until then been inaccessible, to serve at one and the same time as a meeting place for people and as a retreat for quiet meditation. Air, rocks, and water are the three elements which dominate the spot, and Chillida responded to these natural givens with a three-part sculpture: four bent, pincer-like arms extend from each of the three rectangular blocks, one reaching back to anchor the form to the surrounding rocks. Opening vertically and horizontally in different directions, for Chillida symbolizing past and future, two of the forms are mounted on rocks rising from the water while the third comb juts from the cliffs along the shore. Subjected to the forces of nature, constantly transformed by weather and tides, the *Wind Comb* communicates in a most complex way with the various human senses, appealing not only to optical and spatial perceptions but also to those of smell and taste. Above all, the sense of hearing is called upon, since the comb acts like an Aeolian harp plucked by the wind and echoed by the roaring and breaking of the waves. *I.H.*

Hänel, B. *Dualität von Form und Raum: Zum plastischen Werk des spanischen Bildhauers Eduardo Chillida.* 1983.
Paz, O. *Chillida.* Paris, 1979.
Schmalenbach, W. (ed.). *Eduardo Chillida — Zeichnungen 1948–1951, Hände 1949–1974, Formen 1957–1968.* Berlin, 1977.

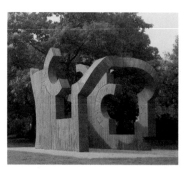

La casa de Goethe, 1986

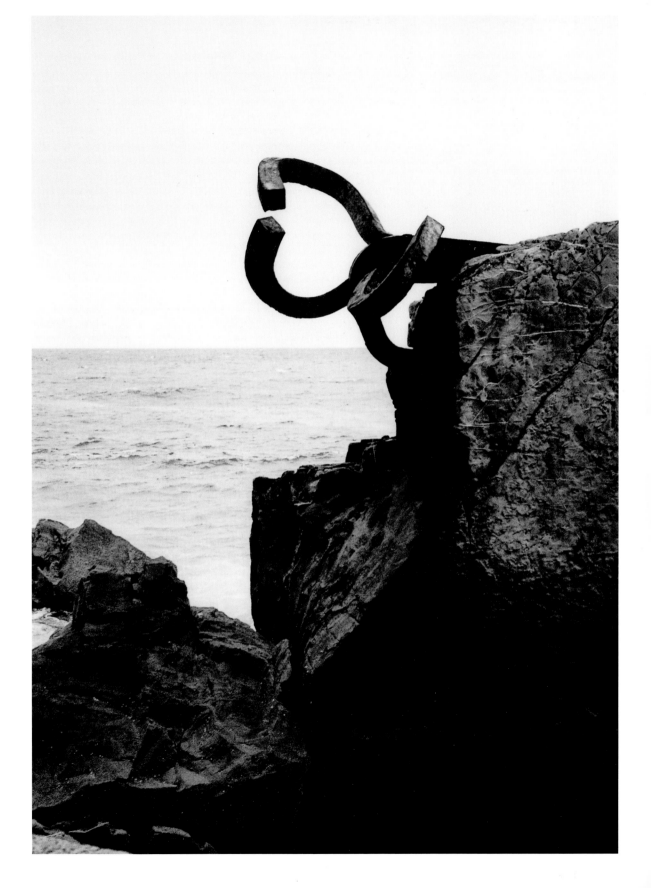

Niki de Saint Phalle

The Tarot Garden, from 1979

1930 Niki de Saint Phalle is born on October 29 in Neuilly-sur-Seine, but grows up in New York

1951 Settles in Europe; travels in Italy and Spain

1956 First solo exhibition, in St. Gallen, Switzerland; plaster reliefs; assemblages

from 1960 Lives and works with Jean Tinguely

1961 Member of the Nouveaux Réalistes

1963 Settles near Paris with Tinguely

1964 First *Nanas*

1966 With Tinguely and Per Olof Ultveldt makes *Hon* for the Moderna Museet, Stockholm

1967 First solo exhibition at the Stedelijk Museum, Amsterdam; her first Nana House is exhibited at the Fondation Maeght in the south of France

1972 Makes *Golem* for a playground in Jerusalem

1979 Starts work on the *Tarot Garden*, a sculpture park in Tuscany

1983 With Tinguely creates the *Stravinsky Fountain* in front of the Centre Georges Pompidou, Paris

1983 Moves into the newly finished sculpture *The Empress* in the *Tarot Garden*

1986 Writes and illustrates the book *Aids, You Can't Catch It Holding Hands* together with Silvio Barradun

1990 In August Jean Tinguely dies

1994 Moves to San Diego, California. The Niki Museum opens in Nasu, Japan

1998 Completion of *Noah's Ark Sculpture Garden*, Jerusalem, together with Mario Botta

2001–03 The Grotto in the baroque *Herren häuser* Gardens is redecorated to Niki's designs of 1999

2002 Dies in San Diego, on May 21

Niki — as the artist is affectionately known to her friends — has fulfilled her life's dream in *The Tarot Garden*: figures, many times larger than life-size, which can be walked through, set beneath the open sky of Tuscany. In this architectural/sculptural ensemble, nestled in the Garavicchio hills near Grosseto, she has summed up her creative work. *The Tarot Garden* is the powerful, theatrical manifesto of a sculptor who has always been concerned with one thing: to lend expression to her personal emotions at any cost. This has included equally sensuality and willingness to fight, aggression, love of color, and mortal agony. In her early days, Niki discovered art as a therapeutic strategy and, through shooting pictures, liberated herself from the pressing burden of patriarchy. This exorcism, which above all applied to her own father, was followed by an evocation of the First Mother in the form of *Nanas*: the pride of her femininity, paragons of fullness celebrated in the form of statues. *The Tarot Garden* picks up the gloriously colorful *Nanas*, elevating them to the monumental, thus arranging a whole pantheon of god images: the magician with the high priestess, the female ruler (in the form of a sphinx), the male ruler, figures of justice, restraint and power, the Falling Tower, the Tree of Life. These are the cards of the "Grand Arcana" of the Tarot, transferred to the three-dimensional (and thus interpreted quite subjectively), which rise up before one in dream-like magnitude. Jean Tinguely, Niki's companion of many years and her lifelong artistic partner, contributed to the project with the steel reinforcing, structural engineering, and with casting the concrete — in other words, he contributed the entire know-how of an experienced civil engineer. It is thanks to his genius that the castle can be entered via medieval arbors and that Niki herself has set up her studio flat inside the female ruler. A team of Italian craftsmen covered this enchanted wood with a carpet of mirror and ceramic mosaic which glitters far across the landscape. The Tarot Garden follows the tradition of fantastical gardens, which range from Bomarzo, through the gardens of the Villa d'Este, to the works of Antoni Gaudí in Barcelona. In using monumental figures, Niki also continues in pre-Christian — Mesopotamian, Egyptian, Hellenistic, and Roman — art traditions. The "idol-like" nature of her creations is thus pervaded with the mystical message of the Tarot. *P. S.*

Niki de Saint Phalle. Exh. cat. Kunst- und Ausstellungshalle der Bundesrepubik Deutschland, Bonn. Stuttgart, 1992.
Hon — en katedral. Exh. cat. Moderna Museet. Stockholm, 1966.
Schulz-Hoffmann, C. (ed.). *Niki de Saint Phalle, Bilder — Figuren — Phantastische Gärten*. Munich, 1987.

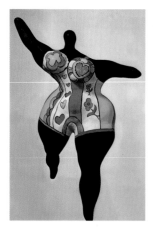

Dancing Black Nana, 1965–66

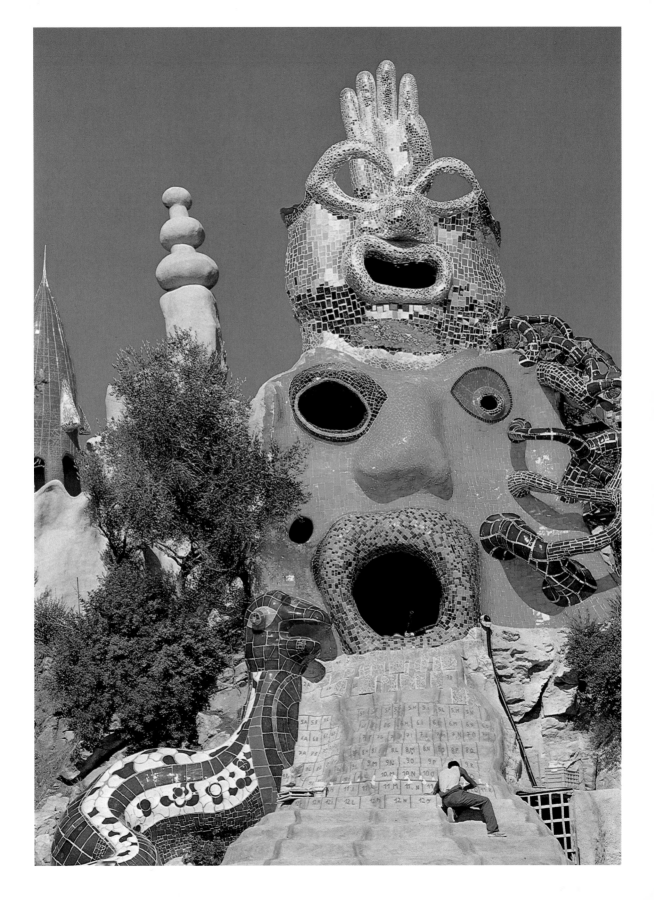

Anselm Kiefer

Ways of Worldly Wisdom: The Battle of the Teutoburg Forest, 1978–80

Painting is for Anselm Kiefer a way of understanding the world and not primarily the representation of subjective experiences. In a paradoxical way, art is for him a coming to terms with what is incomprehensible, the processing of that which remains excluded from the life sphere of individuals, that which is suppressed, or which seems to have been abandoned to oblivion. He sees himself not as a history painter, but rather as an artist who is once again attempting to grasp the totality of the cosmos in visual metaphors and allegorical landscapes of this world. Kiefer sees creative work as an act of giving meaning, or rather as an attempt to do so. Despite a baroque choice of themes, in which the contradiction of eternity and transience is manifested, the images make us recognize that the evocation of the past also contributes to its neutralization, even obliteration, but also that this partial process of blotting out is tantamount to remembrance, which preserves without bringing to life. Kiefer's paintings are without color and without light. Black and gray dominate, as well as dead materials. They exude something oppressive; the inherent theme of deliverance lacks any hope. Painting as paradox, the image as a warning without fear. The compositional structure of *Ways of Worldly Wisdom: The Battle of the Teutoburg Forest* follows a rigid pattern of 3-2-3-2 woodcuts on both sides of the vertically placed tree trunks and the blazing fire before them. The bottom of the pedestal is made up of eight further blocks of woodcuts. This historical image, which could ressemble a wall of bricks, is veiled with a network of radial and diagonal connections in which we can make out "genealogical" connections and associations, but which could also remind us of the cross-section of a tree trunk — possibly a visualization of the idea that even very different upholders of civilization are basically cut from the same piece of wood. Kiefer developed this theme in numerous preliminary stages and interpreted it in many variations. The subtitle *The Battle of the Teutoburg Forest* (in German, *Die Hermannsschlacht*) was used for the first time in 1976 for a painting entitled *Piet Mondrian — Hermannsschlacht*. This historical event was a battle in A.D. 9, when Hermann (i.e. Arminius, chief of the Cherusci) vanquished the three Roman legions of Quintilius Varus' army in a three-day battle in the Teutoburg Forest. With *Ways of Worldly Wisdom*, the title — found by chance — of a historical treatise written by a Jesuit priest, the historical battle is tied into an intellectual, historical system. Accordingly, Anselm Kiefer seeks to represent in his picture not only political history but the ulterior motives as well, the network of circumstances which motivated it and accompanied it. We can see how little he is concerned with objectivity alone by the fact that he combines new names and figures in various versions of the painting, that is, he creates no final image of a conclusive situation. *H. F.*

Anselm Kiefer: Watercolours, 1970–82. Exh. cat. Anthony d'Offay Gallery. London, 1983.
Anselm Kiefer: Bücher, 1969–1990. Exh. cat. Kunsthalle Tübingen, 1990.
Anselm Kiefer. Exh. cat. Nationalgalerie Berlin, 1991.
Rosenthal, M. *Anselm Kiefer.* Munich, 1988.

Heavy Water, 1987

Wege der Weltweisheit : die Hermanns-Schlacht.

Georg Baselitz

The Orange Eaters, 1981

A rather modest impression of everyday life is the starting point for this version of the "Orange Eaters" motif. Georg Baselitz chose it as the basis for a series of paintings which, despite their relatively small format, have extremely complex compositions. Concentrated in their syntax of forms and in the disposition of their painterly elements, examples from this group of works represent a new approach in the artist's work in the early 1980s. Unexpectedly, and therefore somewhat puzzlingly for visitors to the Biennale in Venice in 1980, the painter set his *Model for a Sculpture* in the middle of his exhibition space in the German pavilion. Space-defining suggestions of bodily form have a monumental presence in this wooden sculpture, with its emphatically three-dimensional volumes, which was to show the way for the artist's later development. This total lack of ambiguity in the representation of a body had already been significant in paintings of the work-complex *The Street Picture* of 1979, which directly preceded this sculpture. Interestingly enough, the sculptural vocabulary of individual variations on the "Orange Eaters" theme already orients itself according to the articulations of the wooden sculpture. Whether the *Orange Eaters* are depicted frontally or in profile, the eye of the viewer is caught by the rigorously placed, concise forms as well as by the precise painting style which defines them. With every brushstroke Baselitz creates patterns of form and structure which are suggestive far beyond their purely representational function. Free application of paint and strikingly exact execution are, in conjunction with the independent value of the substance of the paint itself, the decisive means of conveying pictorial impressions and expression. On this foundation, the *Orange Eaters* of 1981 manifests a first step in the direction of figural representation parallel to that of the wooden figures of the same period. The artist employs extreme formalism for the figures in paintings of this phase. In the most important examples, such as *Dinner in Dresden* or *The Brücke Chorus* (both from 1983), the figures are condensed into beings of visionary monumentality. Their persuasive power is gained from the reduction of their bodily forms and is echoed in the masterly composition of the paintings. Characteristics of this kind are prefigured by *The Orange Eaters*. Here, Baselitz carefully avoids the pathos which is intrinsic to his large, later compositions. In this phase of work it is replaced by a new, painterly intensity gained from direct observation which lends *The Orange Eaters* its special expressivity. *A. F.*

Franzke, A. *Georg Baselitz*. Munich, 1988.

Georg Baselitz. Exh. cat. Kunstverein Braunschweig. Braunschweig, 1981.

Schulz-Hoffmann, C. *Georg Baselitz*. Exh. cat. Staatsgalerie moderner Kunst Stuttgart. Stuttgart, 1993.

Waldman, D. *Georg Baselitz*. Exh. cat. The Solomon R. Guggenheim Museum. New York, 1995.

The Big Night in the Can, 1962–63

A.R. Penck

DIS, 1982

Ralf Winkler, who, since the mid-1960s, has called himself A.R. Penck after the speleologist Albrecht Penck (1858–1945), lived in Dresden until his move to West Germany in 1980. Self-educated, he earned his living — among other jobs — as a boilerman, and belonged to a social circle of artists and intellectuals who debated frankly and critically the system and the consequences of socialism as it actually exists. Important results of these discussions are the "systematic" pictures, in which Penck analyzes society in East and West and tries to illustrate it in a concise, sketchy, symbolic pictorial idiom. *World Picture* (1961) and *Large World Picture* (1965) are totally dominated by this preoccupation with East and West. In between these two he created *Der Übergang* (meaning "crossing," or "transition"). A human figure balances on a burning patch across an abyss: an image of deep psychological uncertainty that mirrors the artist's personal situation and at the same time becomes a metaphor for the threat of human existence in the age of the Cold War and nuclear weapons. In the 1970s Penck increased the degree of abstraction of his figures ever further. He was impelled by the vision to develop a sketch-like pictorial language, with the help of which — in a sort of modular construction system — he would be able to depict highly complicated and complex situations from all spheres of life. Penck calls himself a "thematic painter," for whom it is important to analyze and evaluate human relationships under certain social conditions. In a further development of these ideas he created his "standart" pictures, based on intensive study of problems of mathematics and information theory, which are intended to summarize in an artistically compressed and concise manner all theoretical knowledge gained thus far. Two years after moving to the West, Penck again confronted the East-West problem. For the exhibition "Zeitgeist" he created two large paintings: *Chi Tong* depicts conditions in the West, *DIS* those in the East. Whereas, for the West, Penck primarily confirms ambivalent behavior, and the main figure in the picture manages, to balance "after a fashion through the 'on the one hand…, on the other…' quagmire," in the East picture Penck sees "various figures in their confrontation with an abstract system." And he continues: "In the East there was a great illusional space, an abstract, unstructured, chaotic space. And in the foreground these flat figures in action — like a non-stop puppet show. And they are all connected by a current which runs through the entire picture" (*A. R. Penck im Gespräch mit Wilfried Dickhof*, Cologne, 1990). Now world-famous and occasionally resident in Germany, Penck finds that this country, even after reunification, can still force him to make art-historical and theoretical statements even if he himself is able to see things in relative terms: "I certainly understand my time as a dramatic struggle between various powers… But in me, myself, there is also the calm of the uninvolved observer … and the strivings of human beings are no more to me than the wars of ants" (L. Griesebach [ed.], *A.R. Penck*, Munich, 1988, p. 9).
 E.H.

A New Spirit in Painting. Exh. cat. Royal Academy of Arts. London, 1981.
A.R. Penck: Gemälde, Handzeichnungen. Exh. cat. Kunsthalle Köln. Cologne, 1981.
A. R. Penck: Skulpturen. Cologne, 1983.
Dickhoff, W. (ed.). *A.R. Penck im Gespräch mit Wilfried Dickhoff*. Cologne, 1990.
Grisebach, L. (ed.). *a.r. penck*. Munich, 1988.

Standart, 1971

The Crossing, 1963

Cindy Sherman

Untitled Film Still, #3, 1977

The photo shows a clip of a young woman in a kitchen; half coquettish, half forlorn, she glances over her shoulder and out of the picture. The photographer Cindy Sherman shows her affinity for the medium of cinema film in her choice of pictorial means, such as precisely directed lighting and deep shadows, and a subtle handling of black to white values resulting in atmospheric effects. The series *Untitled Film Stills* (1977– 80) — a "film still" being a frozen frame of an on-going film plot — marks the beginning of Sherman's artistic work in which she simultaneously functions as director, actress, and photographer. Her images of women are arranged like stage sets which evoke the nostalgic aura and aesthetic of the 1950s and 1960s, reviving typical Hollywood clichés from sex bomb, housewife, or career woman to the shy small-town girl in the big city. The observer of the photos is caught up in familiar fantasies but can identify with none of them, since it is only through a trick of *mise en scène* that stereotypical images of women are presented to him or her. Sherman makes use of the medium of photography, which already implies a type of game between being and seeming to be, and uses her body as a subject in order also to bring questions about her own identity into play. **B**y casting herself photographically in a wide variety of roles, in other picture series Sherman also questions the identification of models and representational systems prescribed by society. In 1984 she began to change the body beyond recognition with the use of artificial limbs and other features, so that body parts and dolls finally seem to be nothing more than skinned remnants and surrogates of the body. In her *History Portraits* (1989–90), she confronts the traditions of Western panel painting and criticizes the representation of the individual, who is reduced to a soulless shell equipped with a borrowed identity in the form of artificial body parts. In more recent works she has created suggestive images which make secret desires and hidden fears visible. The result is pictures full of cruelty and disgust — horrific visions of brutal sexuality practiced with distorted spare body parts. **I**n the discourse about identity and its loss, so typical of contemporary art, Sherman's work occupies an important position since she undermines the pretence of the holistic subject, presenting us instead with a coreless identity consisting of many different possibilities. Above all, the female identity is exposed as a constructed, prefabricated cultural cliché. Sherman points out to us our own habits of perception and makes use in her artistic expression of the language of the mass media, which offer a large number of false realities and deepen the illusion that reality and fantasies are ours for the taking. *P. D.*

Sherman: Arbeiten von 1975–1993. Munich, 1993.

Danto, A. C. *Cindy Sherman: History Portraits*. New York, 1991.

Sherman, C. *Untitled Film Stills*. Munich, 1990.

Sherman, C. *Fitcher's Bird: Fotografien von Cindy Sherman*. New York, 1992.

Zdenek, Z. and M. Schwander (eds.). *Cindy Sherman. Photoarbeiten 1975–95*. Munich, 1995.

Untitled # 93, 1981

Jenny Holzer

1950 Jenny Holzer is born on July 29 in Gallipolis, OH

1968–70 Studies at Duke University, Durham, NC

1972 Bachelor of Fine Arts at Ohio University, Athens, OH

1977 Master of Fine Arts at Rhode Island School of Design, Providence, RI; moves to New York; her first *Truisms*

1979–82 Works as a typesetter; *Inflammatory Essays*

1980–82 *Living Series*

1983–85 *Survival Series*

1986–87 *Under a Rock*

1986–88 The De Moines Art Center in Iowa organizes a touring retrospective

1987–89 *Laments*

1989 *Laments* Show at the Dia Foundation, NY; exhibition in the Solomon R. Guggenheim Museum, NY

1990 Takes part in the Venice Biennale

1993–95 *Lustmord*

1995 *Erlauf*

1996 *Arno*

1998 *Blue*

2000 Receives the first American Academy in Berlin Art Prize Fellowship for advanced studies

2001 *OH*

Lives in Hoosick Falls, New York

Born into the world of television, advertising, and billboards, Jenny Holzer reflects in her work an age in which the concept of the original has become suspect and the individual picture is increasingly losing importance. Her work is a commentary on how art is received in a consumer society, and what role social manners and simple rules of coexistence now play among people, in view of the growing influence of the mass media. The primary medium of her first series, *Truisms* (1977–79), is, therefore, language. Language fascinates the artist, since she can communicate with it in a way that is not possible in painting. She herself refers to the statements "Fathers often use too much force" and "Murder has its sexual side" as "mock clichés," as attempts to reformulate important messages by means of extreme simplification. At first glance, the *Truisms* contain deeper truths; but they are based on pure clichés that in turn are rooted in certain social structures. The works reveal not only different truths; they also imply that each individual version of the truth can contain its own opposite. When Holzer has a selection of these *Truisms* run past the observer in the form of illuminated information strips, they have lost all connection with a world that can be experienced through the senses. They have been reduced to word forms, the art of formulation, and speech rhythms. In this way, the artist undermines the absolute authority of the commercial information media and forces us to consider what the truth is and whether she is telling us this truth or not. In 1986, Holzer exhibited an installation called *Under a Rock* at the Barbara Gladstone Gallery in New York. The title refers to unpleasant and really unnamable subjects that she drew from earlier series, the *Inflammatory Essays*, the *Living Series*, and the *Survival Series*. She describes them as things that "crawl out from under a rock." Brutal events are reported in a cool, factual manner. The horrific content discloses itself to the reader only gradually: "Crack the pelvis so she lies right. This is a mistake. When she dies you cannot repeat the act. The bones will not grow together again and the personality will not come back…" Jenny Holzer places her entire trust in the strength of words. She uses illuminated advertising signs, paints the walls of high-rise blocks, uses posters in public places, bronze or aluminum plates or stone sarcophagi and benches on which she inscribes her texts. Working in the public realm stimulates a visual mixture of art and advertising, which means that her work becomes part of the real world. She seeks the public realm and casual passers-by, because she believes it is no longer possible to shock or surprise the so-called art lovers in the galleries and museums. "An elite is inevitable." *S. P.*

Aupig, M. *Jenny Holzer*. New York, 1992.
Dickhoff, W. (ed.). *Jenny Holzer im Gespräch mit Naomi Smolik*. Cologne, 1993.
Jenny Holzer. Exh. cat. The Solomon R. Guggenheim Museum. New York, 1989.
Waldman, D. *Jenny Holzer*. Stuttgart, 1997.

Under a Rock, 1986

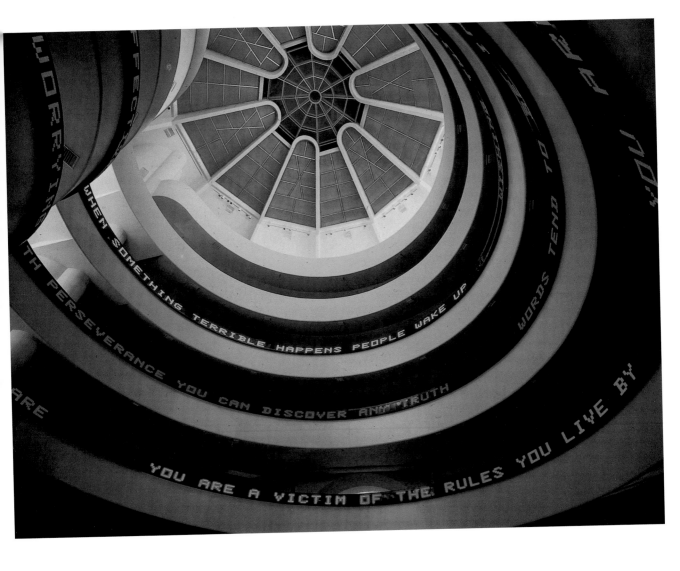

Barbara Kruger

Untitled (I Shop Therefore I Am), 1987

Consumerism as identity: this is the alarming conclusion that Barbara Kruger comes to in her work as a photographer. The viewer is presented with a card with the words "I shop therefore I am" — like a business card bearing the holder's name and a succinct reference to his or her occupation — but here the individual's identity is dependent on his/her role as a consumer. "I shop therefore I am" is a radical reworking of "Cogito ergo sum," once claimed by the French philosopher René Descartes, who argued that intellectual thought alone proves that human beings exist — that conscious thought determines existence. Kruger, on the other hand, sees the relationship between body and soul as the dualism of consumerism and our search for identity. Doubts concerning human knowledge and the conditions of our lives remain and, according to Kruger, these can only be resolved by individuals fitting into the system in which they find themselves, succumbing to it, and becoming consumers. Thinking is no longer seen as the basis of human existence; it has been replaced by consumerism. Kruger's work includes many large-scale photographs accompanied by provocative texts, usually in red. These fragmented photo-text collages take a stand against the image of reality purveyed by the media and, above all, by the advertising industry. Since the late 1970s, the artist has been using personal pronouns to represent the viewer, the intended recipient of her messages, slogans, and stock phrases, which have a revelatory ring to them. In the interchange of I/You, Kruger is using concepts without fixed meanings in order to demonstrate that masculinity and femininity are not stable identities but merely interchangeable "contents" (*You Are not Yourself*, 1982). As a female photographer working in the United States, Kruger's work has largely been influenced by gender debates and the stereotypical roles ascribed to men and women (*Memory Is Your Image of Perfection*, 1982; *Use only as Directed*, 1988) as well as by the picture of society promoted and simulated by television and other mass media (*When I Hear the Word Culture I Take Out My Checkbook*, 1985). S. P.

Außenraum — Innenstadt. Exh. cat. Sprengel Museum Hannover. Hanover, 1991.

Kruger, B. *Remaking History.* Seattle, 1989.

Kruger, B. *Remote Control: Power, Cultures, and the World of Appearances.* New York, 1993.

Linker, K. *Love for Sale: The Words and Pictures of Barbara Kruger.* New York, 1990.

Surveillance Is Your Busywork, 1985

Jesús Rafael Soto

Virtual Volume, 1987

The culmination of the denial of all figurative in art is evident in the work of Kasimir Malevich, which had obvious influence on Jesús Rafael Soto: "That was an important artistic encounter for me, because, through my new points of view, I noticed things I had not seen before: the fact that Malevich was trying to dynamize space." Soto uses simple forms, such as squares and lines, to create the impression of vibration. This is a characteristic of Kinetic art, of which he is a proponent. Unlike other Kinetic artists, he does not employ mechanical or motor aids. Movement is attained only through artistic means. The interest in new currents in art took Soto to Paris in 1950, where he made the acquaintance of Denise René and Jean Tinguely, with whom he held joint exhibitions. He was also inspired by new elements of music, such as the twelve-tone scale, through which he discovered the principles of permutation and repetition — principles which are contrary to classical visual ideas, but come close to Soto's ideas of abstraction in art. In addition, the most recent scientific discoveries in the fields of space and time structures are evident in his work. In his early oeuvre, Soto layers two structures, usually thin lines on a surface, over each other. He is not interested in ornamental effects, but in depicting relationships, such as optical displacement, counterparts, and deviations. In the course of his artistic development he splits these spatial structures into two layers. A construction of strings is hung from a transparent support; strings made of wire or nylon are attached to the supporting structure and later hung freely in a room. The strings seem to separate from the support and float in space. These are structural shapes which, when closely observed, suggest movement: overlapping, penetration, and separation. These phenomena are increased by the movement of the viewer. Thus, the intensity of vibrations created is directly dependent upon the viewer. Since the end of the 1960s, Soto has been creating large, yet light, transparent works. Thousands of evenly spaced nylon strings, hung from the ceiling, are set in motion by the slightest breeze. In *Virtual Volume* of 1987, yellow and white metal rods are arranged in two groups and hang from a support. Together they appear as the negative space suggested by the interior of an upside-down cupola — a color volume that exists in space optically, not physically: an interplay of space and surface, material and light. Color and form are dissolved in the immaterial space of light. "Art is not expression, art is realization." A realization that the viewer makes only after an encounter with Soto's work.

A. L.

Jesús Rafael Soto, Kamakura. Exh. cat. The Museum of Modern Art. New York, 1990.
Soto: A Retrospective Exhibition. Exh. cat. The Solomon R. Guggenheim Museum. New York, 1974.
Xuriguera, G. *Soto: Œuvres récentes*. Nice, 1990.

Vibration, 1965

Bruce Nauman

World Peace (Projected), 1996

1941 Bruce Nauman is born on December 6 in Fort Wayne, IN

1960–64 Studies mathematics, physics, and art at the University of Wisconsin, Madison, WI

1965–66 Studies at the University of California at Davis

1966 Moves to San Francisco; first solo exhibition, at the Nicholas Wilder Gallery in Los Angeles

1966–67 *Self-Portrait as a Fountain*

1966–68 Teaches at the San Francisco Art Institute

1968 Solo exhibition at the Leo Castelli Gallery in New York

1969 Moves to Pasadena, CA

1970 Teaches sculpture at the University of California at Irvine

1979 Moves to Pecos, NM

1985 First use of videotapes

1990 Moves to Galistel, NM

1991 Awarded the Max Beckmann Prize by the City of Frankfurt

1993 Awarded the Wolf Prize in Arts-Sculpture, Herzlia, Israel

1993–5 Solo exhibition at the Museum of Modern Art, New York. Traveling exhibition organized by the Walker Art Center in association with the Hirshhorn Museum and Sculpture Garden

1997 *Bruce Nauman, Image/Text 1966-1996* opens in Wolfsburg, Germany, before traveling to the Centre Georges Pompidou, Paris, the Hayward Gallery, London, and the Museum of Contemporary Art, Helsinki

1999 Golden Lion at the 48th Venice Biennale

Even in his choice of the title *World Peace (Projected)*, Bruce Nauman hints at the complex meaning of this installation with five video projections. In a room measuring approximately 33 by 33 feet, five people appear in larger-than-life video projections on three wall surfaces. Speaking and gesticulating, they continually repeat the same words: "I'll talk, you'll listen — You'll talk, I'll listen — I'll talk, they'll listen — They'll talk, I'll listen," or "I'll talk to you, you'll listen to me — You'll talk to me, I'll listen to you — I'll talk to them, they'll listen to me…." Through the constant shifting of the slowly and clearly pronounced sentences (they are also translated into sign language for the deaf), these utterances increasingly mingle to create an irritating and senseless babble. The room is thus filled with communication on two levels — through language and through images — which is not, however, reciprocal. It seems rather as if the individuals are speaking into empty space. In the self-contained room, visitors to the installation are unable to flee from the messages, an intense experience which both physically and psychologically impresses the central theme of the installation on our consciousness: the ubiquitous problem of interpersonal communication. **B**y the mid-1960s Bruce Nauman had already given up painting and had begun to experiment with new media and technologies such as photography, film, performance, video, and neon art. In contrast to Pop and Minimal Art, which were developed at about that time, his work represents an extremely subjective artistic language which deals above all with the human body and psyche. **N**umerous works and installations by Nauman confront the viewer with unusual, unpleasant, and at times frightening situations, forcing him to experience a heightened awareness of his current situation and himself. This also happens in *World Peace (Projected)* of 1996, although here Nauman, unlike in his earlier installations, chooses to do without such fear-provoking moments and, through his choice of phrases spoken in the future tense, leaves us a final ray of hope for the world peace that mutual communication may someday bring us. In recognizing how new media technologies reach today's viewer more directly than other artistic media, Nauman opened up an entirely new field of creative possibilities for the art of the 20th century. *I. N.*

Bruce Naumann: Skulpturen und Installationen 1985–1990. Exh. cat. Museum für Gegenswartkunst Basel. Basel, 1990.
Bruggen, C. van. *Bruce Nauman.* Basel, 1988.
Corde, C. *Bruce Nauman: Prints 1970–89.* New York, 1989.
Hoffmann, C. *Bruce Nauman: Interviews 1967–1988.* Dresden, 1996.
Schulz-Hoffmann, C.: *World Peace (Projected).* Munich, 1997.

Raw War, 1970

Anthro/Sicio, 1991

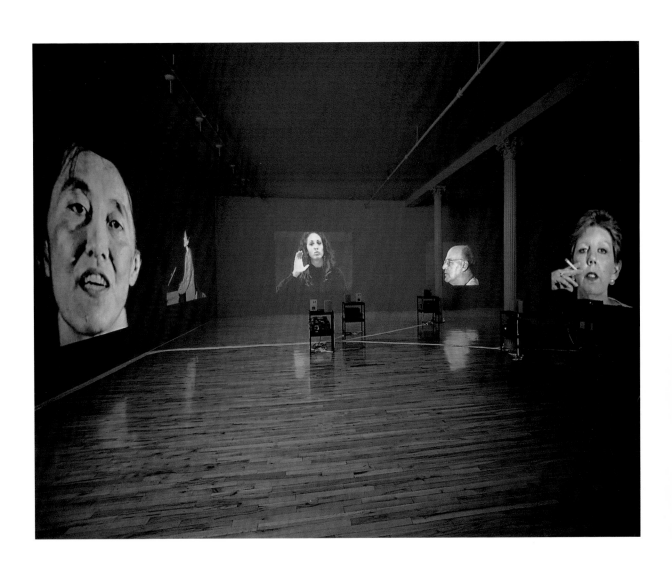

In August 1971, the Christos received a postcard of the Reichstag from Michael S. Cullen, an American living in Berlin. He suggested wrapping the Reichstag. In 1972, Christo executed the first drawings for the Berlin project. In 1973, an office for the project was opened in Berlin. In 1976, the artist visited Berlin for the first time, inspected the Reichstag, and held his first press conference. At that time, there was little hope that the Reichstag would ever function as Germany's National Legislature. **W**hen the Christos started the project in 1971, Germany was still divided. The problems encountered from the outset were numerous and complex. Permission to wrap the Reichstag had to be obtained not only from the West German government, but from the four Allied forces as well. **T**he Christos worked on this project longer than any other of their many temporary works of art. They made many visits to Germany, trying to convince several presidents of Germany, speakers of the Bundestag, and legislators to grant them permission to realize the project. "Christo's art is the creation of beautiful, temporary objects on a vast scale for specific outdoor sites. It is in the populist nature of his thinking that he believes people should have intense and memorable experiences of art outside museums," wrote art historian Albert Elsen in 1990. As with all their artistic endeavors, the realization of the wrapped Reichstag was paid for exclusively by the Christos from the sale of their artworks. Christo's work has been described as "revelation through concealment." Anyone who has seen the Christos' projects, such as the over twenty-four-mile-long *Running Fence* in California, the *Surrounded Islands* in Miami, *The Pont Neuf Wrapped* in Paris, *The Umbrellas* in Japan and the U.S.A., could not forget the excitement, the drama, and the magic inspired by them. In his book on Christo published in 1970, David Bourdon writes: "With ordinary fabric and cord, Christo has wrapped an imposing bundle of work and secured for himself a prominent position in mid-century art … it has been an extraordinary and fascinating career especially for a Bulgarian refugee who, within the space of a few years, has become an international art celebrity." **P**rominent among those who encouraged the Reichstag project are the late Willy Brandt, former President von Weizsäcker, and the indefatigable Rita Süssmuth, President of the Bundestag, who was the greatest supporter of all. The reunification of Germany in 1990 had a favorable effect on the project. The crucial day was February 15, 1994, when the Bundestag in Bonn voted 292 to 223 in favor of the project, with Chancellor Helmut Kohl voting against it. It was, as was quoted in the *New York Times*, "a demonstration of the power, magnitude, and fortitude of the project." **T**he wrapping of the Reichstag in June 1995 was the jewel in the crown of the Christos' many achievements. The wrapped building looked majestic and epic at any hour of the day or night, while five million people traveled to Berlin to see it. When the project was finished and unwrapped two weeks later, the front headline appeared in a Berlin newspaper: "Thank You Christo and Jeanne-Claude." *J.B.-T.*

Baal-Teshuva, J. *Christo: The Reichstag and Urban Projects*. Munich, 1993.

Schellmann, J. and J. Benecke (eds.). *Christo: Prints and Objects, 1963–1987, Catalogue raisonné*. New York, 1988.

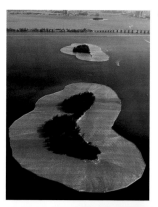

Surrounded Islands, 1980–83

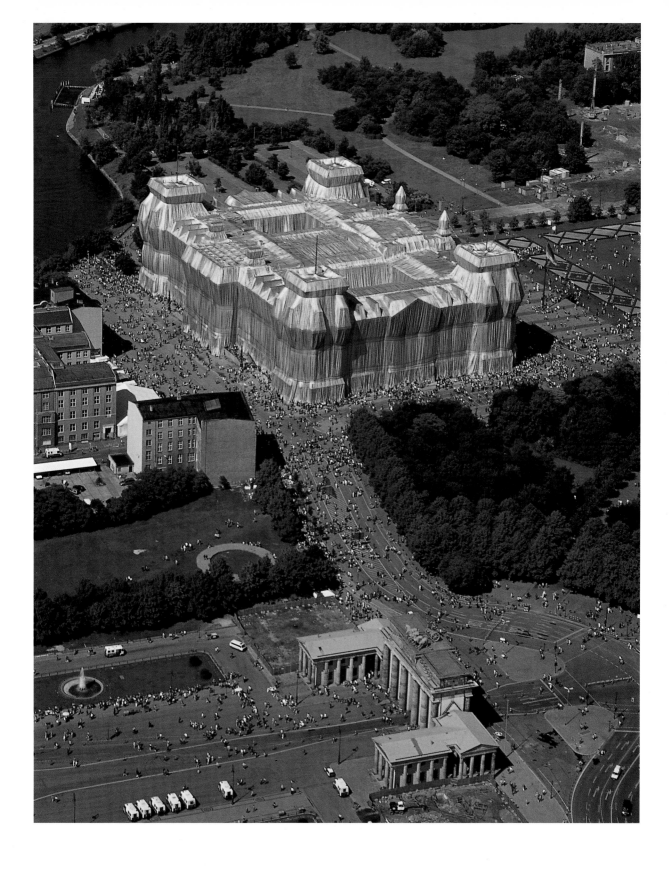

Jeff Wall

Movie Audience, 1979

1946 Jeff Wall is born in Vancouver, Canada

1970 Graduates from the Department of Fine Arts at the University of British Columbia, Vancouver

1970–73 Research stipend at the Courtauld Institute of Art, University of London

1974–75 Teaches in the Department of Art History, Nova Scotia College of Art and Design in Halifax, Nova Scotia

1976–87 Teaches at the Center for the Arts, Simon Fraser University, Vancouver

1984 Exhibition in the Institute of Contemporary Art in London; *The Thinker*

1986 *The Storyteller*; *The Thinker*

from 1987 Teaches in the Department of Fine Arts, University of British Columbia, Vancouver

1988 *Trân Dúc Vân*

1994 *A Fight on the Sidewalk*

1995 Exhibition in the Museum of Contemporary Art, Chicago

1996 Exhibition in the Kunstmuseum Wolfsburg, Germany

Lives and works in Vancouver

The cinema audience is anonymous and only vaguely to be made out in the darkness of the movie theater. The viewers are absorbed in what is happening on the screen. The light from the film projector shines from behind the viewers but does not illuminate them. The light on their faces is visible as a reflection of the bright images on the screen. With his work *Movie Audience*, Jeff Wall chose not the cinema film but the cinema audience as his subject. The people watching the film are seen from a low viewpoint. The individual images are grouped in lightboxes in two pairs and in a threesome in which a child is seen between a woman and a man. Together these three lightboxes, which are mounted with some space between them, give the impression of a row of movie-goers. Placed in front of the dark background, the individual portraits are images which seem to glow from within. With this treatment they recall 17th-century images of the prophets, as well as depictions from Soviet Constructivism and Social Realism in which the man in the street becomes the defender and hero. Different from these images, though, Jeff Wall's pictures preserve a sense of individuality and introversion. In this way they are similar to the depictions of people by August Sander or the subway photographs of Walker Evans. The movie audience looks out of the picture space at the imaginary screen and thus into a realm outside their own space. The men and women seen in three-quarter profile are reminiscent of pictures of prophets and sibyls. Their representation with the exactness of photographs, however, immediately transports them back to contemporary everyday life, and so the images fluctuate between above and below, between heaven and earth, between the sacred and the profane. Through their presentation in large lightboxes, Jeff Wall's pictures shine, since the image and the source of light are one and the same. Light and information penetrate directly into the eye of the viewer. In this way, these images are more riveting than objects which are illuminated by a separate light source. The overwhelming impression of Gothic cathedrals comes, not least, from their glowing walls of stained glass. Jeff Wall uses his lightboxes, which have considerable volume in themselves, as bodies in space. Placed high up and in front of a wall, sometimes also placed diagonally across a room, these picture objects also have the quality of architectural elements. They are both objects and windows at the same time. In the same way as *Young Workers* of 1978–83 and *Little Children* of 1988, *Movie Audience* represents the one side, the spectators in Wall's work. In other works, Wall shows scenes that at least appear to be like snapshots of everyday life, but then in their composition, in their gestures, movements, and in their light embody classical picture canons from art history. Whether the works include people watching or representational scenery, we remain outside and are voyeurs who, uninhibited, can call these images our own. *H. F.*

Brougher, K. *Jeff Wall*. Zurich, 1997.
Friedel, H. (ed.). *Jeff Wall: Space and Vision*. Munich, 1996.

Milk, 1984

Louise Bourgeois

Cell (You Better Grow Up), 1993

Man is the subject and measure of Louise Bourgeois' art. The image of man is evoked or alluded to in his absence through traces of his existence: the objects he uses, furniture, artifacts, fragments of the human body, and, more recently, old clothes and objects of apparel. In the early works, man is evoked by means of *Totems*: tall, slender stelae. The abstract, conceptualized figure is seen as a direct substitute, in the tradition of primitive animistic art. In all its phases, Bourgeois' work is autobiographical and, as such, an expression of the artist's self-reflection through what she calls "remembrance" — remembrance of her own childhood and youth. Louise Bourgeois was born in 1911 in Paris, the daughter of an artist couple who had their flat and studio in the Boulevard Saint-Germaine at the heart of the Latin Quarter of Paris, where the famous Café Flore, the former haunt of artists and writers, still exists today. She spent her youth mainly in Choisy-le-Roi, and later in Anthony on the Bièvre, where her parents acquired a piece of property and opened a workshop for the restoration of old tapestries. Clear traces of these surroundings can be found, especially in Bourgeois' late work, in the spindles, the colorful bobbins of yarn, the bobbin stands, the club-shape pincushions, needles, mirrors, magnifying glasses — utensils which the artist proceeds to link with the metaphor of the thread and the mythology of the three Parcae, the Fates. The ancient concept of fate becomes a major theme of her late work: in the sculptures, and in particular the voyeuristic spaces she refers to as "cells." After 1938, Louise Bourgeois lived in New York, where she moved with her husband, the well-known art historian Robert Goldwater. The link between her old and new homes is formed by her fellow artist-emigrés, and especially the Surrealists. With its interest in psychoanalysis and its manifest avowal of "primitivism," of *Art brut*, of the art of children and the mentally sick, and with its rediscovery of myths, Surrealism was to become the decisive source of inspiration for Louise Bourgeois. No small part in this was played by Robert Goldwater himself, whose book, *The Primitivism in Modern Art*, was published in 1938. He was one of the first to investigate the role primitive art played in the development of modern painting, and even more in sculpture, and to apply aesthetic criteria to assess it. *B.C.*

Louise Bourgeois: Skulpturen und Installationen. Exh. cat. Kestner-Gesellschaft Hannover. Hanover, 1994.
Louise Bourgeois: The Locus of Memory: Works 1982–1993. Exh. cat. The Brooklyn Museum. New York, 1994.
Louise Bourgeois: Der Ort des Gedächtnisses, Skulpturen, Environments und Zeichnungen, 1946–1995. Exh. cat. Deichtorhallen. Hamburg, 1996.

The Blind Leading the Blind, 1947–49

Sitting Woman I, 1938
Oil on canvas
64 ⅛ x 51 ⅝ in.
The Museum of Modern Art, New York

pages 56/57
Amedeo Modigliani

Portrait of Max Jacob, 1916
Oil on canvas
28 ¾ x 23 ⅝ in.
Kunstsammlung Nordrhein-Westfalen,
Düsseldorf

Nude with Necklace, 1917
Oil on canvas
28 ¾ x 45 ¾ in.
The Solomon R. Guggenheim Museum,
New York

pages 64/65
Piet Mondrian

Landscape with Trees, 1911–12
Oil on canvas
47 ¼ x 39 ⅜ in.
Haags Gemeentemuseum, The Hague

Tableau I, 1921
Oil on canvas
38 x 23 ¾ in.
Museum Ludwig, Cologne

pages 26/27
Claude Monet

*The Houses of Parliament, London,
Sun through Fog*, 1904
Oil on canvas
31 ⅞ x 36 ¼ in.
Musée d'Orsay, Paris

Waterlilies, 1916–20
Oil on canvas
78 ¾ x 167 ¼ in.
Musée de l'Orangerie, Paris
(First room)

pages 82/83
Henry Moore

Seated Woman in a Shelter, 1941
Ink and watercolor on paper
14 ⅞ x 22 ⅛ in.
Wakefield Art Galleries and Museums

Reclining Figure, 1929
Brown Hornton stone
22 ½ x 32 ¾ x 15 in.
City Art Gallery, Leeds

pages 144/145
Robert Motherwell

Je t'aime, IV, 1955–57
Oil on canvas
69 ⅝ x 100 ⅜ in.
Bayerische Staatsgemäldesammlungen,
Staatsgalerie moderner Kunst, Munich

Elegy for the Spanish Republic LXX,
1961
Oil on canvas
69 x 113 ¾ in.
The Metropolitan Museum of Art,
New York, Anonymous Gift, 1965

pages 16/17
Edvard Munch

Madonna, ca. 1894
Oil on canvas
38 ⅛ x 29 ½ in.
Private Collection

The Scream, 1893
Oil, gouache, casein, pastel on paper
91 x 74 cm
Nasjonalgalleriet, Oslo

pages 200/201
Bruce Nauman

Raw War, 1970
Neon tubes
6 ½ x 17 ⅛ x 1 ½ in.
6 copies

Anthro/Socio, 1991
Video tapes, projectors, monitors, and
recorders
Hamburger Kunsthalle

World Peace (Projected), 1996
Video installation; 5 projectors,
5 videodiscs, 5 videodisc players,
10 loudspeakers, 1 remote control,
1 stool (clay and paint)
Exhibition copy
Courtesy Sperone Westwater Gallery,
New York

pages 172/173
Barnett Newman

Midnight Blue, 1970
Acrylic on canvas
76 ¾ x 94 ⅞ in.
Museum Ludwig, Cologne

*Who's Afraid of Red, Yellow and
Blue IV*, 1969–70
Acrylic on canvas
109 x 240 ¼ in.
Staatliche Museen zu Berlin,
Preussischer Kulturbesitz und Verein
der Freunde der Nationalgalerie, Berlin

pages 76/77
Georgia O'Keeffe

Jack-in-the-Pulpit VI, 1930
Oil on canvas
40 x 30 in.
Alfred Stieglitz Collection,
Washington, D.C.

Black Iris III, 1926
Oil on canvas
36 x 30 in.
The Metropolitan Museum of Art,
New York

pages 156/157
Claes Oldenburg

Geometric Mouse — Scale A, 1973
Steel, aluminum, enamel
144 x 180 x 84 in.
Moderna Museet, Stockholm

Soft Washstand, 1966
Vinyl filled with kapok, on metal stand
painted with acrylic
55 x 36 x 28 in. (129.7 x 91.4 x 71.1 cm)
Private Collection, Belgium
Copyright Claes Oldenbourg and
Coosje van Bruggen

pages 96/97
Meret Oppenheim

My Nurse, 1936
Object: white shoes, paper frills, on an
oval piece of metal
5 ½ x 8 ¼ x 13 in.
Moderna Museet, Stockholm

Stone Woman, 1938
Oil on cardboard
23 ¼ x 19 ¼ in.
Private Collection, Bern

Object: Breakfast in Fur, 1936
Cup, saucer, and spoon, covered
with fur
Cup diameter 4 ¼ in.; saucer diameter
9 ¼ in.; spoon length 8 in.; height 3 in.
The Museum of Modern Art, New York

pages 170/171
Nam June Paik

Family of Robot: Aunt, 1986
TV casing, monitors, video tapes
86 ⅝ x 52 x 21 ⅝ in.
Thomas Wagner Collection, Hamburg

TV Buddha, 1974
Wodden Buddha, camera, monitor
63 x 84 ⅝ in.
Stedelijk Museum, Amsterdam

pages 190/191
A.R. Penck

Standart, 1971
Acrylic on canvas
114 ⅛ x 114 ⅛ in.
Private Collection

The Crossing, 1963
Oil on canvas
37 x 47 ¼ in.
Neue Galerie der Stadt Aachen,
Sammlung Ludwig

DIS, 1982
Acrylic on canvas
196 ⅞ x 393 ¾ in.
Galerie Michael Werner, Cologne

pages 28/29
Pablo Picasso

*Women Running on the Beach
(The Race)*, 1922
Gouache on plywood
17 ¾ x 16 ⅝ in.
Musée Picasso, Paris

Les Demoiselles d'Avignon, 1907
Oil on canvas
95 ¾ x 92 in
The Museum of Modern Art, New York

pages 102/103
Guernica, 1937
Oil on canvas
137 ½ x 305 ¾ in.
Museo del Prado (Depositó en el Museo
Nacional Centro de Arte Reina Sofia),
Madrid

pages 164/165
Sigmar Polke

Doll, 1965
Emulsion paint on canvas
49 ¼ x 63 in
Private Collection

Modern Art, 1968
Acrylic and oil on canvas
59 x 49 ¼ in.
Anna and Otto Block, Berlin

pages 122/123
Jackson Pollock

Circumcision, 1946
Oil on canvas
55 ⅞ x 66 ⅛ in.
Peggy Guggenheim Collection, Venice

Number 2, 1950
Oil, enamel, silver paint, and
sandstone on canvas
113 x 36 in.
Fogg Art Museum, Harvard University
Art Museums, Cambridge, Mass.
Gift of Mr. and Mrs. Reginald R.
Isaacs & family and of the
Contemporary Art Fund

pages 130/131
Arnulf Rainer

The Back and Forth of Courage, 1982
Oil and oil chalk on cardboard
Fingerpainting
28 ¾ x 40 ⅛ in.
Museum moderner Kunst Stiftung
Ludwig, Vienna

Cross, Black on Yellow, 1957
Oil on particleboard
65 ¾ x 59 in.
Private Collection, Vienna

pages 128/129
Robert Rauschenberg

Retroactive II, 1964
Oil, silkscreen on canvas
83 ⅞ x 59 ⅞ in.
Stefan T. Edlis Collection

Bed, 1955
Combine Painting: oil and pencil on
pillow, quilt, and sheet on wood
supports
75 ¼ x 31 ½ x 8 in.
The Museum of Modern Art, New York

Canyon, 1959
Combine Painting: different techniques
and materials on canvas, with objects
81 ⅞ x 70 ⅛ x 24 in.
Sonnabend Collection, New York

pages 162/163
Gerhard Richter

Atlas, 1962–97
for 48 Portraits, 1974, 8 boards
for Installation 1972, 4 boards

Ema (Nude on a Staircase), 1966
Oil on canvas
78 ¾ x 51 ¼ in.
Museum Ludwig, Cologne

pages 114/115
Diego Rivera

The Day of the Flowers, 1925
Encaustic on canvas
58 ⅛ x 47 ½ in.
Los Angeles County Museum of Art

The Great City of Tenochtitlán, 1945
Fresco
193 ¾ x 382 ¼ in.
Palacio Nacional, Mexico

pages 8/9
Auguste Rodin

The Gates of Hell
Bronze
216 ½ in.
Musée Rodin, Paris

The Thinker, 1904 (First version 1880)
Bronze
42 ½ x 42 ½ x 55 ½ in.
Musée Rodin, Paris

pages 126/127
Mark Rothko

Antigone, ca. 1941
Oil on canvas
34 x 45 ¾ in.
National Gallery of Art,
Washington, D.C.

No. 12 (Yellow, Orange, Red on Orange), 1954
Oil on canvas
115 x 91 in.
Collection of Kate Rothko Prizel

pages 94/95
Georges Rouault

Head of a Tragic Clown, 1904
Watercolor, gouache, and pastel
on paper
14 ½ x 10 ¾ in.
Kunsthaus Zürich
(Gift of Dr. Max Bangerter)

The Old King, 1937
Oil on canvas
30 ⅜ x 21 ¼ in.
Museum of Art, Carnegie Institute,
Pittsburgh

pages 184/185
Niki de Saint Phalle

Dancing Black Nana, 1965–66
Polyester
Height ca. 78 ¾ in.
Private Collection

The Tarot Garden, from 1979
Here: Magician/High Priestess
Concrete and iron, mosaics
Garavicchio, Tuscany

pages 46/47
Egon Schiele

Seated Woman with Raised Knee, 1917
Gouache, watercolor, and black chalk
on paper
18 ⅛ x 12 in.
Narodní Gallery, Prague

Large Seated Nude, 1910
Black chalk, watercolor, and body
color on paper
17 ⅜ x 12 in.
Leopold Museum-Privatstiftung,
Vienna

*Standing Female Nude with Blue
Scarf*, 1914
Gouache, watercolor, and pencil
19 x 12 ¾ in.
Germanisches Nationalmuseum,
Nuremberg

pages 86/87
Oskar Schlemmer

Mythical Figure, 1923
Ink and collage on colored paper,
on cardboard
29 ½ x 68 ⅛ in.
Staatsgalerie, Stuttgart

Bauhaus Staircase, 1932
Oil on canvas
63 ¾ x 40 ½ in.
The Museum of Modern Art, New York

pages 58/59
Kurt Schwitters

Merzbau, 1933
Sprengel Museum, Hanover

Merzbild 31, 1920
Assemblage
38 ½ x 26 in.
Kurt Schwitters collection of the Nord
LB in the nieders. Sparkassenstiftung

pages 192/193
Cindy Sherman

Untitled # 93, 1981
Color photograph
24 ⅜ x 48 ½ in.
Museum Boymans-van Beuningen,
Rotterdam

Untitled Film Still, # 3, 1977
Several copies

pages 198/199
Jesús Rafael Soto

Vibration, 1965
Metal, wood, and oil
62 ⅜ x 42 ¼ x 5 ¾ in.
The Solomon R. Guggenheim Museum,
New York

Virtual Volume, 1987
Sculpture suspended in the foyer of the
Musée National d'Art Moderne,
Centre Georges Pompidou, Paris

pages 146/147
Frank Stella

Harewa, 1978
Different materials on aluminum
89 ⅜ x 133 ⅞ x 28 in.
Gabriele Henkel Collection
Courtesy Hans Strelow, Düsseldorf

Tuxedo Junction, 1960
Enamel on canvas
122 x 73 ½ in.
Stedelijk Van Abbemuseum,
Eindhoven

pages 120/121
Rufino Tamayo

Woman in Gray, 1959
Oil on canvas
76 ¾ x 51 in.
The Solomon R. Guggenheim Museum,
New York

Girl, Attacked by a Strange Bird, 1947
Oil on canvas
70 x 50 ⅛ in.
The Museum of Modern Art, New York

Homage to the Indian Race, 1952
Mural on canvas
196 ⅞ x 157 ½ in.
Museo de Bellas Artes, Mexico City

pages 132/133
Antoni Tàpies

Large Shoe, 1990
Paint and varnish on canvas
77 x 103 ⅛ in.
Private Collection, Barcelona

Porta metál.lica i violí, 1956
78 ¾ x 59 x 5 ¼ in.
Fundació Antoni Tàpies, Barcelona

pages 60/61
Vladimir Tatlin

Letatlin, 1929–32
Different materials
43 ¼ x 815 x 74 ¾ in.
State Museum for Air and Space
Travel, Munino

*Model of the Monument for the Third
International*, 1920
Wood, metal
Overall height 165 ¼ in.; height of base
31 ½ in.

pages 152/153
Jean Tinguely

Hommage à New York, 1960
Action with a self-destructing
mechanism in the Sculpture Garden of
the Museum of Modern Art, New York
March 17, 1960

Hong Kong, 1963
Scrap iron, frying pan, and wheels,
stained black, electromotor
78 x 38 ½ x 33 ¾ in.
Städtische Kunsthalle, Mannheim

pages 150/151
Cy Twombly

Untitled, 1961 (Roma)
Oil, colored chalk, and pencil on
canvas
100 ¾ x 12 ⅞ in.
Galerie Thomas Ammann, Zurich

Vengeance of Achilles, 1962
Oil, crayon, and pencil on canvas
118 x 69 in.
Kunsthaus Zurich

pages 140/141
Victor Vasarely

Rugó, 1978
Acrylic on canvas
111 ¾ x 54 ¼ in.
Collection of J. Salomon,
Circle Gallery

Markab-Neg, 1957
Oil on canvas
55 x 70 ¾ in.
Private Collection, Vienna

pages 204/205
Jeff Wall

Milk, 1984
Cibachrome slide, illuminated by
fluorescent light
73 ⅜ x 90 ⅛ in.
FRAC Champagne-Ardenne

Movie Audience, 1979
7 Slides, mounted in three projectors,
each 40 ⅛ x 40 ⅛ in.;
overall dimension 43 ¼ x 354 ¼ in.
Städtische Galerie im Lenbachhaus,
Munich

pages 154/155
Andy Warhol

White Car Crash 19 Times, 1963
Synthetic polymer paint and silkscreen
on canvas
145 x 83 ¼ in.
Courtesy Thomas Ammann, Zurich

Flowers, 1964
Synthetic polymer paint and silkscreen
on canvas
81 ⅞ x 81 ⅞ in.
Collection of the Abrams Family

Marilyn, 1964
Silkscreen and acrylic on canvas
34 x 34 in.
Courtesy Thomas Ammann, Zurich

Photo Credits

© Prestel Verlag
Munich · Berlin · London · New York 2003
(first published in 1997)

© of works illustrated by the artists,
their heirs and assigns, with the exception
of works by: Josef Albers, Francis Bacon,
Giacomo Balla, Balthus, Max Beckmann,
Joseph Beuys, Pierre Bonnard, Louise
Bourgeois, Constantin Brancusi, Georges
Braque, Marc Chagall, Eduardo Chillida,
Giorgio de Chirico, James Ensor, Max
Ernst, Lyonel Feininger, Dan Flavin,
Alberto Giacometti, Arshile Gorky, George
Grosz, Richard Hamilton, Jenny Holzer,
Jasper Johns, Vassily Kandinsky, Paul
Klee, Yves Klein, Oskar Kokoschka, Käthe
Kollwitz, Fernand Léger, Roy Lichten-
stein, El Lissitzky, René Magritte, Roberto
Sebastian Matta Echaurren, Joan Miró,
Bruce Nauman, Barnett Newman, Georgia
O'Keeffe, Meret Oppenheim, Jackson
Pollock, Georges Rouault, Niki de Saint
Phalle, Kurt Schwitters, Jesús Rafael
Soto, Frank Stella, Vladmir Evgrafovich
Tatlin, Jean Tinguely, Victor Vasarely,
Frank Lloyd Wright by VG Bild-Kunst,
Bonn 2003; Salvador Dalí by Demart pro
Arte B.V./VG Bild-Kunst, Bonn 2003;
Marcel Duchamp by Sucession Marcel
Duchamp/VG Bild-Kunst, Bonn 2003;
John Heartfield by The Heartfield
Community of Heirs/VG Bild-Kunst, Bonn
2003; Willem de Kooning by Willem de
Kooning Revocable Trust/VG Bild-Kunst,
Bonn 2003; Man Ray by Man Ray Trust,
Paris/VG Bild-Kunst, Bonn 2003; Henri
Matisse by Succession H. Matisse/VG Bild-
Kunst, Bonn 2003; Piet Mondrian by
Mondrian/Holtzman Trust, c/o Beeld-
recht, Amsterdam, Holland/VG Bild-
Kunst, Bonn 2003; Robert Motherwell by
Dedalus Foundation/Society/VG Bild-
Kunst, Bonn 2003; Edvard Munch by The
Munch Museum/The Munch Ellingsen
Group/VG Bild-Kunst, Bonn 2003; Pablo
Picasso by Succession Picasso/VG Bild-
Kunst, Bonn 2003; Mark Rothko by Kate
Rothko-Prizel & Christopher Rothko/VG
Bild-Kunst, Bonn 2003; Antoni Tàpies by
Foundation Antoni Tàpies Barcelona/VG
Bild-Kunst, Bonn 2003; Andy Warhol by
The Andy Warhol Foundation for the
Visual Arts/ ARS, New York 2003; Georg
Baselitz by Georg Baselitz; Christo and
Jeanne-Claude by Christo and Jeanne-
Claude; Robert Delaunay by L & M
Services B.V. Amsterdam 970703; Lucian
Freud by Lucian Freud; David Hockney
by David Hockney; Anselm Kiefer by
Anselm Kiefer; Ernst Ludwig Kirchner
by Ingeborg und Dr. Wolfgang Henze,
Wichtrach/Bern; Henry Moore by
The Henry Moore Foundation; Claes
Oldenburg by Claes Oldenburg and Coosje
van Bruggen; A.R. Penck by Galerie
Michael Werner, Cologne and New York;

Sigmar Polke by Sigmar Polke; Arnulf
Rainer by Arnulf Rainer; Robert
Rauschenberg by Untitled Press, Inc./VG
Bild-Kunst, Bonn 2003; Gerhard Richter
by Gerhard Richter; Oskar Schlemmer by
Sekretariat und Archiv Oskar Schlemmer,
IT – 28824 Oggebbio, 2003; Cy Twombly
by Cy Twombly

Front cover: David Hockney
"A Bigger Splash" © David Hockney

List of Contributors: p.4
List of Artists: p. 5

List of Illustrations: p. 209
Photo Credits: p. 215

Prestel Verlag
Königinstrasse 9, 80539 Munich
Tel. +49 (89) 381709-0
Fax +49 (89) 381709-35

Prestel Publishing Ltd.
4 Bloomsbury Place, London WC1A 2QA
Tel. +44 (020) 7323-5004
Fax +44 (020) 7636-8004

Prestel Publishing
175 Fifth Avenue, Suite 402, New York,
NY 10010
Tel. +1 (212) 995-2720
Fax +1 (212) 995-2733

www.prestel.com

Prestel books are available worldwide.
Please contact your nearest bookseller
or write to either of the above addresses
for information concerning your local
distributor.

Translations or texts from the German
were supplied by the following:
Graham Broadribb: pp. 46, 60, 86, 130,
132, 146, 150, 152, 176
Cynthia Cave: pp. 104, 114, 140, 154,
170, 178, 184
Fiona Elliott: pp. 34, 196
Peter Green: pp. 12, 20, 30, 40, 50, 62,
66, 68, 78, 80, 88, 92, 94, 110, 112, 122,
124, 128, 134, 142, 162, 168, 180, 194, 206
Jaqueline Guigui-Stolberg: pp. 18, 32, 38,
42, 54, 56, 58, 64, 74, 82, 90, 98, 100, 102,
148, 158, 166, 172, 174, 182, 186, 188,
192, 200, 204
Hugh Keith: pp. 8, 22, 24, 26, 36, 76,
96, 136
Jenny Marsh: pp. 28, 44, 48, 52, 84, 108,
138, 144, 190

Manuscript edited by Jenny Marsh
Designed and typeset by Wigel, Munich
Lithographies by ReproLine, Munich
Printed and bound by EBS Verona
Printed in Italy on acid-free paper

ISBN 3-7913-2987-1

ICONS
OF ART

The 20th Century